To M[...]

May your moviegoing
be both entertaining and
enlightening.

[signature]

KOSHER MOVIES

KOSHER MOVIES

A FILM CRITIC DISCOVERS
LIFE LESSONS AT THE CINEMA

RABBI HERBERT J. COHEN, PH.D.

URIM PUBLICATIONS
Jerusalem • New York

Kosher Movies: A Film Critic Discovers
Life Lessons at the Cinema
by Herbert J. Cohen

Copyright © 2015 Herbert J. Cohen

Typeset by Ariel Walden

Printed in Israel

First Edition

ISBN 978-965-524-185-3

Urim Publications, P.O. Box 52287,
Jerusalem 9152102 Israel

www.UrimPublications.com

Library of Congress C.I.P. Data in Process.

Contents

Sports 193

Decisions 211

Second Chances 229

Time 245

Ethics 263

Walking in Two Worlds: An Epiphany

I began studying Torah in earnest when I entered Yeshiva University in 1960. The program was designed for students who had not gone to Jewish schools either at the elementary or high school levels. In those early years, I heard about the great Torah luminary, Rabbi Joseph Soloveitchik, who was the intellectual force at the university, but it was not until the late 1960s that I went to hear one of his lectures.

I still remember the excitement of the evening. Parking was hard to find on Amsterdam Avenue in the Washington Heights neighborhood of New York. Cars were double-parked on both sides of the street, and people were looking for tickets to enter Lamport Auditorium where the lecture would take place. I arrived early and found a seat in the middle of the room near the left side of the stage. There was a palpable tension in the air; and after five or ten minutes, the Rav, as Rabbi Soloveitchik was referred to, entered. More than 2,000 people stood up to give him honor. He stepped up to the stage and sat down behind a table, filled with huge tomes, which served as a base for a microphone. The microphone amplified his voice, but I still had to strain to listen. What I experienced was an intellectual awakening.

The Rav shared Torah insights but in a way that reflected a sophisticated and cosmopolitan understanding of life. He could quote from the Bible and from the philosopher Hegel with equal facility. He spoke for close to three hours, and I was not aware of time as I was mesmerized by his talk. Until now, the two worlds of Torah and secular wisdom were two separate worlds. Now in the Rav's animated lecture, the secular and the sacred merged together as two aspects of one holy creation.

The Rav suggested that all of the laws of the Torah, even the social

laws, should be seen as *chukim*, statutes which are not based on reason. There should be no distinction between them and *mishpatim* (rational laws). As an example, the Rav quoted the commandment of "thou shalt not murder." Reason tells us that it is wrong. Everyone will cry if a beautiful young girl is killed; but the Rav queried, what about the murder of an old mean miserly lady, such as Raskolnikov's victim in *Crime and Punishment*? Reason might say that murder is okay in this instance. However, if we assume that all laws are simply directives from God to man that should be observed even if they do not make rational sense, then such a crime is wrong. Without such an approach, the whole world will turn into a jungle where each man will rationalize his own behavior.

Hearing the Rav was a watershed experience in my life. To my young mind, it represented an ideal synthesis of Torah and worldly learning that became a model for me to emulate. It convinced me that Torah and secular learning do not always have to be in opposition. Clearly, the Rav always functioned on a daily basis with the understanding of the primacy of Torah learning and living, and with an understanding that there is an inevitable tension between the Torah and the secular spheres. However, he did feel that there was room for some rapprochement of the two worlds. Indeed, it is the premise of this book that there is much to learn from the secular world if we approach it thoughtfully and critically.

In the mid-1960s, when I was pursuing a master's degree in English at Hunter College, I took a class in European Literature of the Renaissance with Dr. Sears Jayne. One of the authors we read was the Frenchman Rabelais whose work is filled with profanity. Even though we read the work in translation, the four letter words remained intact. As part of the lesson, the professor, who was probably the best lecturer that I had in graduate school, asked the class to read the narrative aloud. As my turn approached, I felt increasingly uncomfortable. My parents never used profanity at home, and I did not feel at ease uttering four-letter words, especially in a coed class. When my turn to read aloud came, I simply could not get the words out, and my teacher then moved on to the next student. Although he did not tell me, I sensed he was disappointed in me. He wanted to liberate me from my real-life frame of reference, just as Rabelais wanted to liberate his contemporary Frenchmen from narrow thinking; yet I resisted. I chose to remain in my limited, parochial world.

I realized then and I realize now, as an Orthodox Jew and as a serious

student of secular studies, that there is a sharp dissonance between the two worlds. I sometimes feel that the term "Modern Orthodox" is an oxymoron, for to be an Orthodox Jew in the contemporary world may be impossible. After all, the values of the modern world are so often antithetical to the values of Torah. As an Orthodox Jew, I strive for sanctity in my daily life, yet the world in which I live and immerse myself pushes me away from it. How should I approach Western culture? Can there be, in fact, a rapprochement between these two opposite forces?

I began to refine my understanding of the problem and develop a coherent approach to the issue after meeting Rabbi Aharon Lichtenstein and being in his Talmud class when I attended Yeshiva University. It was then that I began to emotionally and intellectually integrate the two worlds. Moreover, Rabbi Lichtenstien is the son-in-law of Rabbi Joseph Soloveitchik. For me, Rabbi Lichtenstein was and is a role model, for he synthesizes excellence in Torah study with excellence in secular studies. Most important, he is a master of good character; and as a person of sterling character he has made the most profound impression on me.

In his lectures at Yeshiva University, he often expressed the view that there is value in secular culture. By culture, he meant the study of the best that has been thought in the world, as Matthew Arnold defined it for his Victorian society. The touchstones of great literature of the past can provide a beacon of light for the future. If properly approached and balanced, general culture can be an ennobling and enriching force for mankind. The best of culture, he maintained, offers us through art profound expressions of the creative spirit, which reflects our being created in God's unique image. Moreover, culture offers us the ability to understand our cosmic context. It can help us cope with the human condition and give us a sense of the moral complexity of life.

When someone asked Rabbi Lichtenstein what he had learned in graduate school at Harvard, he responded: "I learned the complexity of human experience." He understood that life cannot always be viewed in black and white terms. Grey is the common hue to much of human experience. The great writers of the past enable us "to see life steadily and see life whole." They give us a more comprehensive picture of the human condition.

My assumptions about secular culture emerge from this perspective, articulated over a span of time, in various lectures that I heard from Rabbi Lichtenstein and others. Furthermore, Maimonides informs

us in his seminal book *Yesodei HaTorah* (*Foundations of Torah*) that we apprehend holiness/God not only through Torah but also through God's creations. We learn about God by studying not only His words but also His works. Everything in creation has an infinite potential for good. My task as a teacher of literature and film is to give students the tools to discriminate between the wheat and chaff of secular culture. In the Modern Orthodox schools in which I operated, the assumption was that I could not keep the outside world out, but that I could help students navigate that world from within. Therefore, I spent time in class giving students examples of literature and film, both contemporary and classic, which made meaningful observations about life that paralleled a Torah worldview.

When My Passion for Movies Began

December 25th is a very special day for me. It is my birthday, and from my early childhood I have fond memories of my sister Martha taking me on the 241st Street/White Plains Road subway line at the tip of the north Bronx from Mount Vernon to Broadway where she would treat me to a grilled cheese sandwich and ice cream soda at the Horn and Hardart restaurant. We would then walk over to the Paramount Theatre or Radio City Music Hall where we would watch a new film that had just opened along with a stage show that included such luminaries as Nat King Cole, Ella Fitzgerald, the Count Basie Orchestra, and Johnny Ray. It was there that I became enamored with the movies. I still remember with what amazement I watched the curtains part at Radio City Music Hall when it unveiled its first wide screen, and there I saw *Shane*, a landmark western that made me an Alan Ladd fan for years.

Movies were a staple of my growing up in the small town of Mt. Vernon, New York. My idea of the perfect day was to go to the synagogue in the morning where I participated in youth services followed by scrumptious cakes with black and white icing, and then it was off to the movies to watch a double feature which transported me to faraway places and to adventures that stimulated my young imagination.

As I got older, I became an observant Jew, knowledgeable about Jewish law and tradition, and my attendance at movies became suspect, especially as the nature of movies changed over the decades. Still my infatuation with film remained and I continued to watch them, but my tastes gradually changed. I began to look for meaning in film. I wanted them to be not only enjoyable, but I wanted to leave the theatre enriched with some kind of message.

An early favorite was *The Defiant Ones,* a story of race relations starring Sidney Poitier and Tony Curtis and directed by Stanley Kramer. It was the kind of movie I could watch again and again because its message resonated within me as a high school student at A. B. Davis High in Mt. Vernon, an academic high school that was about to merge with Edison High, the city's technical high school, into one large Mount Vernon High School where whites and blacks would be more integrated.

As a rabbi and school principal for many years, I have continued my interest in film both as a patron of the cinema and as an instructor of film courses. The arena in which I have operated for most of the time has been high school and there I have been queried many times about the suitability of any given film. At times a teacher wants to show a film in class, and he asks me for my take on it. Sometimes a film that has captured the imagination of my students is now the topic of conversation on campus, and students ask me about it. As a rabbi and as an instructor of literature and film, I am thankful that my opinion is valued; and I thoughtfully weigh my responses to teachers, parents, and students, recognizing that my comments have implications beyond the classroom.

In recent years in religious circles, both Jewish and non-Jewish, there has been a reaction against contemporary film as destructive of core family values and vacuous of meaning. One need only surf the internet to find an abundance of sites that cite the number of profanities in a film, or the number of violent acts or nude scenes, in an attempt to forewarn parents about what their children might be seeing and be influenced by.

This book takes a different tack. It assumes that there are movies worth watching, that there are movies with something valuable to say about the human condition, and that we can take advantage of the good that films offer if we become discriminating consumers. Just as Matthew Arnold in Victorian England suggested that an appreciation of the touchstones of great literature of the past can help us determine who are the great writers of the present, so too an appreciation of meaningful movies of the past can help us separate the wheat from the chaff in cinema and so enable us to appreciate what movies can teach all of us, those who are in school and those who are in the school of life. I am convinced that film can be a tool for self-discovery, as we navigate the many challenges of life together with movie protagonists. A "kosher movie" to me is a film that has something meaningful to say about life.

My plan is to share my life experience, my method, and my analyses of many movies. Having served as a pulpit rabbi, a high school-principal, and a classroom instructor of literature and cinema has placed me on the cutting edge of cinema discussion. Both my congregants and students are immersed in a world of movies, and my regular discussions with them both in and out of class have connected me with them as we discuss the latest movie they have seen. As a rabbi, I have been asked what I think of *Raiders of the Lost Ark*. What do romantic comedies really say about love? What can a Will Ferrell comedy teach us about life? These questions and more will be answered in this book, which aims to marry ancient tradition with the modern cineplex.

An Introductory Word about the Movies

The movies I have reviewed reflect a wide range of topics and genres. This is deliberate, because I did not want to focus only on "great" movies but also on popular entertainments. Moviegoing is a very democratic form of entertainment and different people seek out different stories and different themes. My choice of which films to review is an indication of the eclectic nature of the moviegoing experience.

The reviews are grouped according to theme. At the end of the book, the reviews are arranged alphabetically for easy reference.

A cautionary note about the movies: if you are concerned about the content of the films from a religious perspective, you should consult the parent content advisory information in the IMDB website to learn the reasons for the film's rating. This is especially important if you plan on using the films in a school setting. Items that are considered in the parent advisory are the following: sex, nudity, violence, gore, profanity, alcohol, drugs, smoking, and frightening/intense scenes.

THE MOVIES

PARENTING

I am drawn to films about fathers and sons. I am a father and I am a son, so I have a natural affinity for the topic. Moreover, I have regrets about my role as a son. I was a dutiful son, but I don't remember being a super son in terms of the way I treated my parents. I loved them, I respected them, but I did not honor them enough. I did not know how to do that until I was an adult.

The beginning of my understanding of my obligation to honor my parents was in a summer camp in the Catskills when I was twelve years old. It was a religious camp in which there was daily prayer and study of the Torah. For the first time, I saw that Judaism was a way of life, not just a family tradition, and that honoring parents was not something you did because you felt like it, but rather something you did because it was a Divine requirement. But I was only twelve, so I still didn't see the big picture.

That picture emerged once I entered Yeshiva University, where I was exposed to great teachers, a very bright student body, and a corpus of Judaic knowledge that influenced the way I thought about and practiced Judaism. In particular, I became more aware of my obligations under Jewish law to honor and revere my parents. The only problem was that I was now out of the house most of time and had less opportunity to honor my parents.

Over the years I became more cognizant of my responsibilities towards my parents, but this occurred after I married and had children. Having kids made me a better son to my own parents. I finally began to understand how important is the role of a father and how my own father taught me many life lessons, some explicitly and some by example.

Inwardly, I felt I did not honor my parents enough as a youth, and as an adult I welcomed any chance to do something for them.

One incident towards the end of my father's life gave me a heightened sense of personal fulfillment as a son. My father was in the hospital and very ill. My sister Martha and I came in from out of town to be with him. One evening when I was sitting with him, he asked for an ice cream soda. I was overjoyed that he asked me directly for something and I felt happy to be able to do this for him. I ran to the local ice cream parlor, purchased the drink, and ran back to deliver it to him. I enjoyed watching him drink the beverage through a straw. If only I had been this solicitous of him when I was younger!

After he passed away, I began to think of questions I never asked him about his growing-up years, about his family customs, about his Jewish learning in Russia before he immigrated to America. Fortunately for me, he left a record of some of the events that shaped his character. Many years earlier when he was in the hospital for surgery to remove a cancer of the lung, a disease he developed after years of chain smoking, my mother and sister plied him with questions about his past to stimulate his mind and they transcribed many of his thoughts in a small pamphlet for the family entitled "The Cohen Saga."

Let me share a few of his memories. He lived in a small town in Russia where his family was the only Jewish family among about 200 Christian families. To get an education, he had to go to a village about ten miles away where he would be given meals by the local Jewish residents. Each day a different family provided the meal. Here are my father's words: "When I was six or seven years old, one lady brought a big bread and put it on the table with no knife. She was too busy to think about it. I made the blessing for the bread and waited for the lady to come with a knife to cut the bread. The lady never came and so I walked away without eating . . . The next day she apologized and gave me five cents." The incident reveals a certain shyness about my father, a reluctance to draw attention to himself even if it meant personal inconvenience. This is a quality that manifested itself on a number of occasions as I was growing up and I refer to them in some of my reviews.

Another memory: this one about my sister Carol, who passed away a number of years ago. Again, my father's words about an event in the 1930s: "Carol was our very first child and the greatest disappointment of our lives. She was born retarded or mongoloid. Dr. Leff said when she was born that if we didn't want to take her home, we could leave her

there. Johanna [my mom] knew nothing until seven months afterward, and then she cried her eyes out. This was the beginning of the time we took Carol to all the hospitals and doctors to see what could be done. We were told that there was not much chance of Carol improving greatly, but we did learn that after a while she would learn. Carol lay in a carriage for three years before she walked. It was a very confining life for us with our retarded child, and it still is. However, Carol now goes to a sheltered workshop in White Plains. Travels by bus herself. She is very self-reliant. Behaves quite normally in dressing, but has trouble keeping her room clean. It is always a mess and we tear our hair out when we look at it."

As Carol's younger brother, I loved my sister but had very little understanding of the challenges my parents faced. As a small child, I thought I could become a doctor and solve her problem. When I got older, and especially after my parents died, I began to understand the extent of the daily sacrifices that my parents made to give Carol a productive life. Every morning I remember my father, even in inclement weather, walking Carol to the bus stop for her ride to her workshop and then returning to the bus stop in the evening to meet her.

My parents rarely took vacations, both for financial reasons and because they did not feel comfortable leaving Carol with anyone other than themselves or close family members. I learned from them that when faced with adversity, the best way *out* is actually *through*. Accepting responsibility and not making excuses were hallmarks of my parents' persona.

I have vivid memories of some of my interactions with my parents. When I was in a high school gym class in the late 1950s, someone from the administration came to class and told me I needed to go to the office. Generally, I was not a student who was called to the office, so all sorts of things entered my mind. I began thinking that perhaps one of my parents had died and I started crying. I knew that I had an argument with them the previous night and I felt terrible that I would have to face this tragedy knowing that my last conversation with them was filled with tension and ill will. When I arrived at the office, I was told that someone had found a textbook of mine, and that's all there was to it. I breathed a sigh of relief and resolved from then on to be more sensitive and more respectful whenever I would speak to my parents.

Flash forward: In 1976, right after the Passover holiday ended, I spoke to my mother on the phone. I was in Atlanta; she was in Mt.

Vernon, New York. She had recently recovered from foot surgery and I was inquiring about her welfare and sharing with her how my holiday went. It was a warm, loving interchange. The next morning around 10 o'clock I received a call from my father, crying on the phone, informing me that my mother had just died that morning from a heart attack. That telephone call that I made on Thursday night right after Passover is still in my memory today. It was the last time I spoke to my mother and, thank God, it was a good conversation. It was a sad time, but I was fortunate that my final memory was a positive one. There was no argument, no tension, just love between us and that is a memory I treasure.

In retrospect, these two incidents reminded me that parents are not here forever and we need to cherish the time we have with them. Imagine if the most recent conversation with your parent was your last communication with them? How would you feel about it?

Another aspect of parenting that continues to be food for thought is the reality that I have been a different parent to each one of my kids. I love them all, but I manifested that love in different ways because I was at a different place in my life when each of my children was born. For the first three, I was in my 20s, living in Washington Heights in New York City and did not yet have a real job, only a part-time job teaching English at a community college and receiving a graduate fellowship during my ordination studies. For the second three, I was a rabbi and school principal in Atlanta, Georgia, with a full-time job, living in a real house, and making a decent salary. I was very much consumed by my work. I am sure there were ripple effects in the lives of each of my children in relation to my work at the time.

I have learned many techniques of effective parenting from observing my teachers. Still in my memory, even though it occurred many years ago, is one particular incident. I was a guest at a rabbi's house, and his six children were a bit out of control. Running from this room to the next, it was clear there was an accident waiting to happen, and it did. His seven-year-old daughter, who was tossing a ball to her five-year-old sibling, lost control of the ball and the ball landed in the thick tomato soup of the rabbi. I expected him to reprimand his daughter, but he didn't. Instead, he calmly took the ball out of the soup and continued sipping the soup. He then paused to ask his daughter where she remembered the ball had been before it landed in his soup. Satisfied with her answer, the meal continued without interruption; and the all the kids, embarrassed at what happened, settled down quietly to finish the meal.

As a student eager to learn and not reluctant to ask the rabbi a personal question, I later asked the rabbi how he developed such patience in dealing with his children. He told me that his parenting style developed over time, but that he always knew it was important to control his emotions and not overreact. The incident with the ball was certainly not premeditated, and it would not make sense to get angry with his daughter. Moreover, he saw immediately that his child was embarrassed by the accident, and there was no need for any public correction.

The rabbi also related to me a Talmudic story that had a great impact on his parenting style. A Babylonian Jew married a woman from Israel. In the course of their marriage, he discovered that a language barrier prevented optimum communication between them. Often, when he would ask her to make a particular dish, she would prepare something totally different. In a fit of anger, he directed her to throw out the dish, which she mistakenly understood to mean to break candlesticks over the head of Baba Ben Buta, a prominent citizen. When she struck Baba Ben Buta over the head while he was engaged in a legal proceeding, he did not get angry. Rather, he praised the woman who was carrying out the will of her husband. He then promised her that she would have two pious sons. As far-fetched as the story might seem, it showed the tremendous extent to which one man, Baba Ben Buta, would go to preserve peace in the home. Moreover, the rabbi quoted a Talmudic passage, which says, "God forgives the sins of those who overlook the wrong committed against them."

The Talmud tells us "a man is recognized in three ways, through his goblet, his pocket, and through his anger." If one must display anger, Rabbi Moshe Chaim Luzzato, a celebrated eighteenth century scholar and mystic, writes that it should be "an anger of the face, and not anger of the heart." I have tried to keep this in mind when I interact with my kids.

Another learning experience for me: For many years as principal of Yeshiva High School in Atlanta, I would, in the course of my drive each morning to school, listen to tapes of lectures by Rabbi Avigdor Miller, of blessed memory. The rabbi would discuss the various biblical texts and then open the floor to questions on a wide range of topics. In one lecture, he spoke about the miracle of the apple.

The apple is a fragrant fruit which, by its outer skin color, tells people when is the best time to eat it. Moreover, the core is difficult to chew. Therefore, we throw it away in the ground, where the apple

seed germinates and allows a new apple tree to develop. In addition to providing nutrients and vitamins, the apple tastes delicious, and cleanses our mouth and teeth. As I listened, I began to think of the tremendous miracle of the apple, and decided to talk to my own small children about it. I wanted them to appreciate the everyday miracles we see in nature that are often taken for granted. In subsequent talks, Rabbi Miller encouraged parents to tell one's children "the sun is very good" and that a "piece of bread is magic." He used the same approach to describe these phenomena as he did with the apple.

Pausing to consider the wondrous handiwork of God in each of His creations made my children recognize more profoundly how much they have to be thankful for. This mindset, which I regularly emphasized in my conversations with my children, helped make them into young men and women who appreciate everything given to them by both God and man. In their daily prayers, the liturgy speaks of the Lord, "who creates the luminaries" and who "brings forth bread from the ground." All of these prayers remind kids and adults of the source of all blessing, and create a person who truly appreciates all of God's gifts.

Judaism tells us both through its classical texts and its daily liturgy that life should be appreciated and savored. Every benefit we have can be broken down into a multitude of kindnesses that God performs for us, and we should take note of every step of the miraculous process. When parents promote this view of the world, they reinforce their own role as benefactors of children. The result: Children begin to appreciate more the lifelong kindnesses that parents do for them.

In films, we see little of this kind of parenting. Most of the movies in this section deal with dysfunctional relationships between parents and children, which, by contrast, can make us more aware of what our own behaviors should be with our parents. Since the father-son dynamic preoccupies my thinking, I often focus on that aspect of the movie even though these films contain multiple themes.

Now that I am a father, a son, and a grandfather, I see life as the great Victorian poet Matthew Arnold did. I see it "steadily and see it whole." This sensibility affects the way I perceive stories of fathers and sons, parents and children, in the cinema.

FERRIS BUELLER'S
DAY OFF (1986)
directed by John Hughes

I remember the meeting well. A teacher discovered a student who had plagiarized a paper and gave him a failing grade. The father of the student demanded a meeting with the teacher, his son, and me. He opened the meeting with a line I will never forget: "My son never lies." The teacher, a woman with a sterling reputation for excellent teaching, exemplary character, and an abiding concern for the welfare of her pupils, was stunned by the implicit assertion that she either had lied in making the accusation or made a terrible mistake in evaluating the student's work.

Having worked with students for many decades, I, like most teachers, always assume the best of students. But when confronted with incontrovertible evidence of cheating, I accept the reality that students, even good ones, may occasionally do dishonest things. The teacher in question broke down in tears from the baseless accusation. I, of course, defended and supported her. Several months later, the father apologetically confided in me that his relationship with his son was very rocky, and he felt a need at our meeting to be publicly supportive of his son even if he had doubts about the veracity of his statements.

This kind of misguided, naïve parenting is at the heart of *Ferris Beuller's Day Off*, a comic but true perspective on teenage life in the 80s that still resonates today. The plot, such as there is one, revolves around high school senior Ferris, who decides to cut school on a beautiful spring day and enjoy the day in downtown Chicago. He enlists his girlfriend, Sloane, and his buddy, Cameron, to join him on his self-declared vacation day.

The day begins with a lie as Ferris fakes an illness to his fawning and

naïve parents, who believe everything he says. It is clear that they are preoccupied with their own lives; parenting to them is a diversion, not a mission. Cameron's dad is never seen in the film. We only see his polished Ferrari, glistening in the family's hillside garage. It is an emblem of parental neglect and a reminder of his parents' total preoccupation with material things. In fact, almost all the adults in the movie are out of touch with children. Whether it is parents, teachers, administrators, all are self-absorbed and only peripherally aware of the children with whom they interact.

Two insights emerge from *Ferris*. First, parents need to be present in the lives of their children. They need to spend quality time with them and not be so preoccupied with business that they are clueless about what makes their child tick. Second, Ferris's visit with his friends to the Chicago Art Museum suggests that kids need more than mastery of rote knowledge to succeed as human beings. Ferris, Sloane, and Cameron engage the modern art they view with creativity and wonder. The classroom is boring, but the museum, which houses a major collection of abstract art, unleashes a creativity that speaks to their curious and active teenage minds.

Proverbs tells us "to educate a child according to his personality." This means that it is the job of parents to know their children well and to provide opportunities for them to develop their own unique talents. The patriarch Isaac, according to some biblical commentators, erred in educating his children Jacob and Esau with the same parenting toolbox. He failed to recognize that each one required a different parenting approach, one that recognized their different personalities and intellectual and spiritual inclinations. It may be easy to do more of the same when it comes to parenting, but it may be wiser to do something different that takes into account the way each child learns.

A PERFECT WORLD (1993)
directed by **Clint Eastwood**

When I was twelve years old, I attended a religious camp in the Catskill Mountains in New York. On visiting day, my parents came up to see me. It was the first time I went to a sleepaway camp and my parents and I were looking forward to the meeting. During the visit, a rabbi approached my father and asked him to travel over two hours to pick up Rabbi Aharon Kotler, the founder of the esteemed Lakewood Yeshiva, who would come to the camp to address the campers. My father readily accepted the mission; but when he arrived at the destination, he was told that someone else had picked up the rabbi. This was way before cell phones, so there was no way to contact my father to cancel the mission. I remember distinctly that my father did not utter one word of complaint. He just did what he felt was right and did not complain when things did not go as planned. His response implicitly taught me that when given a task, your job is to do it with the realization that you are not in control of the outcome. Only God is. Jewish law reflects this approach when it tells us that we receive a reward for traveling to synagogue, even if we discover when we arrive there that there is no quorum for communal prayer.

Another story. My father, after many years of driving used cars, finally bought a new car. Soon after the purchase, I borrowed it and drove carelessly down a street where a garbage truck was making a stop. Instead of waiting patiently for the truck to move, I accelerated and scraped the side of the car, ruining the exterior. When I returned home, my dad simply asked me if I was okay. There was not a word of criticism about my thoughtless driving. I felt guilty for what I had done and incredibly stupid, but I realized that my father trusted me to

grasp the folly of my foolish behavior without any reminder from him. I learned from him that sometimes you can learn more from what a parent does not say than from what he says.

All these recollections are a preamble to the subject matter of *A Perfect World*, a film in which the nature of fatherhood is explored. It is a story about two sons who see the world differently because neither has a father to teach him how to be successful in life.

The narrative unfolds in Texas in 1963 when two convicts, Butch Haynes and Jerry Pugh, escape from a state penitentiary and kidnap eight-year old Phillip Perry to use as a hostage against pursuing police. During the course of their flight, Butch, who himself was an abused child, becomes a protector of Phillip and relates to him as a father, offering insights and life lessons that forge a friendship between the two. Butch becomes the surrogate father that Phillip never had.

On the run with Butch, Phillip, only eight years old, experiences an independence that is exhilarating and frightening at the same time. He shoplifts a Casper the Friendly Ghost costume, yet feels incredibly guilty for breaking the moral code that he has learned from his mother. In the course of their picaresque journey, Phillip confronts moral ambiguities for the first time, and begins to make moral choices.

What does being a father mean? As a father myself, I know it means more than a biological connection. It implies a teaching task as well. The Bible states this clearly when it says, "You shall teach your children." Fatherhood means more than paying the bills for your child. It also means guiding your children, teaching them to make wise decisions so they can navigate life successfully. *A Perfect World* reminds us of the perils of not having a father in one's life, and implicitly reminds us of the profound influence of fathers on children, who mentor by example as well as by explicit instruction as my father did for me.

3:10 TO YUMA (2007)
directed by **James Mangold**

I recently taught a poem entitled "Those Winter Sundays" by Robert Hayden to my eleventh grade English class. The poem is about the relationship between fathers and sons, how a son finally understands how much his father did for him as he raised him from boy to man. He remembers how hard his father worked to maintain his household and "no one ever thanked him." He acknowledges that he was unaware of his father's love for him, which was expressed in taking care of the daily needs of his family: "What did I know, what did I know of love's austere and lonely offices?"

These lines resonate in many films that show the complex relationship between fathers and sons, many of which reveal the son not appreciating his father until the father has passed away.

3:10 to Yuma is the story of Dan Evans, a poor rancher and veteran of the Civil War, who is struggling to keep his land in the face of people who want to take it away from him and sell it to the railroad at exorbitant profit. When two men set his barn on fire, he resolves to make things right; but his son, William, has little hope that his father can do this. When Dan tells his son that he will understand when he walks in his shoes, his son bitterly responds, "I ain't never walking in your shoes." He sees his father as weak and incapable of fixing anything. He does not see inner courage, only outer trembling.

Dan is pained by his son's low estimation of him and will do anything to be a hero in his eyes, even escort Ben Wade, a notorious bank robber and murderer, to federal court in Yuma where he will probably be hanged. For a payment of $200 from the railroad company, a huge sum in those days, he puts his life on the line to save his farm and to redeem

himself and his family. He wants his son to know that he was the one who brought Ben Wade to Yuma for trial when nobody else would, a feat that would impress and draw the admiration of his son. Against near impossible odds, he gets Ben Wade to the train to Yuma but with tragic consequences.

The Bible tells us that the commandment of honoring parents is rewarded with long life. A parent of a student I teach recently complained to me about his teenage son who almost never speaks to him. My friend said: "I wish he was an adult already. Then we could talk to one another normally." He also told me that even though he often told his son that he loved him, his son never told him "I love you, Dad." He had no doubt that his son loved him, but he wanted his son to be more forthcoming with expressions of parental appreciation and affection. To the father, expressing love verbally was a way to honor parents and for his son to receive the reward of long life. He was perplexed that his son was not taking advantage of this spiritual opportunity. Moreover, my friend feared that he would no longer be living in this world when his son finally wanted to verbally express his love.

3:10 to Yuma has a lot to say about father-son relationships. It reminds us of how much a father wants to be a good role model for his son, and how satisfying it can be to a parent when children express appreciation and love. A parent-child dynamic may be rooted in love, but the roots have to be watered for that love to flourish.

CITY BY THE SEA (2002)
directed by **Michael Caton-Jones**

Parenting is complicated, especially when it comes to divorce. Many years ago, a friend who went through a stressful divorce, described the toll it took on the relationship between him and his children. His wife, in order to strengthen her own parental identity, created an environment in which the kids had to take sides. His wife manipulated the situation by bad-mouthing her husband and limiting his contact with the kids. Eventually, the kids rejected their father in spite of the children's natural instinct to be loved by both parents.

The professionals tell us that this is the worst outcome of divorce. They urge parents to keep their personal agenda away from the children as much as possible because kids need to maintain healthy and solid relationships with both parents. It was tragic to witness my friend being demonized in the eyes of his kids.

That was not the end of the story. It has been documented that as a result of parental alienation, kids often develop low self-esteem, depression, distrust people, and sometimes fall into substance abuse. Self-hatred also may result because the child may feel unloved by the alienated parent. All these consequences occurred for the children of my friend. Overall, it was a sad and deeply troubling narrative.

City by the Sea, a crime drama, tells the story of Joey LaMarca, a policeman's son who is the victim of parent alienation. His father and mother split acrimoniously and Joey's descent into the world of drugs was part of the fallout. In a drug deal gone bad, Joey without premeditation kills a drug dealer. This sets in motion two parallel forces searching for Joey: the police who see Joey as a prime suspect, and the partner of

the dead drug dealer who wants to kill Joey to preserve the invincible aura surrounding his drug operation.

Vincent, Joey's dad, is conflicted. He has been out of Joey's life for years. On the one hand, he wants to help him. On the other, he feels duty bound as a law enforcement officer to treat his son as he would treat any other offender. Things come to a boil when Spyder, the drug dealer who is looking for Joey, murders Vincent's partner. Joey calls his father to tell him that he did not kill the policeman, and Vincent believes him. This creates the foundation of a new relationship between father and son, who for the first time express their affection for one another in a direct way, without interference from outsiders.

In Jewish tradition the father-son dialogue is founded on mutual trust and a belief in the essential goodness of the other. In the *Ethics of the Fathers*, our Sages point out the kindness of the Creator not only in creating man, but in letting man know that he is a "child of God." When one feels that he is God's child, it is an emotional game changer. When Vincent finally expresses his belief in Joey's innocence and goodness, this sets the stage for reconciliation and love.

CATCH ME IF YOU CAN (2002)
directed by **Steven Spielberg**

Over twenty-five years ago, one of my sons asked me a question of Jewish law. I meditated for a moment and gave him an answer that I thought was correct. About a year later, I discovered that what I told him was incorrect. I apologized for giving him the wrong answer and life went on. Still, however, my quick response of many years ago rankles in my mind. He came to me because he assumed that I was a source of wisdom upon whom he could rely, like money in the bank. My hasty answer wasn't fully researched and turned out to be flat-out wrong. I realized then and now that, in spite of their sometimes challenging behavior, children intuitively respect and revere parents, and we always have to be conscious of our status as teachers and role models for them. Therefore, we need to be thoughtful and deliberate in the counsel we offer, and, more important, to behave in a way that is consistent with the values we teach.

This father-son dynamic is tested in *Catch Me If You Can*, an entertaining and thoughtful drama based upon the true life story of Frank Abagnale, Jr., a clever young man who impersonated an airline pilot, a doctor, and a lawyer in order to bilk others out of millions of dollars on three continents, all done before he reached the age of twenty.

The narrative begins with a dinner honoring his father who has worked for his local civic organization for many years. Frank Jr. watches his father in admiration as he tells the story of two mice who were in peril of drowning in a vat of milk. One succumbs and the other keeps on scurrying about until the milk turns into butter and he is saved. The moral: Hard work leads to ultimate success. It is a great lesson for a father to teach his son.

However, privately Frank's father is not what he seems. He has money problems, which he denies, doing whatever he can to avoid responsibility. Frank Jr. follows his lead but is more creative than his father, charting an egregious course for himself that gets the attention of the FBI.

When, after many months of crime, he pays a surprise visit to his father, the meeting turns into a painful realization of his father's failure to parent him in morality. Frank Sr. complains that the government is after him: "The IRS wants more. I gave them cake. They want the crumbs. I'll make them chase me for the rest of their lives." He also reveals that he knows his son has stolen millions of dollars from unsuspecting victims and is being investigated by the FBI. Frank Jr. pointedly asks him: "Why didn't you ever ask me to stop?" His love for his father is still there, but he is angry and disappointed that his father never voiced objection to his life of crime.

The Talmud tells us that a father has an obligation to teach his son a trade; and if he does not do this, it is tantamount to teaching his son to be a robber. A parent's task clearly is not just to provide for a child's material needs, but to give him moral guidance, to teach him how to navigate an ethical life in a world in which morality is tested every day.

The concrete image of this parental role is what transpires on the Passover Seder night, when the father sits at the head of table and conducts an evening of moral instruction for his family. The evening is filled with life lessons, focusing on the interchanges between father and son. Metaphorically speaking, parents always sit at the head of the table, and it is from that vantage point that we should exercise our parental roles.

THE PLACE BEYOND THE PINES (2012)

directed by **Derek Cianfrance**

When I moved to Israel four years ago, I lost a treasured possession: a silver wine goblet that was presented to my dad when he was president of the local synagogue for a number of years. To preserve the memory of that gift and of my father reciting the blessing over wine on the Sabbath, I decided to buy a replacement cup similar in appearance to the original cup and inscribe it as it was when it was originally presented to my father, and so I did. My father was not an educated man, but he was a wise man to whom I owe a great deal. He was present in my life at critical times, always supporting me and being there offering counsel. Keeping his memory alive both comforts and inspires me.

Fatherhood is at the core of the generational drama *The Place Beyond the Pines*. The first father we meet is Luke Glanton, a well-known motorcycle stuntman who regularly performs at state fairs. He is an absentee father who discovers he has had child with an ex-girlfriend. This revelation evokes a powerful desire within Luke to be a father, to take care of his son and to provide for his physical needs.

Because Luke's father has been absent from his life, he is clueless about what parenting really means, translating it mainly into getting more things for his son. To accomplish this, he needs more money. He first obtains a job at an auto repair shop to supplement his income, but Luke wants more than this job can offer. When Robin, the auto repair shop owner, reveals that he was a former bank robber and asks Luke to join him in robbing a few banks, Luke readily agrees.

The second father we meet is Avery Cross, a policeman and father of a son as well. Raised in an affluent home, his own father is a role model

of wisdom and material success. Avery intellectually understands the challenge of parenting, but his own personal drive for fame and fortune cause him to be an absentee father.

The lives of Luke and Avery intersect, as do the lives of their sons, Jason and AJ, in painful, dangerous ways. There is a Talmudic notion that the acts of the fathers are a signpost for the children, implying that sons often experience situations similar to the ones their parents faced. They face the same challenges, but do not necessarily make the same choices when confronted with similar circumstances. Moreover, the fact that AJ comes from an affluent background and Jason comes from a poor family does not insure or predict success as an adult.

As we watch the relationship between the two sons unfold, we are compelled to meditate on the qualities that make a good parent. The Torah and Talmud clearly define our parental responsibilities towards children. We have to give them moral guidance. We have to teach them how to swim, and by this our Sages mean we have to teach them how to navigate life in the face of all the slings and arrows of outrageous fortune that will befall them. Furthermore, we have to teach them an honest profession, or give them the means to learn one. Finally, we have to help them find a spouse. Implicit in these parental duties is the presupposition that we are involved in our children's lives at critical moments in their lives.

The Place Beyond the Pines demonstrates that parenting does not begin simply with bringing home the baby from the hospital nor does it end with sending our child off to college. In the final analysis, parenting requires presence, not presents.

DEAD POETS SOCIETY (1989)
directed by **Peter Weir**

One of my children once ran away from home. My late wife and I were distraught. We were about to call the police when I discovered our missing son in the backyard. My son and I had a disagreement of some kind and he had disappeared. But he did not go very far. He just wanted to get my attention, and so he hid in the backyard. This unsettling and frightening experience was a watershed event in my parenting life. Until then, I assumed that the toolbox of parenting skills that I had used with my other children would work with all my children. But now I received a wake-up call reminding me that every child is different and I would have to modify my parenting techniques to reflect the idiosyncrasies of each child. I finally understood profoundly King Solomon's statement in Proverbs that we should "train a child in the way he will go." When it comes to parenting, one size does not fit all.

Dead Poet's Society is primarily about a charismatic teacher who profoundly influences his students, but it is also a film about the dynamic between parents and children, about parental expectations on the one hand, and the aspirations of children on the other. Are the two in sync? When Proverbs exhorts us to "train a child in the way that he will go," it means that parents need to understand the natural inclinations of a child and encourage him to use those natural abilities and interests to develop his own adult identity. When Jewish tradition instructs a parent to teach his child a trade, the choice of trade is not written in stone. The presumption is that the child will choose what suits him with parental input, but not with parental control.

When a parent wants control, not mere input, there is conflict,

especially during the teenage years. In the film, Neil Perry, an outstanding high school student, wants to be an actor. He is passionate about it and, without his father's knowledge, tries out and wins the part of Puck in Shakespeare's *A Midsummer Night's Dream*. When his father discovers his son's deception, he decides to remove his son from the school that he loves in order to end his son's acting ambitions. The emotional strain of this parent-child conflict ultimately has a tragic end, reinforcing the notion that children should be allowed to listen to their own inner voices when it comes to choosing one's life work.

This parent-child struggle contrasts with the positive relationship between a teacher, John Keating played by Robin Williams, and his students. The teacher encourages the students to think for themselves, to do something extraordinary with their lives. He tells them to seize the day and enjoy poetry, beauty, and love, all things that make life worthwhile. Thoreau is Keating's literary icon, a writer who listens to the sound of a different drummer, who desires to "live deep and suck out all the marrow of life." Thoreau did not want to die and discover that he had not lived. Keating wants his students to share that robust perspective on life. He invites them to stand on their desks and see things from on high, anticipating that the exercise will embed in their minds the value of seeing things from the balcony. From this vantage point, one can see new approaches to solving problems, new ways to approach the givens of life.

Dead Poet's Society has much to say about teaching and parenting. Viewing it reaffirms the complexity of the never-ending task of both teacher and parent, who, in their own contradictory and loving ways, want to give children roots to plant and wings to fly.

QUIZ SHOW (1994)
directed by **Robert Redford**

As a parent, I am heavily invested in my children. When my kids were younger, I could guide them in a very direct way. Now that they are older, I parent differently because my children live in faraway places. I offer counsel by phone or email to continue my involvement in their respective destinies.

In truth, parenting older children is much harder than parenting young kids. Life is much more complicated for an adult than for a child; and adult children have a mind of their own, which may not always coincide with a parent's point of view. Regardless, I still love my kids whether we always agree or not. I identify with them and share their joys and missteps as well. When they achieve, I feel joy within; and when they stumble, I am still standing by their side, which is why I understood the father-son dynamic in *Quiz Show*, an exposé of the rigged TV quiz shows in the 1950s.

Quiz Show introduces us to Herbert Stempel, the reigning champion on Twenty One, one of the ubiquitous television game shows in which contestants win money based upon their ability to answer questions from a wide range of knowledge areas. Behind the scenes, the corporate gurus are worried about flat ratings, and they ask Stempel to take a dive so that a new intellectual hero can emerge. That new hero is Charles Van Doren, the son of the celebrated academic, Mark Van Doren, a venerated English professor at Columbia University. The producers of the show offer to give Van Doren the answers, appealing to his pocketbook and to his ego. At first he refuses, sensing that he will compromise his name and his family's reputation; but at the end he succumbs to

temptation. In the weeks that follow, Charles Van Doren, intoxicated by money and fame, becomes a celebrity.

Dick Goodwin, a Harvard law graduate, begins to investigate the show, and uncovers that the fix is in. Both Stempel and Van Doren received the answers beforehand. A congressional committee convenes to ferret out the truth, and it becomes clear that Van Doren will be implicated. At that moment, he visits his father and confesses his dishonesty. His father, shocked by his son's revelation, in a heated interchange reminds his son that "your name is mine." Charles has besmirched the family name and it is a painful realization.

In spite of Charles's moral lapse, Mark Van Doren and his wife accompany their son to the congressional hearing. He is a father, not only a mentor, and it is in this role that he looms large. He does not abandon Charles because of his mistake. He is disappointed by his son's betrayal of the public trust, but he still sticks with him even when Charles is publicly humiliated.

Two messages emerge from *Quiz Show*, both of which are found within Jewish tradition. The Talmud tells us that more than erudition, more than wealth, more than status, a good name is man's crowning achievement and is more precious than money or fame. Furthermore, we should never give up on our children, even when they make mistakes. Our role model is the patriarch Jacob, whose sons gave him much grief. Simon and Levi attacked Shechem without asking for their father's approval, and their action was a public relations gaffe of the highest order, recounts the Bible. And when Jacob finds out that the brothers have sold Joseph, he is at first astonished at their behavior. However, at no time does Jacob walk away from his children, no matter how egregious the fault. Jacob can be critical of them, but he cannot desert them.

Our children should be taught the value of their good name and how their actions affect the public perception of their name. Furthermore, we should understand that while mistakes by our children may be painful, our love for them is unconditional.

REAL STEEL (2011)
directed by Shawn Levy

As part of the matriculation requirement for Israeli high school students, they have to do a project upon which their oral examination is based. Since my students enjoy cinema, I gave them the topic of "Influential Movies of the Twentieth and Twenty-first Centuries." One student selected the film *Real Steel*, which describes a future time when human boxing is outlawed because it is too dangerous, and robot fights are substituted. I asked the student why the film was influential, and he responded that it was influential for him because the story of a boy and his father that is the subtext of *Real Steel* gave him an insight into his own relationship with his father and how it might be improved.

Charlie, a former boxer and now manager of a robot boxer, is an absentee father when Max's mother dies. Instead of assuming responsibility for Max, he requests $100,000 in return for signing over custody to Max's aunt. But there is a hitch. Max's aunt and her husband have to go away for a month before they can take Max into their home, so they ask Charlie to take care of him until they return. The month turns into an unforgettable road trip for Max as he accompanies his father through the entrepreneurial world of robot boxing. Charlie buys used robots, repairs them, and then uses them in fights to win prize money. Sometimes his robots win, but most of the time they lose, and eventually Charlie goes broke.

All seems lost until Max serendipitously finds a buried robot named Atom. They reboot Atom and set to work restoring its fighting functions. Although built as a machine to spar with other robots, Max and

Charlie teach Atom how to take the offensive and fight against other mechanically superior machines.

Gradually Charlie and Max find unofficial fights for Atom. Max uses the winnings of matches to buy spare parts and fix Atom, and Charlie begins to pay off his old debts. Eventually, Atom's prowess is recognized by professional promoters and he is offered prestigious matches in the Worldwide Robot Boxing Association. Soon the ultimate match is scheduled between Atom and Zeus, the undefeated champion of robot boxing. The bruising fight is the climax of the film, with the outcome unclear until the last moment.

The heart of *Real Steel* is not the robot gadgetry; rather it is the story of a dysfunctional relationship between a father and a son, both of whom constantly find fault with one another and ascribe the basest of motives to each other. *Real Steel* portrays how that relationship is made whole again. Reconciliation begins when father and son stop focusing on the shortcomings of one another, when they begin to accept one another's imperfections, and when they share a common goal. The shared goal of repairing Atom and preparing him for his fights unites father and son and rids them of old memory tapes of past indiscretions.

As a parent, it is natural to find fault with a child. I often want to correct my children, but I try to be guided by the biblical model of how to give correction. I first ask myself if this is the right time and place. Can I criticize the behavior and not my child? Is my child ready to listen to me, or do I first need to build more trust so that my words will be accepted more readily?

The Bible tells us that criticism is good. We grow when we are able to listen to reproof and make midcourse corrections in the way we live. However, we have to be very careful when we criticize. The language in the Bible for this commandment is "you shall surely reprove." Our Sages inform us that the Hebrew phrase for "reprove" is repeated to emphasize that reproof should only be given when someone is ready to listen. Simply criticizing goes nowhere. Charlie and Max finally understand this, which allows them to focus on the future and enrich their relationship. *Real Steel* does not just refer to robots. It refers to the strong bond between father and son that endures despite the mistakes that we make as fathers and sons.

SILVER LININGS
PLAYBOOK (2012)
directed by David O. Russell

Being a father has been and is one of the greatest gifts that I have been granted. Being called "Abba," "Dad," and "Father" is more important and more gratifying than any other title I could possess. The appellation connects me with the cosmos, making me a messenger of past generations and a messenger of the future through my children.

Fatherhood is not simple. It presents challenges. As I have gotten older, I realize that I have been a different father for each of my kids. Proverbs tells us that we should raise a child according to his uniqueness, and I have tried to be nuanced in using my parenting toolbox. It is not a cookie-cutter activity, reflecting the reality that just as I have evolved as a human being throughout the years, my children also have evolved from childhood to adulthood, and they are still works in progress.

Jewish tradition tells me that I am my child's primary teacher. Although I can delegate that responsibility to teachers and schools, the buck stops with me. This is why parenting can be both joyous and stressful. Having acquired a plethora of life experiences, I want to share these with my children and save them from making mistakes. The reality is, however, that kids often want to test the waters themselves. When a parent wants to be prescriptive, kids may see that as meddlesome, implicitly suggesting that the child cannot make the right call on his own.

This complex father-son relationship is depicted in *Silver Linings Playbook*, a profanity-laced but genuine look at a family dynamic under stress. The film opens as Pat Solitano, who has bipolar disorder, is released from a mental health facility into the care of his parents. His wife,

Nikki, has gone to the courts to have a restraining order placed on Pat because of his proclivity to violence. His father, Pat Sr., has lost his job and now wants to open a restaurant from his earnings as a bookmaker. In spite of this climate of negativity, Pat is determined to reconcile with his wife and find employment, always looking at things positively, looking for the silver lining beyond the present clouds.

It is clear that Pat is still not finished with his therapy; but the court, through a plea bargaining arrangement, has reduced the time that Pat is institutionalized. Refusing to take his meds, he is an accident waiting to happen, responding way out of proportion to life's inevitable challenges. In one symptomatic scene, he wakes up his parents in the middle of the night asking if they know where his wedding video is. It is hilarious and sad at the same time.

Pat's life begins to turn around when he meets Tiffany, a young widow who also has lost her job and shares a number of neuroses with Pat. It is a tumultuous relationship, but one that forces Pat to look at himself honestly and to begin to adjust to his new reality.

As his relationship with Tiffany deepens, his father does not understand the nature of their connection and how it is providing the necessary therapy for Pat's recovery. His Dad only wants to spend time with his son to improve his rapport with him, but he does not know how to do it other than to watch football games together. In a powerful scene between father and son, Dad, with tears in eyes, wonders whether he did enough as a parent. Did he favor Pat's brother? Did he give Pat enough love? Pat for once does not interrupt his father. He listens without comment, and then hugs him. It is an epiphany of love as they embrace and resolve to be closer in the days and weeks ahead.

Silver Linings Playbook is a serious meditation on human relationships. When these relationships are tested in the crucible of life experience, we sometimes realize that the best way to communicate is not through words, but through the language of the heart.

SEARCHING FOR BOBBY FISCHER (1993)
directed by **Steve Zaillian**

As an undergraduate student at Yeshiva University many years ago, I had the opportunity to watch Bobby Fischer play chess. I do not know how to play chess, but a friend of mine who did was participating in a school-wide completion between about seventy-five students and the chess master, who would play all of them simultaneously. I still remember coming down to the school cafeteria and watching students set up their chess boards on long tables preparing for their match with Bobby, who would stroll down the various aisles making his moves quickly as his opponents reflected on what to do next. To my knowledge, no student won his match that night; but it was fascinating to observe this chess genius casually dispose of so many opponents in so short a time.

Searching for Bobby Fischer is a film about chess; but, more importantly, it is a film about life. We watch as little Josh Waitzkin develops a love of chess. He is fascinated by the game and enjoys watching the exciting contests of speed chess in Washington Square Park in New York City. His mother senses his love of the game and pays to have him play one the players in the park. His interest in the game grows, and his father decides to get him a top-flight teacher. Josh studies with the guru but still retains his childlike interests and attitude. Basically Josh is a kind person, the kind of person who wants to be nice to other people. He does not hate his opponents, nor does he look at them as objects to destroy. His mother, on listening to Josh's wish to help a friend, tells him, "You have a good heart. That's the most important thing in the world."

It is this conflict between being nice and being a winner that is the subtext for this sports film about chess. As Josh achieves success in tournaments, his father becomes possessed with his son's genius at

playing the game. Frank Waitzkin comes to see chess not as game nor as science, but rather as pure art. The notion that his son plays like Bobby Fischer animates his ego and he begins to push Josh harder. He, more than Josh, wants the glory, the attention, the honor that he never received in his life. Frank pursues the ephemeral goal of fame, and forgets about balance in life. As Josh advances in skills, his teacher Bruce puts him though exercises designed to toughen Josh mentally. But Josh is boy who likes and respects other people. His coach's desire to make him like Bobby Fischer "who held the world in contempt" evokes a simple, direct response from Josh; "I'm not him." His mother sharpens that observation when she tells her husband that "Josh is not weak. He's decent."

Several Torah themes are embedded in *Searching for Bobby Fischer*. In Proverbs, there is the wise directive to "train the child in the way that he goes" (Proverbs 22:6). The message here is that parents need to understand the uniqueness of their children. Different children possess different personalities, different interests, and different proclivities. That is the lesson that Frank Waitzkin learns as he first pushes Josh to excel, and then comes to recognize Josh for the decent boy that he was and is. Frank ultimately realizes that the game of chess does not define his son, who is much more than a chess player. He is a good son, a caring friend, and a decent human being who wants balance in life.

We also learn from the film that wisdom can come from many places – from parents, from a speed chess hustler in Washington Park, and from a serious teacher of chess. Notably, all are present for Josh's crucial match at the Chess Grand National Tournament in Chicago, the site of the film's finale. Our Sages in the *Ethics of the Fathers* explicitly tell us: "Who is wise? He who learns from every man" (*Avot* 4:1). Everyone has something to teach us if we are careful observers of mankind.

Finally, we learn the pursuit of fame is illusive. The more one runs after it, the more difficult it is to acquire. Finally, fame in the Jewish view is acquired through the simple acts of friendship and kindness that punctuate our lives. The film ends with Josh putting his arm over the shoulder of a friend who has just lost a match and telling him, "You're a much stronger player than I was at your age." As the credits begin to roll, a coda informs us that while Josh still plays chess, "he also plays baseball, basketball, football and soccer, and in the summer, goes fishing." Josh intuitively understands that a fulfilling and meaningful life is a life with balance.

WYATT EARP (1994)
directed by **Lawrence Kasdan**

My father, of blessed memory, was not a frivolous person. He came to America as a young teen fleeing the pogroms of Russia in the early 1900s. He enlisted in the Navy and served honorably. He married relatively late and I wasn't born until he was over forty. He worked hard as a painting contractor, breathing in lead-based paint before OSHA was around; and he did not have time to play basketball with me. He was busy trying to earn a living. In spite of his burdensome job, there was lots of love in my home. My father spent time with me, counseled me, and set a good example of upright living. Honest and charitable to the core, he devoted his free time to synagogue service and to rearing a growing family.

One of my favorite memories is going to the movies with him. My father rarely went, generally considering such pastimes a waste of time. But we did share an interest in westerns. Once in a very great while, I convinced him to come with me. I still remember the pleasure I had watching Gary Cooper in *Springfield Rifle* together with my Dad.

I was reminded of this as I watched *Wyatt Earp*, a three-hour long epic revisionist western about that great western hero. My Dad would not have liked the sordid parts of the narrative and the foul language, but he would have admired the beauty of the vast open spaces and the action sequences.

A subtext of the story is Wyatt's relationship with his father, Nicholas Earp, who gives him critical pieces of advice along his life's journey. It is notable that Nicholas Earp does not talk much; but when he does, people listen because they respect him and know that he loves them. Moreover, he gives advice to Wyatt at the right moment. Our Sages tell

us we have an obligation to rebuke a child, but only when he is ready to listen. If he is not ready, then one should delay the rebuke.

When Wyatt is still a teenager, his father informs him that there are many vicious people who do not obey the law and "when you find yourself in a fight with such viciousness, hit first, and when you do hit, hit to kill." He gives Wyatt a basic primer on how to deal with bad people who break the law and hurt other people. Show no mercy. To be affable is to be weak in the face of evil.

Later, when Wyatt's beloved wife dies of typhoid, Wyatt, depressed and angry, immerses himself in drunkenness and theft. After landing in jail, his father comes to rescue him and pointedly tells him: "Do you think you are the first person to lose someone? That's what life is all about. Loss. But we don't use it as an excuse to destroy ourselves. We go on." He imparts to Wyatt the life lesson that although life at times brings pain, life can still continue. Wyatt accepts these two pieces of advice, which guide him throughout his career as a successful lawman.

The task of a father in Jewish law is to teach his child Torah, to teach him a livelihood, and to teach him to swim, which many commentators take to mean to swim through life. Parents are repositories of wisdom and life experience, and too often we don't take advantage of this. Advice from a person with much life experience who loves you, and who is invested in your successful living is a treasure. *Wyatt Earp* reminds us of the supreme value of a parent's counsel.

BLOOD DIAMOND (2006)
directed by **Edward Zwick**

I recently completed my second year of teaching in an Israeli school and asked my sixth graders what their plans were for the summer. Many told me they were going to summer camp to study Torah and to play sports. Earlier that same morning, I read an article about Hamas summer camps. What do the kids do there? They learn how to handle weapons, use live ammunition in military exercises, and the best way to kidnap an Israeli soldier. What a contrast! Some spend a summer learning how to love; others spend a summer learning how to hate.

I thought of Hamas summer camp as I watched *Blood Diamond*, a gripping, violent thriller about commercial traffic in diamonds that is used to finance conflict in budding African nations, often using children as executioners who are taught at a young age how to hate.

The setting is the Sierra Leone Civil War in 1999, where rebel and government forces are killing each other daily and committing unspeakable atrocities. Caught in the crossfire are the townspeople, one of whom is Solomon Vandy, a fisherman from the village of Shenge. In one sudden raid, he is separated from his wife and children and is forced to work in a diamond field under a brutal overlord. His son, Dia, is conscripted into the rebel forces and is brainwashed to shed his previous identity and become a hardened killer, under the banner of doing what is best for his country.

While working in the diamond fields, Solomon discovers a huge diamond worth a fortune, but his efforts to hide it are seen by his commander, who wants the diamond for himself. In the midst of trying to take it from Solomon, government troops launch an attack, at the end

of which Solomon is incarcerated. In prison he meets Danny Archer, who is also aware that Solomon had hidden a valuable diamond. Danny offers to find Solomon's family in return for the diamond, and so begins their alliance and ultimate friendship, punctuated by many tense moments of mistrust along the way.

Dia, Solomon's son has been trained to kill. His captors blindfold him and give him a machine gun to execute a man. He pulls the trigger, and when he removes his blindfold, he knows that he has a new identity as executioner. The next time he kills, it will be easier because, as a child, he has no conception of the great pain he is inflicting. He thinks that taking another man's life makes him an adult in the loyal service of his country.

This attitude comes to a head when, after many months, he sees his father, who he presumes is an enemy. He holds him at gunpoint, but then something amazing occurs. Solomon reminds his beloved son of conversations they had a long time ago about getting up early in the morning to go to school to study towards becoming a doctor. This childhood memory connects them in the present and Dia puts the gun down, tearfully embracing his father.

There is a concept in Jewish tradition that subjects learned in one's youth stay with a person throughout his life. In fact, one of the Sages of the Talmud remarks that his most important teacher was not the one who taught him the sophisticated logic of Talmudic debate but rather the one who taught him the *alef-bet*, the Hebrew alphabet.

A parent does not always know what will stick in a child's mind, what childhood memory will be the one that will inspire him in later years to lead a life of commitment to parental values. *Blood Diamond* reminds us how important it is to create of reservoir of positive memories in our children that will enable them to remain faithful to our core beliefs and values when they are older. Planting a garden of love can overcome a harvest of hate.

A SIMPLE TWIST OF FATE (1994)
directed by **Gillies MacKinnon**

A friend of mine many years ago confided in me that he did not want to have children. He saw them as an inconvenience and simply preferred to own pets, which would never make demands on him, argue with him, or keep him up at night. He would also not be required to pay exorbitant tuitions for Jewish day school education. When I countered that the Bible commands us to try to have children and that one of the first questions we are asked in the heavenly court is whether we truly attempted to have children, he dismissed my arguments. When I shared the practical reality that children take care of us emotionally and physically when we are older, and that they are a living extension of the legacy we create during our lifetime, he again rejected my thinking. To him, present creature comforts trumped everything.

A Simple Twist of Fate, based on George Eliot's Victorian novel, *Silas Marner*, reminds us that to parent a child is a blessing that can make our own lives more meaningful. When we learn to care for child, we are leaving our own egocentric desires at the door and becoming better human beings by giving to another who cannot take care of himself. This is what happens to Michael McCann, a high school music teacher, when he adopts a small child who serendipitously finds her way into Michael's home on a stormy winter night after her mother dies in the snow.

Until that transformational moment, Michael has led a reclusive life as a carpenter, crafting elegant furniture and amassing a collection of gold coins which he counts every evening and jealously guards. On one fateful night, his coins are stolen, and Michael is shaken to the core.

Depressed and irritable, his mood changes when he discovers Mathilda, the foundling, and rears her as her father. Life becomes meaningful for him as he learns to parent her. Love deepens as he guides her and watches her mature into an intelligent, precocious, and happy youngster.

Complications ensue when Mathilda's real father attempts to adopt her many years later, citing Michael's inability to pay for her education at the finest schools and his eccentric life style. Michael, after all, is only a carpenter who earns very little, and his social life is limited. Following in broad-brush strokes the outline of *Silas Marner*, the film depicts the challenges that beset Michael as he tries to retain custody of Mathilda. For him, parenting is a calling and he does not want to surrender that privilege.

Jewish tradition places great value on having children and on raising them to be images of the Divine. Being fruitful and multiplying is the first commandment in the Bible. God wants the world to be populated, and having children accomplishes this Divine goal. Moreover, Judaism emphasizes the chain of tradition and passing down values to the next generation. This is expressed in the Passover Seder, where children ask questions to parents, who supply answers to inquiring minds. Furthermore, every Friday night in many Jewish homes parents bless their children, poetically comparing them to the great patriarchs and matriarchs of the past, who carried the message of Jewish living to subsequent generations of Jews. Having children allows one to be a messenger of God in this cosmic plan.

As a parent, I have told my children that my most important title is not "Rabbi" or "Doctor," rather it is "Abba" or "Father." What my own parents left me was a host of positive memories that played a role in my own self-actualization as an adult. Their values are embedded in me, and that is their legacy, which I try to pass on to my own children.

A Simple Twist of Fate suggests that the best thing a parent can leave a child is a legacy of love and strong family values. These will endure beyond any material gift.

THE TREE OF LIFE (2011)
directed by **Terrence Malick**

When I was twelve years old, I had what I would call an "outer-body experience." I thought I was in the presence of God. It happened in Mountaindale, New York, in the heart of the Catskill Mountains where I was a camper at a religious boys' camp. We were singing and dancing on Friday night on the holy Sabbath, and suddenly my whole body was tingling. I felt spiritually touched, as if I had gotten an A+ on a final and hit a home run at the same time. It was an exquisite moment.

I also recall that as a very little child, my mother, of blessed memory, encouraged me to say the following prayer when I went to bed: "Now I lay me down to sleep, I pray the Lord my soul to keep. If I should die before I wake, I pray the Lord my soul to take." My mother planted in me a sense of the spiritual life, a sense that God was involved with me. I remember that my earliest conception of God was that of an old man who lived on the top floor of my friend Victor Delgrasso's house. He had an ancient face and a black moustache; and from my child's perspective, he possessed a kind of divine mystery.

I share these very early childhood memories because they resurfaced as I watched Terrence Malick's *The Tree of Life*, a one-of-a-kind movie that seriously attempts to give the viewer a notion of what life after death is like, and how love and forgiveness can enable us to cope with the inevitable inconsistencies and adversities that are part of existence.

Tree of Life takes place in the 1950s and recounts the story of a loving Texas family whose faith is tested in the crucible of life experience. The parents, played by Brad Pitt and Jessica Chastain, experience the tragic death of a child, the father's loss of his job, and the growing-up tensions

between father and son that threaten to destroy their inherent love for one another. Life, which begins with hope and innocence, brings inconsistencies, loss, suffering, and death to the forefront, echoing the Book of Job, which is quoted at several points in the film.

The story is told through the eyes of the eleven-year-old son Jack and through the eyes of the adult Jack, a successful architect who seeks to discover meaning in a contemporary world where wealth is the measure of the man – not his spiritual sensitivity. The film is filled with images of doorways and ladders, as if to suggest that we need to enter another world to comprehend the one in which we are living.

The climax of the movie takes us through one of those doorways. As we cross the threshold, we glimpse the afterlife, an ethereal place where we are all reconciled with one another and where forgiveness is the operative emotion. Free from the constraints of the real world, we can make peace with parents with whom we have had deep disagreements and create eternal bonds of love with people in our lives, both past and present, all of which makes our present life more bearable, meaningful, and spiritually satisfying. The *Ethics of the Fathers* tells us that one moment in the afterlife is more blissful than all of life in this world, suggesting that it is only from the aspect of eternity that we can truly transcend present adversities and appreciate the everyday miracles of life.

The Tree of Life, suffused with poetic images of beauty from all facets of creation, affirms that within one's family are nurtured the seeds of love that allow us to endure and come to terms with the mysteries and tragedies of life.

THE IRON LADY (2011)
directed by **Phyllida Lloyd**

When I was first married, I attended Sabbath services at the rabbinic school where I studied. Present at the services were many of the rabbis who taught me during the week. I recall very vividly one occasion when the young child of one of the rabbis grossly misbehaved. He began to hit his father and used unbecoming language. In spite of the child's appalling behavior, his father did not hit him or rebuke him publicly. He did not shout at him nor scold him nor physically grab him.

At the time, I wondered whether the father was teaching his son by example how to show restraint and how to control emotions, or whether the kid was in control of the situation and mocking his father. To this day, I don't know the answer. All I saw was one snapshot in time, from which no conclusions could be drawn. However, a recollection of the incident reminded me of how complicated it is to be the child of a celebrity or prominent leader in the community. It can be a blessing or a curse. Consider for a moment the children of Margaret Thatcher as depicted in *The Iron Lady*, an exceptional film about a young civic-minded girl who rises in political power to become Britain's prime minister.

The film opens when Margaret Thatcher is past her prime, now a frail and elderly widow functioning in the present but often swept back to the past through imaginary conversations with her dead husband Denis. She has much of which to be proud. Restoring England's financial power in the face of great economic challenges, navigating the volatile relationship between Ireland and England, and successfully managing the Falklands War, are all high points of a long and illustrious political

career. She also is a wise woman who enjoys sharing insights about life. One particular speech encapsulates her lifelong wisdom: "Watch your thoughts for they become words. Watch your words for they become actions. Watch your actions for they become habits. Watch your habits, for they become your character. And watch your character, for it becomes your destiny! What we think we become."

But there is a dark side. Her family pays a price for her rise to power and for the maintenance of that power.

Margaret Thatcher had twins, a boy and a girl, who have a lukewarm relationship with their mother. They are dutiful children, respectful, yet emotionally distant. There is love between mother and daughter, but the connection is strained. Her son Mark lives in South Africa and is not always available even by telephone. At one point in the movie, Margaret watches a DVD of her little children playing on the beach, but it is only a hazy memory of a warm and loving time long since gone. Even her devoted husband is ambivalent about the price the family has had to pay for Margaret's dedication to serving England.

Children of people in leadership roles do not travel a simple road. The eyes of the community are upon them. Sometimes it is fine and the children rise to the expectations of parents and community. Sometimes they do not. It is instructive to note that there is little said in the Bible about the son of the greatest Jewish leader Moses. His son, Gershon, is a footnote in Jewish history, suggesting that Moses paid a personal price for his leadership of the children of Israel. Gershon never rises to a position of leadership or prominence. He remains average in spite of the fact that he was Moses' son. Instead, Joshua, Moses' trusted student, assumes the mantle of leadership once Moses is gone.

The Sages tell us that it is good to work on behalf of the community, and blessings will accrue to you because of that valuable work. But clearly, the Sages also warn us about the potential negative effects of community involvement. Every one of us has to make a careful calculation of the costs and benefits of such holy labor on family, in general, and on children, in particular. The price may be too high.

IMPROVING YOURSELF

When I was in high school, I wanted to be cool. To present myself as cool, I had shaggy hair like Elvis and cultivated an air of mystery about me by talking very little to the opposite sex. Was I real or was I a poseur? They would not truly know. And then I had my religious epiphany, born again as an Orthodox Jew, making my mother's life stressful with my demands as "SuperJew," redefining our observance of Kashruth with more and more stringencies. This was my first experience with redefining myself.

Over the years, I have redefined myself as a synagogue rabbi, a school principal, and then as a teacher. This last redefinition is where I am now. When I was on sabbatical in Israel in 1997, I taught World Literature to English speakers at a women's college in Jerusalem. It was a good experience and the head of the English Department assured me that when I eventually moved to Israel, I would likely get a position at the college. Fast forward to 2010, and the head of the department was no longer at the school and positions for literature instructors whose command of Hebrew was only so-so were a rarity. The new reality was that I had to look for other work. Thank God, I found work, or rather, work found me. Because I possessed a PhD in English, schools were interested in my services; but instead of teaching at the college level, I found myself teaching Anglo-populations at an elementary school and at a high school. It was not what I had in mind, but that's where God wanted me to be, so I adjusted and am happy to be working, to still be relevant, and to make some money as well.

Another way to improve yourself besides by redefining yourself is by acquiring a mentor. The Sages tell us that one should acquire a teacher.

They understood that life presents many challenges and that we need guidance to navigate the rough seas of human experience. We all need mentors to help us. I have been blessed to have many mentors in life, people who were there for me at critical times in my life to offer counsel or just to be good listeners who gave me the time and attention to work things out on my own. One person, however, stands out as my most important mentor, Rabbi Samuel Scheinberg, of blessed memory.

Let me share some information about my relationship with him. I met Rabbi Scheinberg in 1965 when he was the instructor of the senior class at the Yeshiva University High School. I, along with a number of close friends, had graduated college and wanted to continue our Torah studies, but we started late in our learning careers and still were not ready for a class at our normal age level. Surprisingly, Yeshiva University, in a magnanimous gesture, gave us an opportunity to develop our Talmud learning skills by becoming students in this very unusual high school classroom.

Being in the presence of Rabbi Scheinberg on a daily basis was an amazing experience. He had a wealth of knowledge to share with us, and he did so with clarity, warmth, energy, and good humor. It would have been easy for us to feel uncomfortable to sit in with group of seventeen-year-olds when we were twenty-one, but Rabbi Scheinberg made us feel at home in the class, and in his personal home as well, to which he invited us on more than one occasion.

There was a majesty about Rabbi Scheinberg. He was truly larger than life, full of boundless energy and very much in touch with the teenage mind. Not only did he teach us Talmud, but he also taught us Bible one day a week. He was always able to relate it in a practical way to our own lives. You sensed when you studied with him that the Torah really was a guidebook for living. Rabbi Scheinberg was giving you the key to its understanding and was modeling for his students, in his own self-effacing way, what it meant to be a true Torah personality through and through. There was no artifice about Rabbi Scheinberg. His honesty was palpable and his students both revered him and loved him for it. And that's why I viewed him as a surrogate father as did so many others.

My own father certainly was devoted to me and to our family and had much life experience, but Rabbi Scheinberg was a repository of Torah wisdom and I could ask him questions that I simply could not ask my own father. Whenever I called Rabbi Scheinberg on the phone or spoke to him in person, he was always there for me, guiding me and

counseling me throughout my professional career. There was never any thought of personal gain when Rabbi Scheinberg helped you. There was never any ego involvement. He just advised you from a wise, mature perspective, always keeping in mind what was in your best interest. He always wanted the best for you and you sensed this when you asked him a question.

When I got married in 1965, Rabbi Scheinberg recited the blessings at the wedding, and I remember vividly that when he saw the cup of wine not filed to the brim, he stopped and poured in some more, telling me that his wish for us was that God's blessing for us be overflowing. He exuded love for us and it made us love him and made my wife and me more loving, for he showed us what being a genuinely good person was all about. It was not just his erudition, his learning; it was his grace, his being the personification of a mentsch, as revealed in the way he interacted with his children and with his beloved wife, Pearl.

I remember when the rabbi and his wife visited me in Atlanta in 1988, my late wife remarked to me how Rabbi Scheinberg would always serve his wife first and how he would not eat until she was seated at the table. Without saying anything, he reminded me of how sensitive I should be to my wife, the mother of my children. I sensed that he regarded his beloved wife not only with deep and abiding love but with awe as well, for it was she who brought him calm after a hard day's work, and who brought order into a large and busy household of twelve children.

I learned many things from my mentor, Rabbi Scheinberg. I met many challenges with equanimity because of his guidance, and I avoided many mistakes because of his wise counsel over the years.

Some of the films in this section deal with people who made mid-course corrections in their lives and changed their destinies. Others deal with the transfer of knowledge from one generation to the next and from one person to another. When one has a trustworthy mentor, a person can gain immensely. Without one, one can easily miss opportunities to grow and advance in life.

MALCOLM X (1992)
directed by **Spike Lee**

A number of years ago, I attended a dinner celebrating fifty years of my rabbi's service to his synagogue. At the dinner I met many old friends whom I had not seen for close to thirty years, one of whom was a high school buddy who always was a source of fun and adventure. An avid member of the drama society, he was an inveterate comedian in a host of high school plays and musicals. When I saw him, I did not immediately recognize him. He was now a successful immigration attorney with a pensive look, no longer the jocular student I once knew in high school. I bluntly asked him what was responsible for the change in his public persona. Was it simply age and life experience that gave him such a sober visage? He responded straightforwardly: "After high school, I no longer wanted to be perceived as the class clown and entertainer. I was determined to find a new purpose in my life, so I consciously changed my behavior so people would view me as a serious person."

Redefining oneself and finding a new purpose in life is what *Malcolm X* is all about. At the beginning of his journey, he is Malcolm Little, a flamboyant black man who defines himself by how whites see him. Success for him is the white definition of success: access to money, women, and material things. But life deals him a curve when he is sent to prison for ten years for larceny and breaking and entering. There he meets Baines, a member of the Nation of Islam, who exposes him to the teachings of Elijah Muhammed, the founder and leader of the Nation of Islam, which fosters the notion of black supremacy. Slowly, Malcolm becomes attracted to Muhammed's world view. Muhammed

becomes his mentor and Malcolm converts to Islam, believing that it is only through belief in Allah that his personal redemption can come.

When he is paroled after six years, he travels to the Nation's headquarters in Chicago where he changes his last name from Little, a name given to his family by white slave owners, to X, a symbol of his lost African heritage. He then dedicates his life to improving the lives of other blacks by insisting that they take pride in their unique ancestral history. This is his new purpose in life.

Judaism is replete with examples of people who find a new purpose in life and shed their past identities. Joseph redefines himself as viceroy of Egypt after being incarcerated for many years. The Jewish people in a forty-year span of wandering in the wilderness shirk their old slave mentality and become exemplars of free men living under God's law. They exchange the false deities of Egypt for the true kingship of the One God. In the Talmud, the great sage Resh Lakish finds a new purpose in his life when he decides to abandon his life of banditry and devote his life to the study of Torah. The sage Rabbi Akiva leaves the idyllic life of the shepherd and dedicates himself at age forty to the full-time pursuit of Torah study. These are the role models that set the tone for all of us.

There is a custom every year on the eve of the Jewish New Year and Yom Kippur for men to visit the ritual bath and immerse themselves to emotionally prepare for the sublime Day of Atonement. One of the Sages states that the water of the ritual bath is a metaphor for the fluid of the amniotic sac from which emerges new life, new potential. Therefore, when someone steps out of the ritual bath, he symbolically emerges as a newly created man with a new destiny. *Malcolm X* reminds us that no matter what our past, we still have the ability to change our futures and to find a new purpose for living.

PAGE ONE: INSIDE THE NEW YORK TIMES (2011)

directed by **Andrew Rossi**

Two friends of mine do not use email. One is a synagogue rabbi and one is a school principal. Both are in the twilight of their careers and they see no need to update their familiarity with new modes of communication. If people want to contact them, there is always the telephone. To be sure, they are not philosophically opposed to progress; they just don't feel at ease with the computer or the smartphone and are reluctant to make the leap into today's world of technology.

I never had that aversion to technology. My late wife was a math teacher at my school and she introduced computer literacy into the curriculum many years ago. She and my kids kept me abreast of the latest technological advances and I was able to use them throughout my career, enabling me to communicate with people efficiently and quickly. The more techie stuff I used, the more productive I became. Years ago, I had a secretary who wrote drafts of my letters; now, without a secretary, I could do my own correspondence through email with Microsoft Word and respond to my constituency faster than ever before.

This perspective gave me an appreciation for *Page One: Inside the New York Times*, an engaging documentary presenting an insider's view of the state of print journalism today. The key factoid is that the advertising revenue that was central to a newspaper's success is no longer present. Newspaper classifieds have given way to Monster.com and Craig's List and a myriad of internet alternatives to get the word out about a business, a job, or any new initiative. This leaves the paper in crisis mode, trying to survive in the face of decreasing revenues. There are scenes of layoffs, of columnists trying to learn new skills, and

of media people justifying the uniqueness of what the *New York Times* does on the total informational landscape.

What emerge are intimate portraits of talented, mostly older, people coming to grips with radical change in their industry. It is a cliché that change is the only constant in life, and that is clearly what happens in *Page One*. The question is how we deal with unavoidable change. Does it crush us or does it create new opportunities for us?

David Carr, a New York Times journalist, is the film's main talking head. His own history dramatically illustrates the ability to change. At a critical point in his life, he realizes that to see a different ending to his life, there must be a new beginning. Although the film does not deal with his past, Carr mentions that he was a single parent and former crack addict who left his wasteful life behind and reinvented himself as a reporter. No longer afraid of new challenges, he possesses the sobriety and wisdom to deal with failure. He understands that he has to change in order to survive and prosper. Indeed, the film shows him learning to navigate the latest social media craze "Twitter" with the goal of becoming adept at gleaning news and information from this public forum.

A passage in the Talmud is instructive: "Who is a wise man? He who sees a future development." Similarly, Ecclesiastes writes, "The wise man has eyes in his head." The Sages say that this means that at the beginning of something, the wise man foresees what will be in the end. This approach does not only relate to one's career, but to life itself. For successful living, we must be open to change and look beyond the immediate consequences of our actions.

Watching *Page One* may help us get to page two of our own lives.

NO DIRECTION HOME: BOB DYLAN (2005)
directed by Martin Scorsese

A few years ago, I noticed a peculiar item in the news. Bob Dylan, scheduled to appear in Lakewood, New Jersey as part of a tour with Willie Nelson and John Mellencamp, was accosted by a twenty-four-year old policeman who arrested him for vagrancy. When asked for his identification, he said "Bob Dylan," but the police officer at the scene did not recognize the name. Dylan was apparently walking around looking at houses passing the time before that evening's show. The officers then asked Dylan, sixty-eight, to return with them to the hotel where the performers were staying, and there the tour staff vouched for him.

As a teenager, I grew up in the shadow of the great Elvis Presley, so Bob Dylan was never one of my musical icons. But as I grew older and my musical tastes became more eclectic, I began to pay attention to his music, especially his early material, which is why I was drawn to *No Direction Home: Bob Dylan*. As I watched the narrative develop with early footage of his career interspersed with a present-day interview, I made several observations. Dylan was a very curious and bright young man, totally disconnected from his hometown mid-western environment. It was when he came to New York City that he flowered musically, for here he met other poetic and musical originals who shared his quest for artistic growth. Over time, however, he truly saw himself as a "one-of-a-kind" artist, who didn't need to answer to anyone. He confesses that his early lyrics made him a hero to the civil rights and anti-war movement, but these political movements did not drive his art. His art was driven by his musical instincts. In fact, the movie includes footage of him being booed by the audience for performing electric,

rather than acoustic, material. But he didn't care what the audience thought. Moreover, he finds it absurd that celebrities are asked their political opinions since they know nothing about such matters. For him, silence makes more sense than dangling political conversations that go nowhere.

Which brings me to a Torah perspective that is embedded in this movie. Our Sages tell us that one of the pillars upon which the world is based is *emet*, truth or honesty. Whether one agrees with Dylan or not, one certainly will admit that this film portrays him as an honest person in an industry full of pomposity and posturing. Moreover, Dylan did not pursue fame in a conscious way; he pursued music and its varied expressions, and fame came to him. This is what our Sages clearly tell us in the *Ethics of the Fathers*: "He who seeks fame loses it." The implicit message is to focus on being the best you can be and rewards will eventually come.

As I reflected on the movie, I began to appreciate more and more Dylan's musical genius and his uncompromising integrity. At the end of the day, I understand why the police officer probably did not recognize him. The policeman was born many years after Dylan dominated the musical landscape and Dylan himself did nothing to promote his artistry other than write and sing songs. He did not rely on a publicist; rather it was his music that spoke for him. In this sense, we can learn from this musical master. Perhaps if we are true to ourselves and do not look for recognition, we can make our best contribution to the world and notoriety will come to us.

BUCK (2011)
directed by **Cindy Meehl**

When I was about ten years old, my father surprised me by taking me to a veterinarian's office to pick up a dog. It was a "mutt," a mixed breed, part collie and part something else. The visit was one of my "wow" moments growing up. I named the dog Shep, and we became fast friends. He would sleep at the foot of my bed, chew at the bedpost, and wake me up every morning with a happy look. My father taught the dog to go the newsstand a block away and to bring home the paper in his mouth. I thought that was really cool. When my day did not go well, Shep was always there to cheer me up. He was my dependable friend. But, like many kids, I was not diligent about walking the dog and taking care of all the stuff that comes with caring for a pet. Eventually my mother gave the dog away, and I spent that fateful day crying over my lost Shep.

The whole experience, in retrospect, gave me an appreciation for the value of pets in people's lives. The presence of a pet, in a sense, is therapeutic for the owner. He is a reliable friend, never critical of you, lacking artifice, and always anxious to please.

These human qualities of animals form the subtext for *Buck*, an arresting documentary about Buck Brannaman, a horse whisperer with an uncanny ability to understand and train, not "break," wild horses. As we watch him work with horses, he reveals how close his work is to childrearing. The same principles are operative. Be gentle, be kind, be a good listener, show tough love when you have to, and don't scare them. Interestingly, he describes the act of placing a saddle on a horse as a potentially frightening experience for the horse, which may see it as a lion attack. Therefore, the issue of trust between horse and rider

is critical for training progress to be made. The same holds true in parenting children. The more trust between parent and child, the more communication and the more effective is the parental guidance.

It is noteworthy that the most prestigious biblical figures who serve as role models for posterity began their careers as shepherds, people who care for animals. Their job of caring for sheep made them more adept at caring for human beings. Moses, Abraham, Jacob, King David – they all had "shepherd" on their resumes. Similarly, Rebecca, one of the matriarchs of the Jewish people, was selected as a wife for Isaac because of her kindness to animals. When Abraham's servant asked for water, Rebecca brought water not only for him but for his camels as well. This was the litmus test of her character and Rebecca passed with flying colors.

In the Bible, God tells the Jewish people not to muzzle the ox when it is doing work in the field. Moreover, if we see an animal laboring under a heavy load, we are required to relieve the animal of its burden; and when we finish our day's work, we should first feed our animal before we sit down to eat. Furthermore, if we come across a mother bird and want to take its eggs, we must first chase away the mother bird so that it does not suffer any psychological distress. All these sensitivities apply to the human realm as well. In Jewish law, we permit workers to eat from the crops they are harvesting. We assist people who are struggling to support a heavy load, and we avoid causing psychological pain.

Buck reminds us of the many life lessons we can learn by being attuned to the needs of animals. Understanding their needs and their fears can make us more sensitive human beings.

DEPARTURES (2008)
directed by **Yojiro Takita**

My first encounter with death occurred when I was a rabbi in Atlanta, Georgia. It was my first year in the field and I received a frantic phone call from Wesley Woods, a long-term care facility for the terminally ill. I rushed over and found Al in the midst of his death throes. I heard the term "death rattle" before, but now I actually witnessed it. It was a confusing moment for me. I had no experience with funerals or dying and did not know what to say to the family. When Al finally died a short time after I came, I was speechless. Happily for the family, a priest came by and offered meaningful words of comfort.

I thought of this as I watched *Departures*, a deeply touching film with an unusual subtext: the rituals that people experience when a loved one passes, which place death in a cosmic context that comforts the mourners. The rituals connect past, present, and future and bind the living and dead generations for eternity.

Daigo Kobayashi, a cellist in a Tokyo orchestra, loses his job when, because of financial considerations, the orchestra has to disband. He moves back to his rural hometown to live in the home of his deceased mother, and hopes to find a job. He answers an advertisement for a person to "assist with departures" and goes to the interview thinking the work is related to a travel agency. After a cursory interview with the boss, Mr. Sasaki, he is hired and quickly discovers that "departures" refers to preparing the dead for departure into the next world.

It is neither an easy nor glamorous job, and Daigo is reluctant to reveal his occupation to his wife. However, after a number of assignments, he begins to understand the supreme value of his work. Many

of his clients express the utmost of gratitude for his service, and Daigo begins to feel a great sense of personal fulfillment. His wife, Mika, however, does not share his view and wants him to give up his "disgusting profession" and obtain another job. This disagreement between husband and wife generates tension, until one fateful day when a friend's funeral requires his services.

As we watch Daigo perform the casketing ceremony in front of relatives and friends, we understand the powerful emotional comfort he is giving to those who are left behind. It is very much akin to the purification ritual, the *taharah*, that is performed in Jewish tradition in which the body is washed, prayers are said, and farewells to the deceased are articulated. In both Asian and Jewish traditions, there is the given that this world is only a gateway to another, where the spirit reigns supreme. That understanding gives comfort to the mourners, who implicitly know that all human beings, including them, will undertake the same journey from this world to the next.

Interestingly, some of the special rituals of the casketing process are physically similar to the ancient *taharah*, the Jewish ritual purification ceremony before burial. The body is washed, albeit in different ways, and there is great care to insure that body parts are visible only in a minimal way out of respect for the dignity of the departed. Moreover, because the ceremony is viewed as a holy preparation for entry into the afterlife, the one who performs it is valued and appreciated by the family of the deceased. Only the boorish or untutored view ministering to the dead as not a "proper job," as one character says in the film. However, those with maturity and wide life experience cherish the sensitivity of those who labor in this sacred task.

Departures is a one-of-a-kind movie that introduces us to a topic that is removed from daily life, but which helps us understand the long-standing traditions of our faith towards the subject of death. Its sensitive portrait of casketing resonates in Jewish tradition, where preparing the dead for burial is viewed as the highest form of kindness, referred to as a "kindness of truth." There is no payback when you do a good deed for the dead.

GOOD WILL HUNTING (1997)
directed by **Gus Van Sant**

For a number of years as a synagogue rabbi, I officiated at funerals and gave thoughtful and comforting eulogies. But it wasn't until my mother passed away that I really understood what loss meant. I had spoken to her on a Thursday night right after Passover in 1976; the next morning I received a call from my father who was crying, telling me at the same time that Mommy had died. I felt an emptiness within; and at the funeral service the following Sunday in Mt. Vernon, New York, I was speechless and could not sing her praises. I could only share with Rabbi Solomon Freilich, the officiating rabbi, my strongest memories of my mother, and the rabbi in his eulogy gave voice to my thoughts.

After that seismic event in my life, my sensitivity towards mourners who had just suffered a loss was more heartfelt. Loss was not just a sermon topic; it was something that changed my perception of death, which made me more empathetic and more understanding of what it means to be a loved one left behind.

There is a line in *Good Will Hunting* uttered by Will Hunting's therapist, Sean, which expresses the difference between just learning or hearing about tragedy and experiencing it. Sean tells Will, an arrogant, cocky, but brilliant, young man, "You're just a kid. You don't have the faintest idea of what you are talking about." Furthermore, Will does not know about art, about love, about war. All he possesses is book knowledge, not wisdom that emerges from the crucible of life experience. Sean has lost his beloved wife to cancer, and Will casually presumes to know everything about Sean because of a painting he saw in Sean's office. Sean responds to his facile remarks stridently: "You don't know

about real loss because it only occurs when you've loved someone more than yourself," and clearly Will is self-absorbed. To sharpen his observation of Will, Sean, aware that Will is an orphan, declares honestly: "You think I know how hard your life has been because I read *Oliver Twist*?"

In the book of Exodus, we are told that Moses went out to see the suffering of his brethren. Until that time, he was isolated from them and did not comprehend their pain. Witnessing first-hand the beatings they were receiving at the hands of the Egyptians gave him a different perspective. He identified with them and so began his odyssey of redemption. Seeing things from the balcony may be academically satisfying, but it is only through the shared life experience that one learns to understand human tragedy and become more empathetic.

There is another challenge Will has to overcome: low self-esteem. This is nurtured by a cohort of friends who spend all their free time drinking beer, carousing, and engaging in the language of the gutter. Will is unable to see beyond his lowly origins. Only through his friendship with Sean, who does not abandon him in a time of crisis, does Will begin to see his future differently.

The *Ethics of the Fathers* states that sitting among the gatherings of the ignorant removes a man from the world. Association with the philistines of society makes you one of them. It is only when you separate from them that you can begin to create your own independent identity and soar.

Good Will Hunting implicitly suggests to us two truths. A meaningful life is based on shared human relationships. When we empathetically share pain and tragedy, we connect to the human family. Moreover, in order to move forward in life, we sometimes have to make a clean break with the past. Lots of old baggage can limit our ability to fly.

THE RAINMAKER (1997)
directed by **Francis Ford Coppola**

A friend of mine has been studying for the actuarial examinations for the past several years, but without success in passing them. He has hired private tutors to help him, taken online courses, and devotes an hour daily to working on practice tests; but the examination still eludes him. He is a very intelligent young man, a National Merit Scholar in Math, but his paycheck is small without the credential of Enrolled Actuary. Presently, he works for a pension fund company that hired him with the hope that he will soon pass the test that will qualify him for more responsibility in the office and a bigger salary. In the interim, his keen analysis of data and company files has enabled his company to save millions of dollars because of discoveries he has made in the accounting processes of his firm, even though he lacks an official actuarial credential.

There is a character in Francis Ford Coppola's exceptional legal drama, *The Rainmaker*, who mimics what happened to my friend. Deck Shifflet is a paralegal who has failed the bar exam six times, but he is a master at locating critical information about insurance companies and their economically driven claims policies. His resourcefulness enables him to get hired by law firms who take advantage of his knowledge at a fraction of the cost of a full-fledged attorney.

The Rainmaker revolves around the case of a middle-aged couple, Dot and Buddy Black, who file suit against an insurance company, Great Benefit, which denied insurance coverage for a bone marrow transplant for their twenty-two-year-old son Donny Ray, dying of leukemia. In spite of religiously paying their premiums for many years, they are victimized by small print in the insurance contract that precludes the

company paying for aggressive procedures to cure their son. Moreover, Great Benefit has a corporate policy of denying all claims when they are first presented. It is only the customers who press on, despite initial rejection of their claim, who receive any compensation at all.

Rudy Baylor, a young attorney representing the Blacks against the high-powered lawyers for Great Benefit, has just passed the Tennessee bar exam; but he has never before argued a case in front of a judge and jury. It is a daunting task for a rookie attorney, but he has a secret weapon in Deck Shifflet. When all seems lost, it is Deck who repeatedly comes up with an innovative strategy that potentially can win the case, or locate a crucial witness who has long since dropped out of sight.

Deck in professional terms is a loser, but he possesses the street smarts needed to be successful in the sinister world of insurance fraud. Deck reminds us that the possession of a credential, a degree, or a license, does not guarantee wisdom, insight, or financial success.

Rudy recognizes Deck's value and partners with him in his law practice. It is a partnership founded on genuine friendship, mutual trust, and respect. Each one relies on the other for expertise in the area in which he is weak. Rudy's sincerity and humility impress the jury, but it is Deck's resourceful research and knowledge of human nature that buttress Rudy's legal arguments before the jury.

The *Ethics of the Fathers* tells us that the wise person learns from every man. Our Sages teach us that we should never belittle any man, for every man has his hour of glory, his moment in the sun. The synergy of Rudy and Deck reminds us that every person can contribute something to the greater good regardless of pedigree, regardless of intellectual or social background. No one should be considered insignificant, for everyone possesses a gift to offer the world.

JEREMIAH JOHNSON (1972)
directed by **Sydney Pollack**

As a young father, vacations generally meant going to places like Disneyland or to resorts with a pool and kid-friendly activities. Once I became an empty nester, vacation destinations changed. National Parks were the place to visit. My first one was to Acadia National Park in Maine; and over a number of years, my wife and I visited many in the United States and Canada. Instead of going somewhere to be amused, we traveled far to contemplate and appreciate the beautiful world that God has given us. Spending time hiking, surveying breathtaking lookout points, and listening to the sounds of nature, were rejuvenating. Which is why I greatly enjoyed a recent viewing of the Western classic, *Jeremiah Johnson*.

Jeremiah leaves civilization as he knows it and journeys to the mountains. He wants to become a mountain man, living away from the hustle-bustle and corruption of the busy city. He wants to be alone and to discover the beauties of nature first-hand. There is a parallel here to a famous story told about Rabbi Samson Raphael Hirsh, a nineteenth century leader of German Jewry and Bible commentator, who near the end of his life resolved to visit the French Alps. His students tried to convince him not to go because of the risk to his health, whereupon he told them: "When I come before God, I will have to answer for many things. But what will I tell Him when He asks me, 'Have you seen My Alps?'"

The Talmud explains that in the future God will hold us responsible if we do not enjoy the beautiful things He created in this world. It is a good thing to go out and see the trees, the mountains, rivers, lakes, and

oceans. Seeing them reinforces our belief and appreciation for God, who created all of it.

However, there is a dark side to being a mountain man. "Do not separate from the community," say our Sages. Jeremiah learns that a life of isolation can be dangerous and unforgiving, and that there is a price to pay for solitude. For example, he has no backup when things go awry.

One incident, in particular, brings this lesson home. Having married an Indian woman and found a modicum of happiness in the wilderness, he is asked by the US Calvary to lead a search party to bring food to a stranded wagon train. He is not anxious to leave his family, but he reluctantly agrees and leads them to the wagon train. Inwardly, however, he is agitated that the route takes him through a sacred Indian burial ground. The scene of traversing the burial ground is one that encapsulates both the allure and danger of nature. It is a grey day, snowing gently but relentlessly as the soldiers pass by skeletons of dead Indians, foreshadowing a tragedy that is to come. It is an image of both beauty and dread.

Left alone in a vast wilderness with savages all around, Jeremiah is forced to defend himself on countless occasions in order to survive. The Hobbesian notion that life is nasty, brutish, and short finds expression in the harsh life of Jeremiah Johnson. But in spite of it all, he emerges not as a bitter or angry person, but as one content with his lot, understanding that life is filled with contradictions, with happiness and sadness, with beauty and ugliness. It is a mature sensibility, worthy of emulation.

There is much to admire in Jeremiah Johnson. He is a man of few words, of deep feelings, of personal integrity, who, through age and experience, appreciates and values the beautiful world before him.

ZELIG (1983)
directed by **Woody Allen**

Going to grade school in Mt. Vernon, New York, I was a good student, focusing on academics, until my neighborhood changed almost overnight. Low-income projects were built a block away and the affluent fled the hood rapidly. We could not afford to move so we stayed, and my education took a different turn. Surrounded by peers who wanted to be cool, I wanted to be cool too. As a result, I spent time combing my hair and listening to rock and roll instead of focusing on my studies. Over a period of several years in a junior high school of average achievers, I became average. No longer at the top of my class, I became one of the cool guys. I remember vividly going into the school restroom with Ernest, a buddy, and styling my hair just like Elvis, slicked back with a curl dangling in front. Hormones were raging and Ernest and I wanted to look good for the girls. It wasn't until my high school years and my being "born-again" as an Orthodox Jew that I firmly realized that the most fulfilling way to lead a life is to be yourself, to think of larger issues than personal appearance, and not to construct a life determined by the expectations of peers. I finally understood that my goal in life should not only be to be liked, but to be holy, a goal of a totally different order.

I was reminded of this as I watched *Zelig*, the story of Leonard Zelig, a man whose only purpose in life is to be liked by others. It is an all-consuming goal, which even has physical consequences. If he is with Chinese people, he becomes Chinese and can even speak the language; if he is with people of color, the actual color of his skin changes; if he is with physicians, he becomes a doctor who can speak the medical lingo. He becomes whomever he is with. Through a protracted psychoanalysis

with Dr. Eudora Fletcher, we learn that Zelig morphs into whoever he is in order to protect himself emotionally. When alone with himself, he has no identity.

The film traces Zelig's journey towards personal self-actualization, which occurs because of the love of one person who deeply cares for him, who validates him as an individual, and who thus enables him to change his life: Dr. Eudora Fletcher. This notion that a person who knows that he is loved feels valued is a Jewish sensibility. Rabbi Akiva in the Talmud used to say, "Beloved is man, for he was created in God's image. It shows even a greater love when God informed man that he was created in His image." If we know God made us in His image and loves us, we feel special; and that is very good for us emotionally. Because we are all created in God's image, all of us have infinite value.

Moreover, God created the world, say our Sages, with only one man. This teaches us that one life is equivalent to the entire world. None of us is a mere number. Each one of us is an entire world, unique unto itself.

Zelig reminds us that ultimately we achieve very little in life if all we do is imitate others. The key to emotional maturity and progress lies in our very individuality, in our ability to understand how we in our own special way can contribute to and enrich the world around us by being who we are, by celebrating our Divinely-given uniqueness.

78

BIG (1988)
directed by **Penny Marshall**

For many years I would take my ninth and tenth grade classes on a week-long trip to Washington, DC and New York City. Once someone asked me if I ever got bored seeing the same sights year in and year out, and I responded that I did not. Why? Because every time I go on the trip I see the same places, but with the eyes and excitement of a student who has never been there before. Washington and New York become the Grand Canyon every time we make the journey.

The ability to experience the same thing over and over again and yet to feel as if one is seeing it for the first time is a poetic sensibility. This is the central theme of *Big*, a comedy that makes a serious comment about being an adult but seeing the world from the perspective of a child. Wordsworth writes about it in his poetry when he says that "the child is the father of man." I explain to my students that this means that as we grow older, we should still maintain a childlike appreciation of nature. This is the message of his classic poem "I Wandered Lonely as a Cloud," in which an old man experiences the joys of nature as he walks through the woods and discovers a field of flowers dancing in the radiant sun.

Twelve year old Josh Baskin wants very much to be older, to be big. He cannot get the attention of a girl he likes and he is turned away from an amusement park ride because he is too short. In frustration, he makes a wish in front of a mysterious fortune telling machine and, lo and behold, it is granted.

The next day, he wakes up as an adult. Scared at first, he does not know what to do. Even his mother sees him as a stranger who has kidnapped her beloved son. Until he can figure out a way to get back

to his normal life, Josh decides to enter the adult world temporarily. Fortunately, he finds a job at a toy manufacturing company, and his childlike understanding of what toys would appeal to children makes him a marketing genius to the owner of the company. Within days, Josh is promoted to a senior position, and soon finds himself the object of adoration by many of the company's employees, including an attractive female executive, which makes life very complicated for him.

How Josh handles being an adult when he is really only a child makes for many comic situations. But behind the humor, Josh is still only a child who misses his mother, and he yearns to return to his previous life. *Big* captures the ambivalence in Josh's feelings, and gives us a window into the good things that can happen if we can keep our childlike perspectives alive even as we grow older.

Jewish tradition tells us that we need to keep our youthful perspectives on life as we age. On a daily basis, the prayer book reminds us that God renews the world every day, and that is the way we should see nature every day. Moreover, there is a concept in Jewish law that when one sees an ocean once in thirty days, when he hears thunder and sees lightening, when he bites into a piece of food, he recites a blessing. Nothing is taken for granted. There is even a blessing after visiting the bathroom, in which he recognizes the marvel of how the body works. Josh Baskin's story is a fairy tale, but its message resonates in real life: stay young on the inside, as we grow old on the outside.

THE BUTLER (2013)
directed by Lee Daniels

As a youngster, I had little knowledge or understanding of the Holocaust. There was no Holocaust Remembrance Day that focused my attention on this unspeakable tragedy and I did not know any Holocaust survivors. Once I entered Yeshiva University as a freshman, however, things changed. At the college there were courses on the Holocaust, and survivors visited as guest speakers, sharing some of their experiences with the students.

I soon became sensitive to the issue of using German products, and driving around in my new Volkswagen in the Washington Heights neighborhood of Manhattan where many survivors lived was not always a comfortable experience once I became aware of how strong some people felt about Nazi Germany. For me, the Holocaust was still an academic subject, but for them it was an ever-present memory that still haunted them. I recall seeing Sidney Lumet's film *The Pawnbroker* and being disturbed by its narrative about a concentration camp survivor who cannot adjust to his present reality because of his horrific memories of the past. He saw life through the prism of history. I only saw today.

This memory of the disparity between my superficial understanding of the Holocaust and the searing memory of someone who actually has endured cruelty returned as I watched *The Butler*, a moving drama about Cecil Gaines, an African-American butler who served in the White House for thirty-four years during the administration of several presidents and through some of the most tumultuous times in our nation's history. It is an engaging historical film, but also one that

describes the evolution of the relationship between father and son, who view the same events but with different eyes.

Cecil Gaines's history begins with tragedy on a cotton plantation in 1926, where his parents work as sharecroppers. His mother is raped by the farm's owner and his father is then shot dead by him. Out of pity, Annabeth Westfall, the caretaker of the estate, takes in Cecil and trains him as a house servant.

When he reaches his teens, Cecil embarks for a new home, away from the precarious life of a persecuted black man in the South. Serendipitously, he meets Maynard, also a house servant, who finds employment for Cecil in one of the wealthiest households in Washington, DC. Soon he meets the love of his life, Gloria, and they have two boys, Louis and Charlie. In 1957, Cecil is hired by the White House during the administration of President Eisenhower. Louis, his oldest son, elects to go Fisk College, a school far away from home, and there he becomes involved in the non-violent protest movement promoting equal rights for blacks.

Cecil's family story parallels the growth of the civil rights movement in America, and the film masterfully juxtaposes the abysmal treatment of blacks in the South with Cecil's immaculate work in the White House. While his son is beaten and then incarcerated, Cecil is serving guests in the White House dining room with gloved hands.

The tension between Louis and his father intensifies when Louis joins the radical Black Panther organization. For Louis, this is heroic; for Cecil it is insane. After many years, there is reconciliation, but only when both recognize the disparity between each other's life experience. Louis has led a comfortable life in a Washington suburb and has not experienced the childhood trauma of his father. Cecil, experiencing poverty and violence as a young child, feels that real change can only come about gradually and cannot be forced; hence, his antipathy for movements that promote violence, even when the cause is just. This practical approach is expressed by Maynard, Cecil's mentor in his early years, when he offers him advice on how to succeed: "We've got two faces – ours, and the ones that we got to show the white folks. Now, to get up in the world, you have to make them feel non-threatened. Use them fancy words that I've taught you. White folks up north, they like some uppity coloreds."

The great sage Hillel says in the Talmud: "Do not judge your fellow man until you reach his place." It is, indeed, impossible to judge another

82

because our life experiences are so different. Both Cecil and Louis initially err when they view the other stereotypically without understanding the different life journeys each has taken. *The Butler* reminds us of the essential complexity of human experience and how judging people superficially can shatter even the most precious of relationships.

THE BOXER (1997)
directed by **Jim Sheridan**

Many, many years ago, when I was in junior high school, I met Dolly, a sweet and very personable girl with whom I enjoyed spending time. She went to a different school and one day I invited her to visit my school, an institution in which I took great pride. Those were innocent years, and nothing seemed nefarious about my asking a girl that I knew to tour my school. In truth, the tour was excellent except for one small problem. A school janitor saw me in the building after hours with her and reported me to the principal to make him aware of my inappropriate behavior. The visit was innocent, but the next day I was summoned to the principal's office where he lectured me about the appearance of impropriety. It was a speech that had a lasting impact and today I am grateful for it. I learned early on to be sensitive to how my actions might appear to others.

The appearance of impropriety is the catalyst for much of what happens in *The Boxer*, the story of Danny Flynn, a former Irish prizefighter who comes home to Belfast after serving fourteen years in prison. There he reconnects with Maggie, an old girlfriend, now married to an imprisoned IRA man. A paramount value amongst the IRA is that wives remain loyal to their husbands even when they are sent to prison for long terms. The IRA fighters view with disdain the slightest impropriety. They know that if an IRA member were to feel that incarceration would lead to prison as well as the breakup of his marriage, it would become increasingly difficult to recruit members. Furthermore, for many it would be too high a price to pay for their rebellion against the English.

Against this background, Danny meets with Maggie, his old flame.

They originally intended to marry, but life intervened. Danny went to prison as a convicted terrorist and Maggie reluctantly moved on, eventually marrying and having a child.

Their love for one another persists, however, in spite of the long separation. Seeing each other after so many years rekindles long suppressed feelings of love, and they reveal their innermost thoughts to one another. Their private talks, however, soon become public knowledge, and their destinies are changed. Once others become aware of their surreptitious encounters, nothing can remain the same.

In truth, nothing immoral occurs between them. They confess their mutual love, but do not consummate it any way, respecting the unwritten code of the IRA. However, the specter of adultery looms large. Eventually it becomes the excuse for Danny's enemies to torpedo Danny's plans to live in peace and open a non-sectarian boxing club, in which both Catholics and Protestants can participate. Violence erupts leaving innocents murdered and maimed. The future of peace between the Irish and English is jeopardized. Moreover, the suggestion of inappropriate behavior between Danny and Maggie motivates Liam, Maggie's son, to burn down the town gymnasium where the boxers train.

Judaism has much to say about the appearance of impropriety. For example, the Torah tells us that if a woman is alone with a man other than her husband, the appearance of impropriety might trigger a crisis of trust between spouses, which might lead to the dissolution of the marriage.

The appearance of impropriety plays out in many life situations. Judaism encourages us to be sensitive to how our behavior looks to others. We may technically be innocent of crime, but our actions may give a different impression. It is wise at times to see our behavior through the eyes of others.

HERO (1992)
directed by **Stephen Frears**

In my career as a rabbi and day school principal, I often have been involved in fundraising efforts. One, in particular, was memorable. I had been advised that a very wealthy man lived in a small southern town and likely would make a sizable donation to my school. A friend of mine who owned a small plane volunteered to fly me there and so I made an appointment. When I knocked on the door and said I had an appointment, the maid told me that he was busy and I should return in an hour. I finally met him and left with a small $100 gift. The poor results of my visit I chalked up to my inexperience and to the person's innate stinginess. Boy, was I wrong! Years later, I discovered that this "stingy" man made a multi-million-dollar gift to a local hospital and was considered a hero and the major benefactor of that institution. The whole incident reminded me that first impressions are not necessarily accurate impressions.

In life, first impressions last and we often do not get a chance to make a second impression. This truth is basically the story of Bernie LaPlante, a petty criminal who anonymously rescues all the passengers who survive a plane crash in the film *Hero*, but whom no one believes is the hidden hero. The people's first impression of Bernie is, in most cases, their only impression of him.

Bernie is the perpetual loser, perceived by his ex-wife as unreliable and by his boss at work as irresponsible. While rescuing the survivors, he loses a shoe; and when he meets John Bubber, a homeless Vietnam veteran, Bernie gives him his remaining shoe. The shoe looms large when the media cry out for the anonymous hero to step forward. At that moment, John uses the shoe to establish his identity as the "angel"

who saved the lives of so many and claims credit for the good deed. While this happens, Bernie is in jail for credit card fraud and cannot refute John's claim.

The reality is that nobody thinks that Bernie is the hero type. He is unattractive, coarse, and self-centered. Even when he claims that John is a fake, no one trusts him. It is much easier to accept John as the anonymous Good Samaritan because he is good-looking, modest, and very willing to help those in need. He is concerned about the welfare of the others while Bernie is only concerned about himself.

Bernie and John eventually meet under stressful circumstances and discuss what course of action would be best for everyone. Should John maintain the ruse and keep the media and public satisfied, or should Bernie insist that the truth prevail and be personally recognized for the good he has done? The resolution of this dilemma is both comic and thoughtful.

Jewish classical literature is instructive in several ways. It tells us that a man should not pursue fame, for it is illusive. The more we seek recognition and notoriety, the more it escapes us. A good deed done quietly, away from the public eye, is the best way we can do a good deed.

Moreover, we should recognize that every man has his moment of greatness. John Bubber in a meditative moment reminds us that "there's a hero in all of us," and "we're all heroes if you catch us at the right moment." Such is what happens to Bernie LaPlante. There is a moment when he is the real deal, a genuine hero; and that moment becomes a transformational moment in his life, making him more responsible, more caring, and more empathetic for the rest of his life.

THE ISLAND (2005)
directed by Michael Bay

I live in a city in Israel with a very diverse population, both religious and non-religious. Even within the religious community, there are divisions. However, all religious factions believe there is a God in the world, that He gave us in the Bible instructions for living, and that there is accountability for what we do and do not do, if not in this world, then in the next.

In spite of these commonalities, the groups differ in how they express these deeply held beliefs. One group maintains its beliefs but engages in the world, feeling that the outside world has much to offer but that we have to discriminate between the wheat and chaff of secular culture. The other group believes that interaction with the outside world can be fatal. It can contaminate our faith and leave us bereft of holiness. The consequences of separation from the outside world is the subject of *The Island*, a science-fiction adventure in which a population is kept in isolation for a nefarious purpose and where conformity to the existing order is valued above all. When people are trained to dress alike, think alike, and perform similar tasks, there is less likelihood of a challenge to the status quo, leaving those in authority with free reign to do as they will.

It is the year 2019. Lincoln Six Echo and Jordan Two Delta live in an isolated district, governed by rigid protocols. The community is trained to believe that the outside world is contaminated with the exception of one island. Periodically, a lottery is held in which one resident is selected to leave the isolated district and live on the island, where he or she will have an ideal life.

Lincoln discovers serendipitously that the earth is not really

contaminated. Further investigation reveals that the lottery is a ruse to remove residents from the compound in order to kill them and harvest their organs on behalf of wealthy donors, who have invested large sums of money to manufacture clones of themselves so that they can live longer. Dr. Merrick, the scientist in charge of the project, suspects Lincoln of subverting his plans and launches a full-scale effort to destroy him and Jordan Two Delta, who has partnered with Lincoln in a bold escape from the compound. For Merrick, any attempt to undermine the conformity of life at the compound is a threat to his power.

Conformity alone is not a Jewish ideal. Jewish tradition encourages conformity when conformity is a means to an end, not an end in itself. In an insightful essay on religious conformity, Rabbi Marc Angel writes: "Rabbinic teaching has it that the Sodomites placed visitors in a bed. If the person was too short, he was stretched until he fit the bed. If he was too tall, his legs were cut off so that he fit the bed. This parable is not, I think, merely referring to the desire for physical uniformity; the people of Sodom wanted everyone to fit the same pattern, to think alike, to conform to the mores of the Sodomites. They fostered and enforced conformity in an extreme way." This is akin to the extreme sameness fostered in Merrick's compound, a conformity imposed by authority that is used solely to take advantage and exploit people.

This is not the Jewish way. *The Island* reminds us that to develop as human beings, as reflections of the Divine, expressing our individuality is essential. Loyalty to the eternal and commonly held values that have kept us together for millennia does not preclude thinking for oneself. Indeed, thinking for oneself is an affirmation of the divinity within us.

YOUNG SHERLOCK HOLMES (1985)

directed by **Barry Levinson**

When I was a graduate student in Hunter College in New York, I took a course in Modern American Literature with a group of very bright students, but Jonathan surpassed them all. Strangely, he rarely came to class; but whenever he did come, he shared insights that truly mesmerized me. I learned more from him than from the instructor. He taught me the value of thinking outside of the box when interpreting and understanding the great classics of literature.

On the eve of the final, Jonathan called me and asked if he could come over and borrow my notes. He knew my notes were complete and accurate and he wanted to review them before the test. Happily, I gave them to him. Inwardly, I felt it was his choice to attend class or not, and if he felt attending class was a waste of his time, so be it. It was my choice as a friend to share my notes with him.

Friendship is at the core of *Young Sherlock Holmes*, an imaginative recreation of how Sherlock Holmes and John Watson became friends. Their personalities are diametrically opposed. Holmes is independent and daring, and Watson is a "play-it-by-the-book" medical student, staunchly averse to risk, always worried about jeopardizing his academic future. However, he admires Holmes's adventurous spirit. Despite their differences, their affection for one another grows and is celebrated in the many detective novels of Sir Arthur Conan Doyle.

The film begins in Victorian England on a dark night when we see a hooded assassin use a blowpipe to shoot a dart into an unsuspecting man. The dart causes the man to hallucinate and commit suicide. Two more people die under similar circumstances; and Holmes, a friend of one of the victims, tries to piece together clues to find the murderer. This

leads to all sorts of escapades in which he and Watson put themselves in danger as they discover an Egyptian cult bent on taking revenge for a wrong committed many years earlier.

At the end of their adventure, Holmes and Watson take leave of one another, and Watson realizes he forgot to thank him. Years later, Watson reflects on Holmes: "He had taken a weak, frightened boy and made him into a courageous, strong man. My heart soared." The friendship had transformed Watson, and for that he was eternally grateful.

The *Ethics of the Fathers*, a classic of Jewish wisdom literature, reminds us not to take friends for granted and to appreciate what they do for us. Specifically, we are bidden to "acquire for yourself a friend." One of the Sages interprets the aphorism by telling us that to acquire a friend, we cannot be rigid in our own opinions. We have to be open to the voice of others who see things differently. When we are sensitive to the needs of others and are tolerant of diverse opinions, then friendship grows. Friendship cannot thrive in an environment where friends are not free to express their opinions without fear of ridicule. Moreover, the Sages point out that we should give honor to anyone who teaches us even one piece of wisdom.

These aphorisms resonated as I watched *Young Sherlock Holmes*. The story, narrated by Watson, reveals that he grew as a person because he recognized that Holmes, although different from him, was a person of great insight from whom he could learn. Watson did not let his own personal bias interfere with nurturing a new friendship. Indeed, friendship ultimately flowers in a garden of tolerance.

I AM SAM (2001)
directed by **Jessie Nelson**

As I write this review, I am observing the *yahrzeit*, the anniversary of the death, of my oldest sister, Carol, who passed away close to thirty years ago. Carol had Down's syndrome, a severe form of mental retardation. When she was born in the late 1930s, this condition was in the proverbial closet, and rarely discussed in public forums.

My conversations with Carol when I was a child were always straightforward, but once I was very surprised by a remark of hers. My father was trying to get her to speak slower so he could understand what she said and he told her: "Hold your horses." Carol responded: "I have no horses to hold." To my ten-year old mind, Carol's answer was hilarious, and both my family and I burst out laughing. Carol laughed too, understanding that she told a good joke.

The incident reminded me that when we deal with people with disabilities, especially mental retardation, we have to leave our preconceived notions at the door. We have to realize that there are many gradations of mental retardation and they present themselves in many different ways.

I can recall Bobby Duffy, a mentally handicapped fellow I met in my childhood, who was a superb ping-pong player. Watching *I Am Sam*, in which several Down syndrome adults reveal an encyclopedic knowledge of Beatles legend and lore, made me think of Bobby who excelled at one endeavor even though he was intellectually functioning at a very low level. I was reminded of Bobby again when my son-in-law, a special education expert, was working for a school with the acronym of SCHI,

which stood for School for Children of Hidden Intelligence. The name of the school was ingenious because it implied that even handicapped kids had intelligence, albeit an intelligence of a different kind.

I Am Sam tells the story of Sam Dawson, a mentally challenged adult who has fathered a child with a homeless woman who leaves Sam right after giving birth to their daughter. She wants nothing to do with either Sam or the new baby, and Sam is left with the awesome responsibility of caring for his child, which he does with the assistance of Annie, a kind neighbor.

In a few years, Lucy, his daughter, surpasses her father intellectually and social services challenge Sam's ability to care for his precocious daughter. A court custody case ensues, and Sam desperately seeks legal representation.

Due to an unusual set of circumstances, Rita, a high-powered lawyer, volunteers to help Sam on a pro bono basis, and thus begins her journey on a road to understanding the world of mentally challenged people as well as a road to self-understanding. An early conversation between Sam and Rita illustrates the initiation of Rita's learning process. She asks Sam: "I just don't know what to call you: retarded, mentally retarded, mentally handicapped, mentally disabled, intellectually handicapped, intellectually disabled, developmentally disabled, " to which Sam responds: " You can call me Sam." Rita quickly learns that labeling people does not allow you to truly recognize the uniqueness of every human being.

Jewish tradition regards every child as special and as possessing a perfect soul. From the point of view of Jewish law, mentally retarded children are not accountable for their actions. The Chazon Ish, a great sage of the twentieth century, suggested that such children have a unique purpose in the world. Unlike normal children who are charged with improving their character, the purpose of the Down's syndrome child is to bring out the best in others, to foster sensitivity in those whom they meet both within the family and without. For example, when Rita asks Sam to manipulate the truth for the sake of retaining custody of Lucy, Sam tells her that he cannot do this. Lying is not in his genetic code. He can only tell the truth and he cannot use subterfuge. This forthright answer silently encourages Rita to face the truth of her own family situation, married to an unfaithful husband and mother to a child that has little respect for her.

I Am Sam is an emotionally touching film that helps us understand the world of the mentally challenged. In the process, it makes us reflect on our own modalities for relating to family and friends. Sam reminds us that love is more important than wisdom in lubricating our human relationships.

DANCES WITH WOLVES (1990)

directed by **Kevin Costner**

Every once in a while, movies can instantly transport you to another place and another time in an instant of cinematic magic. There is a scene at the beginning of *Dances With Wolves* that does that for me.

The Civil War is raging and there is stalemate between the Union and the Confederate armies, positioned on opposite sides of a field. Lieutenant John J. Dunbar, whose leg is badly injured, realizes that his leg will be amputated, and so he attempts to end his life nobly by riding his horse in front of the Confederate lines where he will be an easy target. Contrary to his expectation, they shoot at him but do not hit him. It is a poetic scene of transcendent beauty as he rides his horse with his arms flying outwards facing possible death.

Dunbar's brave act rallies the Union troops who storm the Confederate line of defense. His heroism gets the attention of a general who dispatches his personal surgeon to tend to Dunbar and save his leg. As a reward for his service, he is given Cisco, the horse that he rode in battle, and his choice of a new post. Dunbar chooses to serve on the barren frontier, and so begins his odyssey of personal discovery far away from the fields of war.

Dunbar's new post is desolate, but he relishes the beauty and quiet of his new home. He begins to repair it and waits for reinforcements to arrive. In truth, his whereabouts are unknown, and in time he is discovered by a tribe of Sioux Indians who are camped nearby. He forms a friendship with Kicking Bird, the tribe's medicine man, and gradually gains acceptance by the Indians who appreciate his help in finding buffalo for them to hunt for food and clothing.

As I watched the film, which is epic in visual proportion and in theme, I thought about what it takes to become part of a new society. If you want to be welcome, you have to go out of your way to meet people, to share in their pain and in their joy, and you have to learn their language. Realizing that his life of isolation is going nowhere, Dunbar decides to leave his post to get to know the Indians. He does not wait for them to come to him. Once in their environment, he accepts the Indians' initial suspicion of him, and tries sincerely to understand their way of life. It is only when he masters their language that he becomes fully integrated with them.

Reflecting on my own experience as a new immigrant, Dunbar's journey provides a good model of adjustment to a new world. I recall an Israeli telling me when I first arrived to introduce myself to my neighbors, not to be reclusive and stay home or only associate with Anglos. Such a path is insular and will not connect you with Israeli society. Rabbi Ezra Bick, quoting the great medieval sage Maimonides, observes that the person who separates himself from the community, no matter how great his personal qualities, has cut himself off from the "fullness of the image of God," for it is only within the community that man can realize his true spiritual potential. Maimonides writes: "One who divorces himself from the ways of the community, even though he has not transgressed transgressions, but is only separated from the congregation of Israel, and does not perform good deeds together with them nor enter into their troubles nor fast on their fast days, but goes about his way as one of the people of the earth, and as though he were not one of them - he has no portion in the World to Come."

Dances With Wolves implicitly reminds us that it is only within the community that we can truly actualize our potential. John Dunbar understands this when he identifies with the Sioux tribe that has embraced him. Together with others, he finds himself.

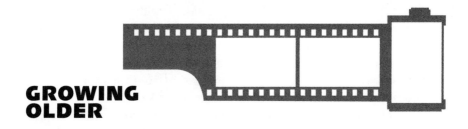

GROWING OLDER

It was always me and them. I was a young person and they were the old folks. Then one day I got up and realized I was part of them. No longer was I immune to the vicissitudes of a changing body. I began thinking of the consequences of aging, both professionally and physically. I was no longer sought out as a master school principal. No one wants to hire a seventy-year-old, even if the professional thinks that he is at the top of his game.

Physically, I had to do more to maintain a healthy body, more stretching, more warm-up and cool-down time, more vitamins, and more pharmaceuticals for a variety of ailments. I had to be careful not to fall or trip while doing my daily walking or running regimens, because now the healing and recovery times were longer if I were to become injured. But beyond staying fit and healthy, I wanted to be relevant, to matter.

My role models for aging were my Torah teachers who maintained an intellectual energy and curiosity well into their senior years. They were following the biblical prototypes of Abraham and Moses, who in their advanced years accomplished their greatest deeds. Many of them were writing, teaching, advising, not with the alacrity of youth, but with the deliberate wisdom gained through a life of learning and doing. They were still in the game.

One person, not a teacher, who stands out in my mind, is Ronald Gruen, of blessed memory, an adult student who attended my Sunday morning Talmud discussion group in Dallas, where I was a family educator for the community Kollel, an adult study entity based at a local synagogue. Ronnie was in his mid-90s and drove his own car to

class each week. Possessing a sharp mind, I could count on him to ask stimulating questions that kept the entire class engaged.

One week we were discussing the laws of finding objects in the Talmud and our obligation to return what we find, especially if the object has a sign on it indicating ownership. He raised the following question: What should you do if you find a piece of jewelry with a Nazi insignia? Are you still required to locate the owner to return the object? The answer is complex, but the question raises a moral dilemma: Is one obligated to return an item to someone who might be the personification of evil? It was a fascinating query from an elder who still provoked the teacher to think out of the box.

The movies in this section all deal with issues relating to growing old and its consequences. The stories are varied, but the challenges faced by the protagonists are similar. Many responses to advancing age are unconventional and many test the limits of good judgment. There is no panacea for aging.

THE BEST EXOTIC MARIGOLD HOTEL (2012)
directed by **John Madden**

When I turned sixty, I realized that in spite of the fact that I felt at the top of my game in terms of the skill set I brought to Jewish high school education, I was no longer perceived as such by potential employers. They wanted younger people to assume positions as school heads. I was part of the past, not the future. This is one of the reasons why living in Israel has been exciting for me. Here I can recreate myself as a Jewish educator, not as a head of school, but as a valuable piece of a larger educational entity. Here I can redefine my mission.

This is the essential narrative arc of all the characters in *The Best Exotic Marigold Hotel*, who have an emotional epiphany as they stay at a hotel "for the elderly and beautiful." *Marigold* captures the pain of growing old, its challenges, and its possible joys if one approaches this time with a positive attitude, and focuses on what one can do, not on what one cannot do.

Old age is a time of loss but also a time of freedom and redefinition. All of the main characters come to this picturesque hotel because of an attractive brochure; but, in fact, the hotel is in a state of disrepair and neglect. In a sense, the hotel is a mirror of its new guests who also are "elderly and beautiful."

Evelyn, recently widowed, is forced to sell her home to cover her late husband's huge debt, and her vacation is a reprieve from the pressures she faces on the home front. Graham, a retired judge, has come to India to find a long-lost lover. Jean and Doug come because it is an affordable vacation after giving their daughter most of their savings to start a business. Muriel, a retired housekeeper, comes because she can

obtain a hip replacement in India at a fraction of the cost in England. Madge is seeking a husband, and Norman is seeking sexual adventure and companionship.

The intertwining stories, however, share a common thread: how do we come to terms with old age, with declining physical strength, and with the knowledge that our life is coming to close? How do we deal with feeling marginalized or ignored?

All the characters in the story have an emotional awakening. Most are able to redefine their life. Some sadly cannot and remained paralyzed by yesterday's perceptions. They see, as one character says, neither light nor joy and are unable to seize life's new opportunities. There is a remarkable piece of wisdom, articulated at several points in the film, which suggests the proper approach for senior living. Sonny, the hotel manager, a young man with senior insight, offers the following perspective when things are not going well and the worst is expected: "Everything will be all right in the end. If it's not all right, then it's not yet the end."

This is a point of view that is expressed in the Talmud when the Sages tell us that whatever God does for us is for the good. It may not be apparent immediately because we see only a part of the picture. If we were to see everything from beginning to end, we would understand that, in the final analysis, from the aspect of eternity, everything is good. A conversation between Muriel and Evelyn encapsulates this philosophy in a humorous way. Evelyn observes: "Nothing here has worked out quite as I expected," to which Muriel responds: "Most things don't. But sometimes what happens instead is the good stuff."

The Best Exotic Marigold Hotel reminds us that retirement does not have to mean the end of life as we know it. It can be a time of self-evaluation, a time for redefinition, and a time for the assumption of new and worthwhile tasks. In truth, in the Bible there is no word for retirement. Abraham does not retire. He is productive until his last breath. Moses also does not retire. He is active until the final day of his life. They lead a life of purpose, in which every day has meaning. Their senior years are golden because they use them to clarify life's goals and to implement a strategy for purposeful living.

THE HUSTLER (1961)
directed by **Robert Rossen**

THE COLOR OF MONEY (1986)
directed by **Martin Scorsese**

As a youth, I played basketball every Sunday at the local JCC on the Spartans, but "Spartans" was only our name. We had a mediocre record. Opposing us were much better teams, and one player outshined everyone. Robby regularly scored over twenty points a game, and when he reached high school, he was a superstar. Watching him was poetry in motion.

I expected to read about Robby in the newspapers, but it didn't happen. Robby dropped out of college, never fulfilled his potential, and played basketball in local recreation leagues as an adult. The snapshot in time that I saw in high school was no predictor of future success. Only in retrospect do we possess clarity. That is why I chose to review two movies that present the same character, "Fast Eddie" Felson, as a young charismatic pool hustler in *The Hustler* and then as a successful liquor salesman twenty-five years later in *The Color of Money*. Watching both films gives us a rare opportunity to see the evolution of a character over a span of years. Has he changed, and if so, in what way?

There is a scene in *The Hustler* when Eddie, a pool-playing virtuoso, is told that he has talent, but lacks character. Eddie, self-absorbed and arrogant, pursues money. To him, it indicates success; and he admires Bert, a wealthy gambler. When Sarah, Eddie's girlfriend, asks Eddie how he knows that Bert is a winner, Eddie responds, "He has things." It is a

shallow perspective on life, and it takes a tragedy to remind Eddie that there are more important things than money and fame.

The Color of Money depicts "Fast Eddie" twenty-five years later, still a flawed character. He renews his passion for pool through a young protégé, Vincent; and offers to take Vincent on the road and teach him how to make money by playing pool in venues where he is unknown. Eddie still wants fame vicariously, and the temptation to hustle still motivates him.

Eddie, however, eventually begins to see in Vincent aspects of his younger self that repel him. Money is now irrelevant to Eddie; what is important to him is simply being the best and winning fairly. There is a moment when he sees his reflection in a pool ball, and what he sees he does not like. Eddie's newfound integrity reinvigorates his pool game, and his ultimate challenge is not winning a game of pool under dubious circumstances, but rather beating Vincent in a private game.

Ethics of the Fathers says that "every man has his hour" of prominence and success in life. Eddie had his in *The Hustler* and now Vincent has his in *The Color of Money*. The question we all face is what happens after our hour in the sun. Do we allow old age and self-doubt to emotionally cripple us, or do we redefine ourselves in light of our new reality? Abraham, our forefather, is a role model. The Bible tells us that "Abraham was coming in days," an unusual way to inform us that he is old. The commentators tell us that this indicates that, in spite of his age, he was vigorous and productive on each day of his life into his senior years. He never retired until God retired him. Change for him was a constant.

Making changes is never easy, but in a moment of reflection, Eddie changes his perspective and desires integrity to crown his life. Finally, he understands the maxim of King Solomon that "a good name is better than precious oil," that integrity is better than wealth.

HUGO (2011)
directed by **Martin Scorsese**

I recently had a conversation with a friend who moved to Israel ten years ago. I asked him why he made the move at the age of fifty when he was gainfully employed in a senior technology position with a well-established company. He told me that, in spite of the outward perception of his success, he saw the handwriting on the wall in terms of his professional life in America. Younger people were rising in the company who were more adept and knowledgeable, and he knew it was simply a matter of time before he was let go. That reality motivated him to move to Israel and reinvent himself here where he opened a "quickie-lube" automobile service center, which is now thriving.

I thought about my friend as I watched *Hugo*, an engrossing, imaginative story of an innovative businessman, Georges Melies, who is left behind as the world changes and technology advances. Unlike my friend, he is unable to reconcile his creative past life with a future that is changing every day, and so he becomes depressed and sad over a fate of which he has no control.

The agent of his emotional redemption is Hugo Cabret, a twelve-year-old boy orphaned when his widowed father dies in a museum fire. They had shared a love of the movies. In particular, the imaginative films of Georges Melius captured their imagination, and were the cinematic favorites of father and son.

After his father's death, Hugo is taken in by his alcoholic uncle who maintains the clocks in the railroad station, and Hugo learns how to maintain and repair them. While managing all the timepieces, he tries to fix a broken automaton, a mechanical man, which his father bought

many years ago. It is this project that animates Hugo, who senses that his father has left him a message that only the automaton can reveal. Desperate to keep his father's memory alive, Hugo steals mechanical parts to repair the automaton, but he is eventually caught by a toy store owner named Georges Melius who makes and fixes toys. Their relationship is at first tense, but when Hugo discovers that the toy store owner is the same Georges Melius, the moviemaker and creative genius who was beloved by his father, he wants to repair not just the automaton but Georges Melius as well.

We learn that Georges was a master filmmaker, who introduced clever and original special effects into his silent movies. Unfortunately, the advent of World War I changed the entertainment landscape in France, where the story takes place, and Georges is forced to sell his movies in order to survive financially. Hugo discovers that Georges actually created the automaton, which was the only surviving remnant of his creativity. Hugo, of course, possesses it and wants to return it to its creator. How he does that is the stuff of a magical movie, with exquisite art direction and cinematography, which makes *Hugo* a contemporary masterpiece.

King Solomon tells us in Proverbs that failure is part of life, but it should not paralyze us. The message to all men is to never despair after setbacks or tragedy. God may be orchestrating things behind the scenes, and one can find meaning even in the most dire of circumstances. The proper response to adversity is to learn from it, not to give in to it. When Georges Melius finally has his emotional awakening, he acknowledges his debt to a brave young man "who saw a broken machine and, against all odds, fixed it. It was the kindest magical trick that ever I have seen." The reference is both to fixing the automaton and to Hugo's rekindling of Georges's creative fire, enabling him to join the larger community of artists from which he had been detached for so many years.

Hugo reminds us to help those broken souls who need human connection, and to "fail forward" and learn from adversity rather than wallow in despair.

ON GOLDEN POND (1981)
directed by Mark Rydell

As a youngster, I often found it hard to see how older people can be in love in the conventional romantic sense. After all, physically they were often overweight, had sagging skin, and possessed grey or no hair, hardly the attributes I would consider beautiful. But when I myself got older and also began to manifest those same characteristics, I realized that seniors could be deeply in love, and physical attributes were not important. Love transcends the physical in happily married couples. In time, I understood the wisdom of King Solomon in Proverbs who, in praising the woman of the house, reminds us that "outward grace is deceitful and beauty is vain," and that the basis of enduring love is a shared life vision based on a common spiritual destiny, not the smoothness of one's skin or the size of a waistline.

This is one essential message of *On Golden Pond*, a story of a loving couple in the twilight of life. Norman and Ethel Thayer, masterly played with great honesty and sensitivity by Henry Fonda and Katherine Hepburn, return to their summer home on Golden Pond. Norman is beginning to lose his memory and in a tense and disturbing moment runs back to his cottage without finishing the errand on which Ethel sent him. He confesses to her: "You know why I came back so fast? I got to the end of our lane. I couldn't remember where the old town road was. There was nothing familiar. Not one damn tree. Scared me half to death. That's why I came running back here to you. So I could see your pretty face and I could feel safe and that I was still me."

Couples married for many years view love in ways that are impossible for newlyweds to understand. The ebbs and flows of life, the sharing of joys and sadness, bring loving couples closer together. Each represents

a safe harbor to the other, a place of refuge from a world that is shutting down around them, when mortality is not an abstract concept, but an ever-approaching reality. This deep connection only develops over time, and does not come about instantaneously.

Another message of *On Golden Pond* relates to Norman's relationship with this daughter Chelsea, from whom he has been estranged for many years. Chelsea calls Norman by his first name, which underscores the emotional distance between them. She returns to the summer cottage to celebrate her father's eightieth birthday, but she still carries baggage with her. She remembers all the times her father was absorbed in his own pursuits and not present for her emotionally.

Her mother finally rebukes her: "Don't you think that everyone looks back on their childhood with a certain amount of bitterness and regret about something. You're a big girl now. Aren't you tired of it all? It doesn't have to ruin your life." This is a valuable life lesson: Get rid of old, unpleasant memory tapes; look with fresh, unbiased eyes at your old relationships and begin anew.

Chelsea eventually does this and, after many years, calls her father "Dad," not by his first name, suggesting that she is now prepared for a new relationship with her father.

In Jewish law, a child is forbidden to call a parent by his first name. This implicitly instructs the child to be constantly aware of a parent as someone who is a source of authority, guidance, and love, not just another buddy. *On Golden Pond* reminds us to revisit our parental relationships, repair them if needed, and create new memories that will bind together generations in the future.

THE BUCKET LIST (2007)
directed by **Rob Reiner**

In the 1966–67 academic year, I was studying in a yeshiva in Israel, and in the spring I had to have a hernia operation at Hadassah Hospital. I have vivid memories of the night before the operation. My roommate in the hospital was scheduled for serious surgery and he said to me: "I wish I had what you have." It was a statement that reverberated in my mind for many years. We never realize how blessed we are until we become aware of the trials and travails of others.

People who are staying in a hospital tend to commiserate with one another simply because being ill in a health care facility can be a lonely experience. This is the opening scenario of *The Bucket List*, a touching narrative of two men from opposite sides of the track who share a common malady that brings them together in friendship.

Car mechanic Carter Chambers and billionaire hospital tycoon Edward Cole initially meet in the hospital after both have been diagnosed with terminal cancer. As they undergo their treatment, they share in brief their respective life stories and come to like one another. Carter is a family man, devoted to wife and children; Edward has been divorced four times and is estranged from his only daughter.

As they become increasingly aware of their mortality, Carter begins penning a "bucket list," a list of things to do before the inevitable end. When he shares it with Edward, Edward offers to finance a trip for both of them that will enable Carter to do all the things on his bucket list and more. In spite of his wife's protest, Carter agrees, and they begin their around-the-world adventure, visiting tourist sites in China, India, and France among other places.

Towards the end of their trip, Carter realizes how much he misses his wife and decides to return home. Back in the States, we see Carter surrounded by a loving wife and children, and Edward alone in his luxurious apartment. It is clear that Carter's life is more blessed because of his loving family.

Throughout the film, Carter expresses the wisdom of the ages. Early on in his relationship with Edward, he tells him of two questions that a person is asked at the gateway to Heaven: Have you found joy in your life and has your life brought joy to others? He encourages Edward to find the joy in his life before it is too late.

Furthermore, Carter reminds Edward that "you measure yourself by the people who measure themselves by you." In other words, when people look to you as an example of a good person, then this is a sign that you are living a life of decency and kindness. The *Ethics of the Fathers* echoes this idea when it tells us that the right course for a man to follow is to choose a path in life that is a credit to him and that earns him respect from his fellow man.

These messages of healthy living resonate in Judaism. The Bible and the Talmudic Sages tell us to love other people, for when we love others we bring joy to our own lives. It makes us less self-centered and enables us to feel happiness in the accomplishments of others. God is overflowing with kindness and so should we be. The patriarch Abraham is the exemplar of the attribute of loving-kindness in Jewish tradition. When guests came to his home, he went to extraordinary efforts to make them feel important and welcome. He gave them a sumptuous meal, even while he himself was recovering from his own circumcision in the heat of the day. The *Ethics of the Fathers* bluntly states: "If I am only for myself, what am I?" It is part of man's mission to be concerned about all of God's creatures. *The Bucket List* reminds us to live life to the fullest, to count our minutes, and to be generous to everyone.

ADVERSITY

Adversities come in all shapes and sizes. It could mean the loss of a loved one or a professional challenge. I experienced both at different times in my life.

On Thursday, January 12, 1989, corresponding to the sixth of Shvat on the Hebrew calendar, my wife Sandra died of a brain aneurysm. She was forty-four years old. A few days earlier, they called me at school to tell me that Ema wanted me home. When I came home, I learned that she had blacked out, but now she was awakening as an ambulance pulled up to our door.

Ema and I agreed that I would follow the ambulance to the hospital in case I needed a car later. I panicked when, in the middle of the ride to the hospital, the siren and the emergency lights of the ambulance went on. I arrived at the hospital to find Ema in great pain and confusion. We had an opportunity to squeeze one another's hand, and then she was wheeled to emergency services.

Then the nightmare began. Her situation worsened. I stayed in the hospital and prayed for Ema. The waiting room was filled with friends and well-wishers. But our prayers didn't work. Ema passed away on Thursday. I could not believe then nor can I believe now what happened. I looked at my youngest daughter, Chanie, and could not comprehend that she would no longer have Ema to talk to, to confide in. I was totally lost.

Having experienced the loss of my wife, which the Talmud compares to the loss of the Holy Temple in Jerusalem, I have some small under-standing of family tragedy. Jewish tradition provides rituals that help us to come to terms with the tragedy from a practical perspective and

enable us slowly to integrate our tragedy into new lives, devoid and bereft of a loved one. There is a seven-day period of intense mourning in which one stays confined to the house, then a thirty-day mourning period in which one returns to one's daily routine but still observes some mourning practices such as not shaving, and a third year-long mourning period in which one refrains from joining into public expressions of joy. After that, there is a yearly commemoration of the day of death of the loved one when charity is given and memorial prayers for the deceased are recited.

It is noteworthy that the first meal that the mourner has when he returns from the funeral includes a hard-boiled egg. This is partly done to compare the egg to the mourner. Just as the egg has no mouth or opening, so too the mourner lacks the capacity to speak. In the face of tragedy, there can only be silence, for the sadness is overwhelming. The egg, however, also contains a positive message. It is round like the cycle of life. Tragedy is a part of life, but there is life beyond tragedy. After the mourning, we do not forget our loved ones, but we need to realize that life continues and we have to rebuild after this emotional cataclysm. The egg tells us to move on, even if we do not want to.

When I think of adversities related to my professional life, I recall my own experience when I was pursuing a PhD at Georgia State University. I began in 1972 expecting it to be a five-year program. I did not receive my PhD until 1984. During all my studies, I was married, the father of several children, and had a full-time job. All these obligations made consistent study difficult and I had trouble passing one of the six required doctoral examinations. The school was ready to ask me to leave the program, but one professor, Dr. William Sessions, went to bat for me. He asked for an extension of residency for me and for permission for me to retake the problematic examination after I had taken more courses.

Thanks to his intervention and the help of God, the university gave me more time and I eventually reached my goal. Indeed, I experienced great joy and relief when I finally received my PhD.

Observing how different people cope with adversity can be instructive. Everyone is different and has different issues, but the overriding theme of many of the films in this group is the acceptance of what is and the resolve to face it innovatively and at times heroically.

110

THE VISITOR (2008)
directed by **Thomas McCarthy**

When my wife, of blessed memory, passed away over twenty-four years ago, I felt totally adrift. It was hard for me to imagine living without her. There was a temptation to withdraw from society, to seek solace in memories, and to immerse oneself in work to dull the emotional pain. However, the Torah has a different view of the aftermath of losing a beloved spouse. While it is impossible to recreate the past, the Bible clearly tells us it is not good for man to be alone. Life is meant to be shared, and the Talmud openly instructs the surviving spouse to remarry even into one's old age. To be alone as the years advance is not what God wants. *The Visitor* reminds us of the emptiness of living alone and suggests the remedies that can keep us engaged in life.

The Visitor is the story of Walter Vale, a disillusioned college professor who has recently lost his beloved wife. Since her death he has become reclusive, preferring a life of solitude. His quiet and predictable world unravels, however, when two illegal immigrants, Tarek and Zainab, a white male from Syria and a black woman from Senegal, mistakenly take up residence in his Manhattan apartment. At first he wants them to leave; but recognizing their vulnerability in being sent out at night to find new lodgings, he invites them to stay. Their sojourn in his apartment lasts many days during which a deep friendship grows between him and his tenants.

Walter develops an interest in hand drumming, which is recognized by his tenant Tarek, an accomplished drummer, and Tarek volunteers to teach him. Drumming captivates Walter, indirectly propelling him towards more human connections. He plays with a drum circle in Central

Park and shares the rhythms with people of varied cultures. The drum represents a kind of communal heartbeat which links all men together, and Walter breaks out of his aloneness to join the family of mankind.

The story takes a tragic turn when Tarek is picked up by the police and is placed in a Queens detention center. Walter intervenes and hires an immigration lawyer to help. In spite of his best efforts, Tarek is deported. Although Tarek is likely to have a grim future, Walter has been transformed by his friendship with Tarek, Zainab, and Tarek's mother. He has moved from being a solitary man to a man who wants to connect with other people. The last scene of the film depicts Walter in an underground subway station playing the djembe loudly, which metaphorically expresses Walter's new heartfelt approach to life.

Our Sages tell us "not to separate from the community." It is spiritually dangerous to be alone. Solitude can lead to depression and an unhealthy preoccupation with oneself. Therefore, it is good to be involved with others and to feel the distress of others; for one who feels another's pain shares it with him and, in a sense, lessens the emotional burden of the sufferer. Walter's attempt to help another makes him into a better man, a man who is alive to himself and to others. Moreover, the Torah tells us in many places to take care of the stranger, the one who is most defenseless in society, for we were once strangers in the land as well. This empathy for the outsider is a hallmark of a Torah personality; and Walter, a very decent man, becomes an even better man when he understands the plight of the stranger and does something to alleviate his problem. By helping others, he helps himself.

EXTREMELY LOUD AND INCREDIBLY CLOSE (2011)

directed by **Stephen Daldry**

During my years as a synagogue rabbi, I would often speak at funerals and do my best to comfort the bereaved, but it wasn't until I myself experienced a loss that I could truly empathize with the mourner. With time, we do adjust to the loss and life continues; but the shadow still remains. It is felt particularly when we have something good to share with family members, and we suddenly realize they are no longer here to share the moment with us.

When I achieved my crowning academic achievement, a doctorate in English Literature, my mother and father had already passed away; and I felt their absence acutely, for they would have enjoyed the moment with me as only a parent can celebrate the good things that happen in the life of a child. This sense of loss was intensified when I suddenly lost my wife in January of 1989. This was a tragedy of a different kind. My world fell apart. It was my personal 9/11.

Let me share a strange yet normal memory. I remember very vividly having chicken soup at the home of a friend in Israel after the funeral in Beit Shemesh, Israel. The soup was so tasty that I asked my host for the recipe so I could give it to my wife. I could not comprehend that she was no longer here.

I still can make no sense of the tragedy that affected our entire family during those dark January days. Perhaps this is why I responded positively to *Extremely Loud and Incredibly Close*, a film that deals in a thoughtful, nuanced way with the loss of a husband and father on 9/11.

The film recounts the story of Oskar Schell, a young boy whose father perishes on 9/11 in the Twin Towers. Through flashbacks, we see

the close and loving relationship that existed between father and son. When Oskar's father dies, the loss is devastating and he is inconsolable.

A year later, he explores his father's closet and discovers a key in an envelope with the name "Black" written on it. Oskar then sets out on a journey to find out what the key fits, thinking that it is a message from his father. The journey connects him with a wide assortment of people who listen to his story, often befriend him, and share life's wisdom with him.

In time, Oskar comes to terms with the reality that some things in life never make sense. His mother, suffering her own emotional pain, remarks: "It's never gonna make sense because it doesn't." That does not mean, however, that one cannot find comfort in the memories a loved one leaves behind, in the life lessons learned from a beloved spouse or parent who is no longer in this world. The mystical figure of a person falling to his death at the beginning of the film is reversed at the end. The falling image falls up instead of down, signifying that Oskar has matured, conquered his fears, and is now ready to move on with the memories of his Dad animating him as he transitions into adulthood.

What happens in *Extremely Loud and Incredibly Close* is in many ways a reflection of the Jewish mourning cycle. The initial seven-day grieving period is intense. The mourner does not even leave his home. But at the end of the week, the custom is to walk around the block, to begin a new cycle as it were. The pain is still there, but God is telling us to keep going in spite of tragedy. We will never understand the reasons for tragedy, but Jewish tradition reminds us that tragedy should not be the only thing that defines us, nor should it paralyze us as we face an uncertain future.

MARVIN'S ROOM (1996)
directed by Jerry Zaks

Both of my parents died suddenly while they were still leading active lives. I never had to think about elder care or nursing homes. It was not until a friend of mine asked me to accompany him on a visit to several assisted-living and nursing home facilities that I began to understand the dilemma that families experience when they are facing the reality of caring for a loved one who cannot take care of himself. Children want to do the right thing, but decisions are often made not by considering what's best, but by what is affordable.

There is a scene in *Marvin's Room*, a serious drama with lots of comic relief, which captures this dilemma. Two daughters, opposite in temperament, are visiting a senior care facility for their father who has been "dying for the past twenty years," and who now needs full-time attention. One sister, Bessie, has been caring for Marvin, her father, for the past seventeen years, ever since he had his first stroke. The other sister, Lee, has been absent all those years, and even now does not want to make a personal sacrifice for her ailing father. She fears that her future will be compromised and states unequivocally: "In a few months, I'll have my cosmetology degree. My life is just coming together; I'm not going to give it all up, now!"

What brings the sisters together after so many years is the sad news that Bessie has leukemia and may not be able to care for her father any longer. Bessie contacts Lee, who has two boys, and asks her to come with her kids so that they all can be tested as potential bone marrow donors. They may be able to save her life; and, as a consequence, Bessie can continue to care for their father. If Bessie dies, the responsibility

will fall to Lee. That possible scenario is the catalyst for their visit to the elder care facility.

Complicating factors is Lee's oldest son, Hank, who has been in a mental institution after deliberately burning down their house in an act of rebellion against his mother whom he hates and who he feels was the cause of the split between his parents. Hank idealizes an absentee and abusive father he barely knew, and his mother feels the brunt of Hank's misplaced anger. Family dysfunction abounds.

Marvin's Room gives us a window into the world of families faced with awesome decisions. It exposes the raw nerves of a family, both challenged and confused by an inevitable future. The film depicts two points of view, one very dark and one optimistic, suggesting that confronting the mortality of a loved one can be a stimulus for reinventing one's life and reordering life's priorities. In fact, Lee and Hank finally undergo an epiphany in which they understand that living fully means giving to others, not just being concerned about one's own needs.

The Bible exalts the commandment of honoring parents, which is defined in books of Jewish law as providing for the needs of parents, especially when they get older and cannot take care of themselves. This includes feeding them, clothing them, escorting them, and respecting them. *Marvin's Room* provides a textbook case of varied responses to a life problem facing many, and in its own idiosyncratic way reminds us that love trumps all. Family endures when children care for their parents.

THE ROAD HOME (1999)
directed by **Zhang Yimou**

Living in Israel has brought me in touch with many peo-
ple whom I met earlier in my life. Let me explain. Firstly,
many friends of my youth had a dream of ultimately living in
the holiest place in the world and now many of them are actually liv-
ing here. It is a retirement village in which no one is really retired.
Everybody is redefining themselves in some way and connecting to
the eternal past of the Jewish people, while at the same time living a
vibrant present existence. Secondly, there are others whom I meet not
because they are new immigrants in the land, but because they come to
Israel to bury a loved one. It is a place for an ingathering of the exiles,
those who are living and those who are not. When we come to Israel,
we know we are coming home in a profound way. Watching *The Road
Home* evokes comparisons to this Jewish sensibility, but emerges from
a Chinese tradition.

The title of the film *The Road Home* alludes to the journey of a man
to his final resting place. Specifically it refers to the tradition of carrying
the coffin to the grave so that the deceased "doesn't lose his way." This
is a movie about deeply held traditions that both animate and connect
people over the span of many generations, traditions that link them to
the past and to the future.

The film opens as an urban man is returning to the rural village of his
birth to bury his father, a revered teacher who brought wisdom to many
generations of youngsters. Looking at the photo of his parents evokes
a retrospective of the courtship of his father and mother many years
ago. It is a romance based not so much on physical attraction, although

there is that element, but mostly on a shared understanding of life and a common destiny.

After this poetically charged story of courtship, the film returns to the preparations for the funeral, which will require a march of several miles to the burial site in the midst of a blinding snow storm. Everybody in the village wants to participate in this tradition of escorting the dead, especially when it is a way to show respect for a beloved teacher. Their affection for him is palpable as we watch the villagers vie for the opportunity to carry the bier despite the inclement weather.

As a final mark of respect and tribute for his father, the son, on the day after the funeral, teaches a lesson in the village schoolhouse, which is about to be demolished. He stands before the children, echoing the instruction of his father. The subtitles emblazoned on the screen reveal clearly the life lessons imparted by his father: "In everything there is a purpose. Know the past. Know respect for your elders." By encouraging the students to appreciate and value the past, he assures them of a meaningful present and future. The teacher is the glue that binds the generations.

Torah values are ubiquitous in the movie. There is the value of respect for elders, the value of respect for tradition, the value of a loving relationship founded on common values, and the value of finding meaning in adversity. Ecclesiastes tells us that "it is better to visit a house of mourning than a house of feasting, for that is the end of all men and the living will lay it to his heart" (7:2). The Talmud echoes this idea because the lessons learned there are so profound and so meaningful for purposeful living. In the case of *The Road Home*, the loss of a loved one becomes the road to greater self-understanding.

UNFINISHED SONG (2012)
directed by **Paul Andrew Williams**

A friend of mine recently redid his wills in Israel. He told me he did not want to leave a mess when he died. He did not want his wife and children to be in a state of confusion. Moreover, he told me that he was concerned that some of his children did not get along with one another, and he wanted to give an equal share of his estate to each child so that none would feel more privileged than the other or in a more financially advantageous position than the other. In general, he was concerned about leaving a legacy of *shalom*, of peace in the family. *Unfinished Song* is about the last days of Marion Harris, a terminally ill woman who wants very much to leave her husband and son a legacy of peace, of reconciliation with one another after many years of misunderstanding and bickering.

Arthur Harris, Miriam's spouse, is a faithful husband but misanthropic in character. Although he dearly loves his wife, his relationship with his son is terrible. He rarely speaks to him, and when he does, it is with a critical tone in spite of his having a lovely and spirited granddaughter with whom he enjoys spending time.

Things change for Arthur when Miriam asks him to join her at a local seniors' choir group, which is preparing for a regional singing competition. He repeatedly refuses, regarding the people who do participate as misfits who have nothing better to do with their time. But then Miriam dies and Arthur is left alone with his grief. For a while, the solitude is helpful to him as he sorts out his feelings and tries to accommodate himself to his new life. Slowly, he begins to rethink the past, to recognize his shortcomings as a father, and to attempt to reconstruct his life in a way that will connect him emotionally to his son

and granddaughter. The climax arrives when Arthur decides to sing a solo with the choir to honor Miriam's memory.

By participating in the chorale and identifying with its members, Arthur opens up emotionally to the other choir singers and transforms himself from a bitter old man to one who appreciates the value of friendship and family. He even begins to have a meaningful dialogue with his son.

Unfinished Song reminds us that sometimes we are here to begin a song and sometimes to finish the song of others. The Talmud tells us that it is not our job necessarily to complete a task. All we have to do is to begin. Once we begin, we do not know where the task will lead, but the very act of starting creates a new direction, a new purpose in our lives. When Arthur finally decides to cast his lot with the choir, he begins to understand his wife Miriam's fervent desire to make the best of every available moment to enjoy life and to bring happiness to others. This realization inspires him to live with optimism and friendship.

Furthermore, the film encourages us to take to heart the words of someone close to death. What they say should be taken very, very seriously. In fact, the Talmud states that "the words of one in danger of imminent death are as if they were written and delivered." Those last words are weighty, for they are delivered when one is facing mortality. It is the last opportunity to make things right. What a person utters at those critical moments functions as a last will and testament, as a message for eternity.

THE DIVING BELL AND THE BUTTERFLY (2007)

directed by **Julian Schnabel**

There is a scene in the middle of this film that captures the essence of disability. The central character is immobilized on a vertical bench while a fly perches on his nose. He cannot swat it nor can he tell anyone else to bat it away. Finally, it flies away and there is a sense of relief. The insect is a little irritant, yet it looms large in the face of an absolute inability to dismiss it.

When I turned sixty, I began to realize that I, too, could not always rid myself of bodily pain or discomfort. It takes time and mental effort to come to terms with a changing body. I experienced little aches and pains, my daily run became more challenging, and I knew that I could no longer be casual about my health. A sense of mortality became present in my life.

This sense of mortality can paralyze someone, or spur him on to making every day count by savoring the moment and appreciating the beauty of everyday miracles. The roadmap is unclear. It is not comforting to know that one is no longer in control of his body. This difficult and painful insight is at the heart of *The Diving Bell and the Butterfly*.

The film's opening titles are placed against a backdrop of medical x-rays, foreshadowing the serious medical condition of Jean-Dominique Bauby, former editor of *Elle* magazine. As he wakes up from a coma, we see things from his perspective. Everything is in and then out of focus. He tries to talk to doctors and nurses, and we share his frustration and disappointment when he realizes that no one hears him. The doctor informs him that he has a rare condition called "locked-in syndrome," which prevents him from moving anything other than one of his eyes.

This ability to blink becomes Jean-Dominique's way to communicate with the outside world.

Realizing that he is unable to communicate to family, he profoundly regrets some of his past. To the mother of his three children whom he never married, he thinks: "I can never make amends." To the friend who spent many years in a foreign prison and who calls him when he is released, he wonders, "Why didn't I call him back?"

Slowly, Jean-Do begins to understand that, in spite of his paralysis, he can still live in his imagination and in his memory, two parts of his life that are free and unrestricted by physical disability.

All of us have seen handicapped people, but the inner struggle that goes on in their minds is largely unknown to us. We can sympathize, but we cannot really understand the overwhelming emotional darkness and isolation of one who lives daily with physical challenges. Now, through this film, we get a glimmer of understanding about life lived with physical limitations. Furthermore, it reminds us of the blessings Jews say every morning in which they thank God for the fact that each part of the body is working. We thank God that we can see, that we can walk, that we can go to the bathroom and relieve ourselves. No aspect of our physical life is to be taken for granted.

When a dear friend of mine would be asked how he was doing, he always responded, "Thank God, fantastic." He did this because he truly felt thankful for the everyday miracles with which he was blessed. Watching *The Diving Bell and the Butterfly* will make you appreciate life more. Do the math and count your blessings.

THE IMPOSSIBLE (2012)
directed by **J.A. Bayona**

I once landed in Ben Gurion Airport in Israel without a working cell phone. I had contracted with a car service to pick me up, but time was passing and the driver was nowhere in sight. I began to get panicky because of my inability to contact my driver, and decided to ask someone to borrow a cell phone. The first person I spoke to told me he could not lend me his cell since it was running low on power and he needed to conserve power to insure that he could contact his family. The second person I addressed happily lent me his phone and I was able to reach my driver.

I thought of this incident as I watched a scene in *The Impossible*, a gripping narrative of a family's survival after being caught in the deadly 2004 tsunami in Thailand. Swept along in a flood, the Bennett family is separated. Husband Henry, mother Maria, and sons Lucas, Tomas, and Simon are tossed by powerful waves and wind up isolated from one another. Henry desperately wants to make a phone call to determine the safety of his family. At first, he is rebuffed by someone whose cell phone is low on power; but a second request is answered and Henry can finally make his call. It is a touching scene that reminds us how important is the kindness of strangers when one is in dire straits.

Maria and Lucas soon find one another and set about to locate a safe haven. However, Maria spots a small boy alone crying for his family. She insists that they rescue him in spite of Lucas's protestations that this detour will place them more at risk. Maria reminds him that the child could have been their missing sibling and Lucas acquiesces.

Kindness in the face of adversity is a central theme of *The Impossible*. When Maria is finally found by locals and taken to the hospital, she

encourages Lucas to help reunite families. Lucas collects names and tries to match them as he scours the crowded hospital corridors. When someone recognizes a name he has called, Lucas is overcome with joy, a joy that intensifies when he actually witnesses a father and son reunite. As his search to bring together family members continues, Lucas moves from focusing on self to focusing on others.

There is a compelling story in Genesis in which Abraham prays for Abimelech, king of Gerar, who, thinking that Abraham's wife Sarah was his sister, took Sarah into his royal home. As a result, the Bible tells us, all the wombs of Abimelech's household were closed and no one could bear children. Abraham prayed that they be healed and they were.

The next section of the Bible details the story of the birth of Isaac, who was born to Sarah at the age of ninety after many years of infertility. The great medieval commentator Rashi, quoting a passage in the Talmudic tractate of Baba Kamma, states that the juxtaposition of these two narratives teaches us that if someone prays for mercy on behalf of another when he himself needs that very same thing, he is answered first. This conceptually represents what happens to Lucas. When he shows compassion for others and is concerned for their welfare, he himself is rewarded with the survival of his own family.

The Impossible depicts the chaos that surrounds any rescue mission after a large natural disaster. Survivors search for loved ones, identities are confused in the ensuing hours and days, and medical help is hard to find. The narrative of the Bennett family reminds us of the enduring bond between all survivors of a catastrophe and of the need to be involved with the destiny of all, not the destiny of one.

WAR OF THE WORLDS (2005)
directed by **Steven Spielberg**

During the Cuban Missile Crisis of the 1960s, I was taking a philosophy course at Yeshiva University. Students felt that there was real possibility of a nuclear holocaust, and my malaise was deepened when my Philosophy professor ended his Thursday class by saying "See you on Monday if there will be a Monday." I remember asking one of my Judaic studies teachers what would happen to the Jewish people in such a doomsday scenario. He told me that the Jews might suffer as well as the rest of humanity; but that there would always be a remnant of the people left, for God's covenant with the Jews was eternal and the Jews would never totally disappear from the world. The only appropriate action we could take now was to do good deeds and pray for peace.

These memories percolated in my mind as I watched *War of the Worlds*, a story of what might happen if a malevolent extra-terrestrial force were to target the earth for destruction. The film opens as Ray Ferrier, a divorced dad, picks up his children, Robbie and Rachel, from his ex-wife who is going on a weekend vacation with her husband.

Ray has a very small parenting toolbox; and while he enjoys spending time with his kids, he has little idea of who they are and what makes them tick. His parenting skills are tested when calamity strikes. Soon after they arrive at his Bayonne, New Jersey home, unseasonably strong winds and lightning set the stage for a Martian invasion of the earth. Martian tripod killing machines emerge from the bowels of the earth and incinerate everything around them. Ray, in a panic, flees to Boston with his children in one of the only remaining working vehicles, hoping

to find sanctuary in the home of his former in-laws where their mother is staying.

Scenes of death and destruction traumatize Rachel; and when they find temporary refuge in a deserted building, she asks her father to sing her a lullaby so she can sleep. Ray doesn't remember any lullaby, but he manages to sing a song that calms her. Ray realizes that in times of crisis, family comes first. The safety of loved ones trumps all other considerations.

Jewish tradition fosters a similar mindset. It is the family that is the bedrock of stability that enables one to endure the storms of adversity. The Bible emphasizes that when the Jews went down into the iron furnace of Egyptian slavery, they went down as families; for it is within the family unit that people can find safe haven and it is within the family where lifelong values are nurtured.

There is a well-established family custom that Jewish parents bless their children regularly. Some do it once a year on Yom Kippur, the holiest day of the year; others do it every Friday night. It was my own custom to do it once a year, but in recent years I wished I had done it weekly. To look into your children's eyes once a week, to utter a blessing to your son and daughter, and then to hug and kiss them, seems an exquisite pleasure for a parent. Why do it only once a year? Kids leave home when they grow up, but the memory of an embrace, of a heart-to-heart moment of love, leaves a bank account of affection that can draw interest for many years.

My children and I live in different communities now, but my children often call me on Friday to ask for by blessing. I cannot hug them from Israel, but I can tell them I love them, and that means a lot to them and to me.

War of the Worlds reminds us that in times of crisis, family comes first. It is wise to nurture family ties with our young children so that we all can enjoy the warmth and constancy of our mutual love as we and our children grow older together.

SPARTACUS (1960)
directed by **Stanley Kubrick**

In my teaching of English language and literature, I discuss with my students six traits of good writing. One of those is *voice*, which means that when you write, you have to make it personal. People who read what you write should sense a vibrant, interesting intellect emerging from the words. Otherwise, the prose is forgettable. The same idea holds true in movies as well. Large battle scenes and vast landscapes by themselves do not mean much. It is only when they are the background for a distinctively human struggle that you pay attention to the dialogue. Therein lies the greatness of *Spartacus*, the movie.

As a young boy, my mother took me to the movies to see biblical epics like *The Ten Commandments* and *Samson and Delilah*. They were fascinating and enjoyable, but none presented me with people to whom I could relate. They were pseudo-history lessons and did not touch my heart. Indeed, movie epics did not touch my emotions until I saw *Spartacus* in 1960. It was a game changer in my eyes, because the hero was someone with whom I could identify – his wife was beautiful, wise, selfless, and they were both devoted to a higher and noble cause. Moreover, I watched the scenes of combat and I witnessed up close the varied faces of people, young and old, who fought those battles. I cared about their fate. Spartacus's struggle for freedom against overwhelming odds resonated deep within me.

The story begins in Rome in 73 BCE when Spartacus, a Thracian slave, is brought from Libya to Italy to join a school of gladiators. It is there that he meets Varinia, also a slave, and they fall in love.

On one fateful day, a Roman general visits the school and, for his

entertainment, requests two gladiators to fight to the death, one of whom is Spartacus. His Ethiopian opponent refuses to kill him, and the Roman general kills the black gladiator for this insubordination. Spartacus's hatred for oppression seethes, and soon after he leads a slave rebellion against their Roman masters. In his campaign against the Roman army, he frees hordes of slaves along the way, who decide to join his army. Spartacus is successful at first, using guerilla tactics to defeat a number of small Roman armies. But eventually, Rome decides to make a priority of annihilating the forces of Spartacus. Rome enlists the military might of two legions of Roman soldiers to put down the rebellion and destroy both the man and the legend of Spartacus. In the penultimate battle, Spartacus's army of slaves consisting of men, women, and children is slaughtered, and the rest are crucified along the Appian Way.

When Spartacus is asked by his comrade shortly before his death if it was worth it, he responds affirmatively. Although he may die, thousands after him will be born free men. He lives and dies in the present, but his idea of freedom for all men transcends generations. Remarkably similar to this is a story told to me by one of my Torah teachers. After the Holocaust when so many Jews perished, he related to me that he saw himself as a messenger transmitting a message for posterity. From the aspect of eternity, his life's mission is to transmit Torah values to subsequent generations. He is especially cognizant of his responsibilities as a messenger of his father and mother who imbued him with a passion to teach the morality of the Bible. He senses the presence of his parents at all times, and feels charged to perpetuate their memory by teaching Torah wherever and whenever he can.

Spartacus on one level is an exciting narrative of a slave revolt. More importantly, his story reminds us that potentially we all are messengers and exemplars of noble living that can influence future generations.

FIRST BLOOD (1982)
directed by **Ted Kotcheff**

As a senior at Yeshiva University in the 1960s, I solicited ads for the annual yearbook. Since I had recently purchased a Volkswagen, I asked the dealership for an ad, and they readily agreed. I sent in the ad with the check, and a few days later received a letter from the yearbook editor informing me that he had to return the check and could not include the ad. Why? Because there were many Holocaust survivors who would be upset that Yeshiva University would run an advertisement for a German company.

The incident was eye opening. I simply was getting an ad, but in the eyes of others who had suffered at the hands of the Germans, my innocent act was perceived as ignorant and insensitive. I quickly became aware that there was a vast gap between my perception of Germany and that of others who had been victims of German cruelty. Someone who has suffered and endured unspeakable horrors responds differently than someone who has not. The tourist sees tragedy one way, the resident another. For the resident, it is real, not theoretical.

Those different perceptions inform *First Blood*, the movie that introduced John Rambo to film audiences. His story begins after the Vietnam War as he journeys to the American Northwest in search of an army buddy. His unscrubbed appearance makes him look like a drifter and he is arrested as a vagrant by the local sheriff, who judges only by appearances. The long-term effects of the Vietnam War are not on the sheriff's radar screen. To him, it is ancient history. But to Rambo, it is not. At the jail he is harassed and brutalized. The sight of a razor about to shave him while he is being restrained evokes a memory of his torture at the hands of the North Vietnamese. He responds by bolting

from his captors and escaping to the mountains on a stolen motorcycle. Only later does the sheriff learn that Rambo is a former Green Beret, an elite Special Forces soldier who was awarded the Medal of Honor.

What makes *First Blood* special is its portrayal of the aftermath of war – the emotional scars that remain on a person after the battles are over. In a touching scene in which Rambo shares his pain with his former commander, he agonizingly laments about the dissonance between now and then: "Back there I could fly a gunship, I could drive a tank, I was in charge of million-dollar equipment, back here I can't even hold a job parking cars!" He cries over the loss of a close friend who was blown up by a shoeshine box that was wired with explosives: "The box blew his body all over the place. There were pieces of him all over me. I couldn't find his legs." These experiences remain with Rambo long after the guns have been silenced. The memories are part of his DNA for the rest of his life.

Three lessons clearly emerge from Rambo's trial by ordeal. First, the experience of war is a game changer in the psyche of man. It leaves wounds that are not always visible, but nonetheless inform a person's behavior and thinking. We need to understand this when relating to people who have endured such adversity. Second, never judge a person by appearances alone, the way the sheriff judged Rambo. Jewish wisdom literature reminds us: "Do not look at the bottle, but at what is inside of it." Third, judge every man favorably, say our Sages. When we assume the best about others, our own lives will be enriched.

APOLLO 13 (1995)
directed by **Ron Howard**

In reflecting on my career as a high school principal, I recall many board meetings in which a few board members would panic if the enrollment did not go up every year. That statistic alone was the acid test, and a low enrollment number on any given year would be the catalyst for extensive discussions about what was wrong with the school and what we needed to do to fix it.

Fortunately, most board members took the long view and saw the inherent complexity and difficulty of establishing a Jewish day high school in a city that never had one. Thankfully, they supported me over the years in building Yeshiva High School of Atlanta.

Panic in the face of adversity is not a good response, and I was reminded of this truth as I watched *Apollo 13*, a classic film about one of America's early space flights in 1969.

"Life is not a straight line," a friend once told me when I was dealing with a lot of things that were going wrong. The key is to stay focused at moments of crisis. Rather than lose one's cool, concentrate on how to solve the problem.

The tag line for the film is "Houston, we have a problem," and they do have a serious problem. After months of preparation, the crew, led by Commander Jim Lovell and assisted by Fred Haise and Ken Mattingly, is scheduled to fly to the moon. Two days before the launch, Mattingly is compelled to withdraw from the mission because he has been exposed to measles and he has never had them before. The possibility that he could become ill during a crucial part of the flight disqualifies him; and Jack Swigert, an astronaut who has been out of the loop for

many weeks, is asked to fill in for Mattingly. Lovell decides to accept the substitute rather than wait for another turn to fly to the moon.

The problem is compounded once the astronauts leave earth. While in flight, Jack Swigert performs the routine procedure of stirring the oxygen tanks and the oxygen tanks explode, causing a mechanical failure. Now the mission is not to land on the moon, but to get home safely.

The two characters who stay focused and don't lose their cool are Jim Lovell and Flight Director Gene Kranz at mission control in Houston. Aiding them is Ken Mattingly, who simulates what is going on in the space capsule in order to give the Apollo crew the best advice to stay alive. These three men, who are very bright and who fully identify with the Apollo crew, think creatively to come up with solutions that will enable the men to re-enter earth's atmosphere and arrive home safely.

The Bible is filled with examples of people who, when faced with negativity and bad karma, rise above the problem and find a way to succeed. Joseph, son of Jacob, is one role model. According to a Midrash, he is left in a snake-filled pit by his brothers. He then is sold as a slave in Egypt, and later finds himself in prison where he languishes for a number of years. During all that time, he does not give up and surrender to his environment. Instead, he finds a way to survive and eventually he is catapulted to the position of viceroy of Egypt. He does not look at the present dark moment as forever. Rather, he sees beyond it. He knows he has a mission, and in his own quiet and deliberate way works to actualize a bright future.

Apollo 13 affirms that same message. When things go awry, do not collapse. Instead, analyze the situation and develop a strategy for success.

TAKEN 2 (2012)
directed by Olivier Megaton

I was recently eating at a restaurant with friends when one of them pointed out to me that my eyes were riveted on the big picture window behind him and not on him. He felt I was not paying attention to him. I apologized for my wandering eyes and asked for his forgiveness. I was grateful to him for rebuking me. I realized that having a conversation with someone does not just mean being in the same room with someone and talking. For anything meaningful to happen, I have to be emotionally engaged with what my friend is saying. I have to be aware not just of words, but of nuances in speech, in gestures that accompany words, and in body language as well. These critical issues of active listening and being aware of one's surroundings are crucial in the action thriller *Taken 2*.

Brian Mills, an ex-CIA agent, invites his ex-wife, Lenore, and daughter, Kim, to spend some time with him in Istanbul. Unbeknownst to him, he is being targeted by a group of Albanian terrorists who want to take revenge for the death of family members who were killed by Brian in past operations.

Once in Istanbul, he and his wife are taken by the terrorists, and Kim is his only lifeline to rescue. In a tension-filled scene, he gives Kim instructions that are critical to saving his life and the life of her mother. Kim must go to his hotel room, find his suitcase, remove the gun and several hand grenades from inside the suitcase, and then throw the hand grenades in designated areas free of human traffic. All this is done so that Brian can track his whereabouts by listening carefully to the sound of the explosives. The louder the sound, the closer is Kim and

rescue. Kim listens to her father with great concentration because she knows his life depends on it.

As I watched this violent, farfetched but entertaining yarn, I thought of how critical it is to pay attention when listening to others. Brian is an experienced CIA agent. He knows how to listen and how to be aware of all sensory information. When he is first seized and blindfolded in a car, he can sense his location because of the various street noises that he hears and because he can determine distances by measuring his travel time from one destination to the next. He listens with his mind as well as with his ears. He is not just passively noting noises – he is paying attention, and this is much different from merely hearing sounds.

In Jewish law, there is much debate about the difference between merely hearing something and paying attention to what you hear. The laws pertaining to the proper performance of prayers is where much of this discussion takes place. Is simply reciting prayers sufficient or must you be mentally engaged with the words as well? According to some authorities, if one simply hears the words but does not pay attention to their specific meaning, he has to repeat his prayers, since words without thought are meaningless.

Merely mouthing words without intellectual or emotional investment, without eye contact, is valueless. If we want to communicate important feelings, if we want to learn subjects deeply, if we want to connect with other human beings in a serious way, we have to be good listeners. We cannot simply nod our heads when someone is talking to us. We have to actively listen and take in what the other person is saying. Without listening attentively to others, we miss what they say and fail to deepen our relationships with our friends, our neighbors, and our loved ones. When we pay attention and not merely listen, we enrich our lives and the lives of others.

TOY STORY 3 (2010)
directed by **Lee Unkrich**

Many years ago, I hired what I thought was a star teacher. He gave an excellent model lesson, had good references, and even played the guitar. Yet I soon discovered a serious flaw. He never wanted to deal with parents. It seems that, once long ago, he was abused verbally and emotionally by an insensitive school parent. The repercussions of that event still lingered and colored his approach to all parents. He was still angry with them, for they were the enemy. Ultimately, I had to let him go because our school welcomed parent engagement and did not see parents as adversaries.

The experience reminded me that sometimes we let a bad experience define how we behave in the future. In truth, it is a great tragedy if we cannot move beyond a hurtful experience, if we permit anger and ill will towards others to dominate our lives.

Toy Story 3, an animated film that is a parable of human relationships, provides one classic example of this through the character of Lotso, the chief toy in a day care center full of dysfunctional and malevolent toys that lord over the new recruits who come to Sunnyside Day Care. Lotso has allowed a bad experience in his youth to forever taint his relationships with anyone he meets. The backstory reveals that Lotso was also once a treasured toy, but his owner abandoned him, or so Lotso thought. In truth, she lost him and did not deliberately abandon him. Lotso, however, lived on the false myth of his abandonment and made that bad experience the seminal one in his life. Anger was what drove him and defined him.

Into Lotso's monstrous world enter a group of naïve toys, who fear obsolescence when their owner, now grown up, departs for college.

They fear abandonment, but take heart in the possibility of finding a warm and friendly environment in a local day care center. From a distance it looks attractive. But a closer look reveals that the ownerless day care toys are not only used but abused. The kids at the day care do not feel any emotional connection to the toys. The children play with the toys and then toss them away. In contrast, the new recruits, accustomed to an owner who had invested in a relationship with them, want in some way to replicate that situation. They want to feel valued, emotionally connected, and respected. The toys are truly us.

Their first impression of Lotso is positive. He is soft spoken and huggable on the outside, but they do not realize he is an angry monster on the inside. His past anger has determined his future.

Jewish tradition tells us that anger is one of the worst traits to possess. In fact, the Talmud compares it to idol worship. When one is angry, it is a manifestation of a lack of belief in God's providential supervision of the universe. After all, how can one be angry if God is in charge of things? It is a Jewish mode of sensibility to presume that, from the aspect of eternity, everything ultimately will make sense because God is orchestrating events in a hidden way which our finite minds cannot comprehend at the moment.

Lotso, whose life is defined by anger, reminds us not to allow negative memory tapes of the past to determine our present or future. It is a bad thing when anger lives rent-free in our brains and influences our present relationships.

TRISTAN AND ISOLDE (2006)
directed by **Kevin Reynolds**

When I was a synagogue rabbi, a very agitated young man once confessed to me that when his girlfriend revealed that she was pregnant, he broke off his relationship with her and told her to get an abortion. Now, several months later, he was overwhelmed by guilt. Life had moved on; he could no longer correct the situation, and he was very depressed and upset with what he did. Despite his insensitivity, his irresponsibility and his moral weakness, I intuitively understood he needed to feel that all was not lost. It was important to transmit the message that failure is not terminal. You can make terrible mistakes, but you can perform redemptive acts that mitigate punishment. This is an important life lesson.

Tristan and Isolde deals with young people who make grave mistakes in judgment and the consequences of those mistakes. It is a tragic love story that takes place in medieval times when war raged between the British and Irish. The English are divided into clans and are routinely attacked and killed by the Irish. Lord Marke of Cornwall plans to unite the various tribes of Britain by becoming king and leading a united people to victory over the Irish. Marke is respected by most of the lords; his courageous demeanor in battle adds to his luster and the promise of his inspiring leadership.

Joining him in battle is Tristan, an orphan boy, who was saved from certain death by Lord Marke. Tristan is a loyal and brave warrior and fulfills Marke's expectations as his heir apparent. But in a fierce contest with the Irish, he is wounded by a poisoned sword, and assumed to be dead. His funeral boat washes up on the Irish coast, where he is found by Isolde, the king's daughter, and her maid. Slowly, he is nursed to

health and Tristan and Isolde fall in love. However, circumstances force him to return to Britain.

Through a series of events, Tristan is reunited with Isolde in Britain, but she is now promised as a wife to Lord Marke by her father. She reluctantly goes through with the wedding, but the love that began on the shores of Ireland runs deep. Passions rage and Tristan and Isolde begin an illicit relationship that both know is doomed.

From the beginning, they are conflicted. Tristan says "I feel on fire and a guilt I can't comodify." Isolde agonizes: "Why does loving you feel so wrong?" It is a tortured relationship, in which two souls are divided by loyalty to a dear friend and benefactor, Lord Marke, and a burning desire to forget all moral boundaries and commit to loving one another in spite of what people say or think.

Lord Marke recognizes that their commitment to one another pre-dated his marriage to Isolde and, in a magnanimous gesture, offers them an opportunity to escape together. At that moment, however, Tristan understands what is at stake for Lord Marke and the nation. He sends Isolde away, reminding her that if they were to flee together "for all time people would say it was our love that brought down a kingdom." Duty triumphs over personal feelings and Tristan joins the battle against the Irish, ultimately sustaining a mortal wound.

Our Sages tell us that one hour of repentance and good deeds in this world is better than the entire life in the World to Come, and that one can acquire eternal life in one moment of repentance. The sin of Tristan and Isolde cannot be dismissed. It is an egregious moral fault. But while we are alive, we can still influence our spiritual future. One selfless act, even one committed by a sinner such as Tristan, can change our eternal destiny and the destiny of others.

RISE OF THE PLANET OF THE APES (2011)

directed by **Rupert Wyatt**

A friend of mine has two dogs. Whenever he and his wife go on vacation, they place the dogs in what is essentially a dog hotel, where they will be fed, walked, and cared for while their owners enjoy their time off from work. Several months ago, one of the dogs died and my friend went through a genuine grieving experience. He was depressed, very mellow instead of his usual upbeat self, and generally quiet as he processed his loss. When I spoke to him, I felt that the dog was not just a dog to him, but functioned like a human friend, always there with him in times of trouble to comfort him and provide a beacon of light in dark times. The dog was a real companion that made his life more positive, happy, and fulfilling.

The human dimension of animals, that part of them that connects to our humanity, is the subtext of *Rise of the Planet of the Apes*. Will Rodman, an entrepreneurial scientist, works at a genetic therapy pharmaceutical company developing a drug that may heal mental disorders such as Alzheimer's and Parkinson's. There, apes are used as test subjects for experimentation on gene therapy that will improve brain function. A byproduct of this research is that the chimpanzees used as the test subjects become more intelligent, more like humans in the way they think and behave, and this endears them to humans who like animals. To Will Rodman, the apes become companions, not just subjects of experimentation.

Will convinces his boss that he has enough data to proceed with human trials for the drug after getting promising results from apes. When one of the apes subsequently displays violent behavior, Will's research team is directed to put down all the apes. Will then breaks protocol

when, instead of putting down the last baby ape as he is instructed to do, he brings it home and rears it in his own home, where he lives with his Alzheimer's afflicted father.

The baby ape, Caesar, makes amazing intellectual progress and is able to communicate complex ideas. As the mental state of his father deteriorates, Will decides to steal some of the drug that he has been using with Caesar in the hope that it can reverse his father's malady, which it does for a limited span of time.

Five years elapse and Caesar grows physically as well as mentally. But he cannot always understand the physical cues of humans. This leads to violent behavior by Caesar when he sees people threatening those about whom he cares. Eventually, his aggressive actions cause him to be placed in an animal sanctuary where he meets other apes. There he begins to develop a cohort of apes who want to rebel against their human masters.

There is a concept in Judaism that one should not commit a sin in order to do a good deed. This, in fact, is what Will Rodman has done. He has abandoned scientific protocols in order to run tests that he hoped would cure Alzheimer's and bring relief to his father and to millions of others. His goals were laudable but the means reprehensible. This is similar to a dilemma in which many of us find ourselves: Do we follow the rules when our personal interests are at stake in doing so?

An example from my principal days: A girl in our high school was discovered with drugs in her locker. There was a school rule that any student who is caught with drugs at school is expelled. Her parents, generally supportive of the school, wanted me to make an exception to the school rule, arguing that if I expelled her from the school it was likely to be the end of her Jewish education. Moreover, it would foster relationships with other troubled teens. Inwardly, I knew that if I did not expel her, I undermined the school rule prohibiting drugs and sent a message to parents that in matters of health and safety, the school was indecisive. After some brief thought, I concluded that the school clearly had to be decisive. It was critical that parents trusted the school to look out for the well being of the students. And so I expelled the student despite the pleadings of her parents and social workers who felt breaking the rule in this case was justified.

Making exceptions to rules is risky business. Our Sages tell us to always consider the ripple effects of our actions. It is from the aspect of eternity that all our present decisions are ultimately judged.

THE INCREDIBLE SHRINKING MAN (1957)
directed by **Jack Arnold**

In 1957 I was enrolled as a boarding student in a Jewish high school on the edge of Harlem in New York City. The father of a fellow student, visiting from out of town, invited me to join him and his son for dinner at a downtown restaurant. The dorm counselor was nowhere to be found, so I could not ask anyone for permission to leave campus. I decided to join them anyway and began to think of an excuse to give the dorm counselor in case he rebuked me. *The Incredible Shrinking Man* had just opened and the perfect excuse came to mind. I will tell him that I went to the local movie theater to see this film about a man who shrunk in size. It seemed like an easy plot to summarize and so I would not be penalized for traveling outside of the local neighborhood. And that is what transpired. The excuse, weak as it was, worked.

Little did I realize when I actually saw the movie several months later that it was much more than a film about a man who shrinks in size; rather it was a profound meditation on the ultimate meaning of life. Watching this black and white science-fiction movie fifty-seven years after it first appeared, I genuinely admired not only its special effects, which were progressive for its time, but also its thoughtful commentary about man's place in the universe. Let me elaborate.

Scott Carey, on vacation with his wife Louise on his brother's boat, sees a strange fog, which is really a radioactive mist, glide over the boat leaving a wet sheen on his body. Six months later, Scott senses that his clothes are becoming loose on him and that he is losing weight. The sudden weight loss prompts him to visit his physician, who assures him that nothing is wrong. However, a subsequent examination

does confirm that Scott is, in fact, losing vital chemical elements and is actually shrinking in size. In an unsettling scene, husband and wife discuss the implications of this malady for their marriage. At the end of the conversation, Scott's wedding ring falls off because of his shrinking finger size.

As time passes, Scott continues to shrink to the size of a child. Since Scott is no longer able to work, they have mounting bills. As a result, Scott sells his story to the press, who treat Scott as freakish pop phenomenon. Louise tries her best to be optimistic and encourages Scott not to lose hope. However, after many tests, the doctors conclude that there is no remedy and Scott runs out of the house in despair.

In his wanderings, he meets a dwarf, Clarice Bruce, who tells him that being small does not mean life is over and devoid of happiness. The message is uplifting for Scott, who embraces her perspective on life until one day he sees that he is shrinking again and is even shorter than Clarice.

We next see Scott, only a few inches tall, living in a doll's house. When his wife Louise leaves to go shopping, she inadvertently leaves the door open, allowing a cat to enter the house. This creates a life or death situation for Scott, who runs for his life to avoid the clutches of the cat. He accidently falls into the basement after the cat scratches him. Louise, finding a piece of Scott's clothing with blood, presumes that Scott is now dead.

Scott slowly regains consciousness, and begins to search for food in a hostile environment where a common spider becomes his arch-adversary. The life-and-death fight between them is intense, and Scott emerges from it wiser and more accepting of his place in the cosmos as he gazes at the stars above. His final words are both haunting and uplifting: "To God, there is no zero. I still exist."

Scott's malady can be viewed as a metaphor for any life-altering illness. News of such an event is often frightening and potentially depressing. Therefore, it is noteworthy that Scott, now a speck in the infinite universe, draws comfort from the knowledge that in God's eyes he still counts. In Jewish tradition, man is composed of body and spirit. While the body is subject to the vicissitudes of nature, the spirit is not. *The Incredible Shrinking Man* is a clarion call reminding men of their infinite value, even when faced with imminent mortality.

RAIN MAN (1988)
directed by **Barry Levinson**

My sister Carol had Down's syndrome. As a little boy, I would fantasize about becoming a doctor and being able to transform Carol into a normal person; but as I grew older I understood that my hopes for Carol were only a dream. Over the years I tried to be a dutiful brother, especially after my parents passed away. When my own children were of age, I explained Carol's situation to them and they were always warm and accepting of their aunt, who always had a sweet smile for them whenever she saw them. I often reminded my kids of how fortunate they were to possess a normal intellect, with the potential to learn so much knowledge. Why things happen is ultimately unknowable, and we need to reflect that there but for the grace of God go I.

Rain Man tells the story of two siblings, Charlie Babbitt who is normal, and Raymond Babbitt, an autistic "savant" who has been institutionalized. Charlie is very self-absorbed, immersed in a world of money and materialism. When Charlie learns that his estranged father has died, he travels to Cincinnati for the funeral and to settle the estate. There he learns that all he will receive from the estate is a classic Buick Roadmaster, while an undisclosed beneficiary will inherit three million dollars. The beneficiary turns out to be the mental institution where his brother Raymond lives, a brother of whose existence Charlie was never aware. Charlie kidnaps Raymond from the institution in the hope of forcing the trustee of the funds to make a settlement with Charlie for half the inheritance. Thus begins their cross-country trip together.

In the course of their trip, Charlie observes Raymond's fixation on ritual as a calming mechanism in the face of change. Raymond must

watch certain TV programs, he must go to bed by 11 PM, and he must have pancakes for breakfast on specific days. At first Charlie thinks this is a massive charade and feels he can correct Raymond's behavior. Over the course of their journey, however, he learns that Raymond's autism is not subject to a quick fix. His routines provide stability, and any deviation potentially creates chaos for him and those around him. For example, Raymond refuses to fly on an airline unless it is Quantas, which has a zero crash record. The problem is that Quantas does not fly from Cincinnati to Los Angeles. This is the catalyst for the car trip across America, a shared experience that bonds the two brothers together, ultimately resulting in Charlie's recognition that, in spite of his brotherly love, the people and the institution in which Raymond lives are best equipped to care for him.

As a young rabbi, I remember my own naïve arrogance when I thought that I could fix all problems. In retrospect, I realize the delusion of my youth. It was not until years later and encounters with people in the real world that I understood that there are occasions when I did not have all the answers and that I had to call a professional for guidance.

Perhaps one of the lessons we learn from people with disabilities of all types is to be appreciative and grateful for our own normality. In fact, I told my children that when we see people with a visible abnormal appearance, we recite a blessing: "Blessed are You, God of the Universe, who makes creatures different." It could be that the Sages who formulated this blessing wanted to convey the message that all humans, no matter what their intellect or appearance, are creations of God imbued with an essential sanctity and infinite value. *Rain Man* reminds us of this truth.

BOILER ROOM, (2000)
directed by **Ben Younger**

My wife and I have bought a few homes in our lives. Each purchase probably represented the largest purchase we made until that point in our lives, and the down payment represented much of our savings. However, we, like many others, bit the bullet and made the purchase on the assumption that our income would grow, which would eventually enable us to pay the mortgage. Sometimes we made money on the sale of the house and sometimes we lost money. Over the years we have become philosophical about ups and downs in money matters. We cannot control the housing market and, in the final analysis, God is in charge and whatever happens is for the best even if we don't always see it in the short term. Nonetheless, the purchase of a home can be a stressful moment in the life of a family.

Nowhere is this more evident than in an excruciatingly painful scene in *Boiler Room*, a coarse, profanity-laden look at the world of young stock brokers who cold call customers with promises of big returns on their investments. One call goes to Harry Reynard, a family man who gives $50,000, his entire savings for a house, to Seth Davis in return for what is essentially worthless stock. We watch in agony as Seth lies to his client in order to make the sale. Harry buys the dream and loses his money and family in the process. It is a gut-wrenching scene to watch.

Boiler Room, based on real-life accounts of stockbrokers, is very disturbing. Young men are schooled in how to lie to clients in order to make big profits for themselves. There is a culture of conspicuous consumption at the firm. Successful brokers buy expensive cars, the latest techie gadgets, and have neither heart nor soul. They make a pact with the devil and revel in it at the unsuspecting client's expense.

Seth Davis, the narrator of the story, is the son of a judge, and even though his relationship with his father is turbulent, he understands the ethical problems with his new job. He is torn between financial success and moral responsibility. Ultimately, it is the relationship with his father that moves him to try to make things financially right for Harry, his desperate client, and ethically right for himself.

Boiler Room reminds us of the perils of living a life in which the only goal is the acquisition of more and more things. People become objects to exploit, not good friends and neighbors. The *Ethics of the Fathers* tell us that the truly rich man is the one who is content with his lot, who does not spend night and day trying to amass wealth. Wealth in Judaism is a means, not the end goal. Wealth enables us to help the needy, to welcome guests to our table, and to support community institutions and worthy causes of all types. Wealth is to be shared, not hoarded. The Book of Ecclesiastes states: "The lover of money will never be satisfied with money; a lover of abundance has no wheat." The acquisition of worldly goods is ultimately futile. Only good deeds accompany a man to the grave.

There is another lesson in *Boiler Room*. Harry purchases the worthless stock without consulting his wife. Our Sages tell us, in reference to a quandary of Abraham, that he should consult with his wife Sarah. The spouse who loves you and has your best interest at heart should not be ignored when making major decisions in life. It is important to "listen to her voice," as the Sages say. A pow wow with a loved one reinforces peace in the home.

HEAT (1995)
directed by **Michael Mann**

We are blessed with many friends. Being in the synagogue rabbinate and serving as a school principal, we have always had many guests at our table and it has always been a joyous experience, for it afforded my family and me the opportunity to make many friends.

However, I have had few close friends. My immediate family members have always been my best friends. They were the people with whom I wanted to spend my free time.

But once I made *aliyah* and redefined myself as a teacher, not the man in charge, our guest list in Israel shrank. Instead of inviting congregants, students, and their families, we now mostly invite friends. At first this was strange to me since I perceived myself as a community figure whose mission it was to connect with congregants, parents, and students and encourage them to move further along the path to religious observance. Now I just had to be a good friend. It was as simple as that.

My wife, Meryl, helped me make this transition when she reminded me that being a friend means more than having a person for dinner. It means developing a relationship, getting to know the other person well, and sharing in his joys and sorrows. Friendship means connection in a deep sense.

I thought of this as I watched *Heat,* a crime thriller in which a career criminal, Neil McCauley, avoids connection. He does not want to foster any lasting relationships because they will make him vulnerable and perhaps get him killed. It is a sad, lonely, and solitary existence, but a necessary one for a criminal whose success thrives when people cannot identify him and do not know him well. Early in the narrative, he

remarks to a confidante: "Don't let yourself get attached to anything you are not willing to walk out on in thirty seconds flat if you feel the heat around the corner." McCauley leads a life of disconnectedness because attachments and friendships expose him to risk.

Pitted against McCauley and his team is police lieutenant Vincent Hanna who doggedly perseveres in hunting him down. Hanna also leads a solitary life because of his utter devotion to his job. His all-consuming goal is to catch his man, even if it is at the expense of taking time to nurture his relationship with his wife and stepdaughter.

In one mesmerizing scene, McCauley and Hanna meet over a cup of coffee in a restaurant and commiserate about their respective and all-consuming occupations. Hanna shares his concern for his depressed stepdaughter and reveals how his third marriage is headed for disaster because of his obsession with work: "My life's a disaster zone. I got a wife. We're passing each other on the down-slope of a marriage – my third – because I spend all my time chasing guys like you around the block. That's my life." McCauley opens up as well, revealing how his relationship with his girlfriend is fraught with peril because at any moment he may have to leave her. The meeting concludes on an ominous note as both men acknowledge they may have to kill one another if the situation requires it.

Jewish tradition values connection with others. The Sages implore us not to separate from the larger community. Joining with the community affirms our connection with others; it stabilizes and nurtures us. In Hebrew the word for friend is "*chaver*" and the word for connection is "*chibur.*" Both words share the same root, which means "staying connected." When man is by himself, it leads to self-centeredness, selfishness, and gratification of self. That is not the Jewish way, for it is through the crucible of relationships that our life is enriched and character refined.

The obsession-driven characters in *Heat* remind us of the perils of being a loner. We may get what we want, but it is an empty victory when there is no one with whom we can share our happiness.

THE LAST SAMURAI (2003)
directed by **Edward Zwick**

I have been living in Israel for a year and a half and have taken two trips back to the States. On my first trip, I brought a long list of things to buy to bring back to Israel. On the second trip, the list of things to bring back was brief and non-descript. I realized that by living in Israel I was becoming less interested in material things, getting used to a lifestyle of living with less, and arriving at a place philosophically where I truly felt that less is more.

This way of life is celebrated in the rousing and violent adventure *The Last Samurai*, which depicts in a symbolic sense the struggle between modernity and tradition. Tom Cruise is Nathan Algren, a Union soldier in the post-Civil War period, who is haunted by the ghosts of his past indiscriminate killings. He is recruited by the Japanese government to help quash a Samurai insurrection that threatens the economic well being of the New Japan, which is promoting increased trade and dialogue with the West. Algren accepts the job, but in an early and bloody confrontation with the Samurai, he is captured and brought to their mountain village. There, Katsumoto, the leader of the Samurai, engages him intellectually and emotionally. In this remote and picturesque setting, Algren soon finds himself enamored by the simple lifestyle of the Samurai, who live by a rich code of ethics supported by close ties of friendship and family.

Hallmarks of the Samurai way of life are self-discipline, devotion to a set of moral principles, and striving for perfection in whatever they do. Algren senses the spirituality of the Samurai and learns how to focus his mind so that he feels "life in every breath." In many ways, the Samurai values echo the Jewish notions of living by a higher law

and striving for spiritual perfection. Before the climactic battle scene, there is a scene of prayer, suggesting that success in battle depends on one's spiritual state. This is very much a Jewish sensibility. In these heightened moments of awareness right before battle, when life is so precarious, there is thoughtfulness about what really matters in life. Tradition is paramount. Katsumoto articulates this in a dialogue with the financial entrepreneurs who want to remove the archaic Samurai from the contemporary political landscape. The money men see them as a relic of the past, preventing Japan from entering the modern industrial age. Katsumoto tells them that the Samurai cannot forget who they are or where they come from. For him the sacred traditions animate and give meaning to the present.

When Algren, at the movie's denouement, informs the young emperor of Japan of Katsumoto's death, the young monarch wants to know how he died. Algren perceptively and wisely responds: "I will tell you how he lived." His answer reminded me of the Jewish imperative to live by the commandments and not die by them. Following the eternal principles and traditions of the Torah gives meaning to one's daily existence, imbuing each day with a sense of transcendent purpose. Both the Samurai and the Jew understand that although life can be filled with peaks and valleys, with joy and pain, leading a life of the spirit can give meaning to the entirety of one's journey on earth. The film closes with speculation that Algren returns to the Samurai mountain village where he first met Katsumoto to begin a new life of spiritual integrity. He has discovered that progress is not always a good thing and that, spiritually speaking, less is often more.

THE NUN'S STORY (1958)
directed by **Fred Zinneman**

I was an average student in high school, so when I entered Yeshiva University as a freshman, I was overwhelmed with the many very bright students around me. It took me some time to feel I could compete academically; and for most of my undergraduate career, I did not participate much in class discussion.

I got mostly A's in my courses, but did not offer my opinion in class until I took a course in Russian and Scandinavian literature in my senior year, which changed my perspective. I received an A on every test, yet received a B for the course. I went to my professor and asked him why I received a B. His response went something like this: "You do not participate in class discussion. You may know the material for the test, but I have no sense that you really understand the novels in a sophisticated way and can integrate them into some kind of thoughtful discussion." I realized then that it was not good enough to know the subject; I had to show others that I knew it. Therein lay the conflict: self-effacement versus self-promotion.

For me, the conflict was not easily resolved. I was raised in a home of modesty and humility. My father was president of the local synagogue and my mother was president of its sisterhood and she worked countless hours for the Association for the Help of Retarded Children in Westchester County. They were selfless, quiet people, not at all interested in getting recognition. I never heard my parents utter a word about seeking honor for the good work they did, and I shared that perspective as I matured.

This approach towards doing good without receiving recognition resonated as I watched *The Nun's Story*, a narrative of a young girl,

Gabrielle van der Mal, who decides to become a nun. The daughter of a renowned physician, she has a solid understanding of tropical diseases and wants to devote her life to working in the Congo where she can alleviate the suffering of many. As we watch her move through the various stages of becoming a nun, she is continually challenged. Although far superior academically to her peers, she is always asked to submerge her ego, to overcome her desire for personal recognition, and to allow others to achieve their dreams at her expense. Her mentors encourage self-effacement even over self-esteem. Instead of sending her to work in the Congo with the indigenous population, which she wants, she is sent there to work in a European hospital. There she contributes mightily, but this does not satisfy her desire to work with the natives. The constant obstacles she faces are all designed to teach her humility and self-effacement.

In truth, humility is a value in Jewish tradition. Moses, the greatest of all prophets, was known as the most humble of all men. The commentators underscore this when the Bible reveals that Moses was eighty when he became the leader of the Jewish people, an age at which one would expect him to seek a modicum of comfort and ease in life. Yet he is chosen by God at that age precisely to emphasize that he accepted the mantle of leadership not because of any desire for fame or recognition, but solely to respond to the command of God. He is devoid of ego. All he wants is to do God's will, and then he will disappear from the stage.

The Nun's Story encourages a similar spirituality. As the Reverend Mother advises Gabriel: "Do good, then disappear." Ideally, the desire to do good should not hinge on the approval or approbation of others. We should do good for God's sake, not our own.

LEAVES OF GRASS (2010)
directed by **Tim Blake Nelson**

There was a time when "college dropout" was a pejorative term, but no more. Think Bill Gates or Steve Jobs. But as a teenager in the 1950s, conventional wisdom was that getting a college degree was a prerequisite for success in life. Now many years later, I have a different perspective. While there is much to say about the positives of college, there are also negatives. I understand that it is a potentially corrupting environment, that it is filled with its own intellectual biases, and that the possession of a college degree does not guarantee success in life.

All this floated through my mind as I watched *Leaves of Grass*, the story of two twin brothers, one a Classics professor at Brown University, the other the grower of high-grade marijuana in an elaborate and sophisticated hydroponics warehouse. Two bright children, same parents, yet radically different approaches to life. Consider Jacob and Esau in broad brushstrokes.

In the opening scene, Bill Kincaid is lecturing about the perfect world of the Greek philosophers, but he concludes by observing that, in spite of their desire for perfection, they and we still live in an imperfect world. All the brains in the world do not necessarily create a happy or moral universe. The Talmud echoes this when it states that the good deed is superior to the study of holy text. Good actions supersede intellectual accomplishments.

The plot thickens when Brady Kincaid tricks his twin brother into returning to their hometown. His motive: to use him as his double to create an airtight alibi for his own nefarious plans. Complications ensue, and the unpredictability of life asserts itself in a series of surprising,

improbable, and violent events, which on a deeper level reflect the dissonance between the academic world of theory and the real world in which we live.

To underscore this tension between theory and reality, Brady describes his view of God to his friend Bolger. He explains that man and God operate on two parallel lines, always following one another but never intersecting. In the end, man's quest for God is neither linear nor necessarily satisfying.

This conflict is highlighted when Bill meets Janet, a poet and high school English teacher. Enamored with her, he shares his approach to life, which is grounded in the academic virtues of study, order, and reason. She confides to Bill that she entertained the possibility of teaching college students but found them too close-minded, just the opposite of what our own conventional wisdom would say, and contrary to Bill's perception of college students. For Bill, this is a cathartic insight as he tries to navigate both his and Brady's world.

These philosophical understandings are mirrored in the *Ethics of the Fathers*, a revered piece of Jewish wisdom literature, which says that it is not in the power of man to understand the inscrutable universe, to explain, for example, the peace of the wicked or the suffering of the righteous. Finite man cannot comprehend the infinite God. All he can do is to follow the parallel line of God, as it were, and do one's best in an imperfect universe.

This philosophical reconciliation with man's imperfection is signaled by the closing image of Bill and Janet, relaxing on beach chairs and holding hands in the rain. Rain, which frightened him as a child, now is both calming and restorative. Bill now experientially knows that life does not always provide answers, and that our human task is to persevere in the face of ambiguity.

SINGIN' IN THE RAIN (1952)

directed by **Stanley Donen** and **Gene Kelly**

In traditional Jewish communities, the typical response to someone who asks you how you are is to say *"Baruch Hashem*, Thank God, well."* A dear friend of mine with whom I used to study Torah texts would utter a slightly different response: "Thank God, fantastic." My late wife and I thought it was a beautiful answer because it implicitly recognized the notion of being thankful for everyday miracles, for the things we often take for granted. When people ask me why I say "Thank God, fantastic," I tell them I am thankful that I got up this morning, that all my limbs are working, and that my health is good today, because health is wealth. I give the same response to the cashier at the supermarket checkout line as I do to my friends, both of whom are surprised by and appreciative of my answer. The essential life lesson that I am imparting is to always look on the positive side of things. Gaze and reflect on what you have, not what you do not have. This is the subliminal message of the light-hearted musical *Singin' in the Rain.*

The plot of this iconic musical is straightforward. Don Lockwood, who epitomizes Eddie Cantor's famous aphorism that "it takes twenty years to become an overnight sensation," labors for many years in vaudeville as a singer and dancer and then travels to Hollywood where he works as stunt man. He finally gets a break as an actor in the movies and achieves great success as a silent film star. His co-star, the vapid Lina Lamont, is his polar opposite and Don has to work hard to convey love for her in their silent screen epics.

Things change when *The Jazz Singer*, the first talking movie, makes silent films obsolete. Lina, whose grating voice is ill suited for talking

movies, becomes a challenge not only for Don, but for the studio as well. Their dilemma: how to replicate the success of Don and Lina in the new era of sound movies.

The solution comes in the form of Kathy Seldon, a talented chorus girl with enormous singing and acting chops. After a serendipitous meeting with Don, which begins badly, she meets him again and they develop a fondness for one another that morphs into love. Things get dicey when the studio decides to dub Lina's voice with Kathy's in the next Lockwood and Lamont film, *The Dancing Cavalier*, in order to produce a successful talking movie. Everything seems to go wrong, but Don's friend Cosmo Brown invariably comes up with a suggestion mitigating the problems. He always looks at the sun, not the rain.

Unlike many movies nowadays, the film ends with the lovers "happily ever after." The iconic expression of this enduring happiness is Gene Kelly's rendition of "Singin' in the Rain" as he dances with the rain pouring down on him. It is a classic moment in cinema with both lyrics and scene blending perfectly with one theme of the film; namely, to always look on the bright side of things. Consider the lyrics: "I'm singin' in the rain / What a glorious feelin'/ I'm happy again/ I'm laughing at clouds/ So dark up above/ Let the stormy clouds chase/ Everyone from the place/ Come on with the rain/ I've a smile on my face/ I walk down the lane/ With a happy refrain/ Just singin' in the rain."

There is a blessing that traditional Jews recite when hearing good news: "Blessed Art Thou, Lord of the Universe, who is good and does good." Conversely, when you hear sad news, you refer to God as "the Arbiter of Truth." The implicit message is that whatever God does is for the good, even if at the present moment it seems sad. That is because Judaism in its essence asks us to view all of life from the aspect of eternity. Therefore, we should always try to be content, even on rainy days, even when clouds of sadness overwhelm us. Let us all sing in the rain.

THE TRUMAN SHOW (1998)

directed by Peter Weir

I remember hearing a lecture by the great sage Rabbi Joseph Soloveitchik, a master of Torah studies as well as philosophy, who observed that some of man's most important decisions are based on instinct and emotion rather than deliberate forethought. As an example, he cited his decision to marry his wife. At the end of the day, it was emotion, not logic, that moved him.

When I was a young college student immersed in both general and Judaic studies, it was a revelation to hear this. I naively assumed that the great Torah scholars always made important life decisions based only on careful calculation, not by stirrings of the heart. Here I heard that, while reason is important, there are times in life when emotion trumps reason – and understandably so.

I thought of this as I watched *The Truman Show*, a fantasy about Truman Burbank, the star of a reality television program which has been filming Truman's entire life since birth with thousands of hidden cameras, twenty-four hours a day. Actors play Truman's family and friends, and Truman is unaware that his life is being manipulated by others. Indeed, everything in Truman's life is planned by others. Who he meets, who he befriends, even who he marries is determined for him. Cristof, the mastermind behind the TV program, creates an alternate reality in which Truman will be fearful of any deviation from the norm. He wants Truman to lose any desire to explore new places and have new experiences, so that "The Truman Show" can go on forever mesmerizing its viewer audience.

But trouble looms when, during the thirtieth year of the show, Truman begins to question some of the givens of his idyllic existence.

He notices that he meets the same people every morning in exactly the same sequence, he has exactly the same conversations with them, and he wonders why his wife unexpectedly starts touting the benefits of a supermarket product in the middle of a serious conversation.

When Truman seeks to escape his mundane but perfect world, he encounters many obstacles. He cannot arrange for airline flights, the bus for which he buys a ticket to travel to a distant city breaks down before it even leaves the terminal, and when he drives, police stop and warn him of an impending forest fire up ahead. His skepticism about the authenticity of his life is acutely felt when a police officer he has never met calls him by his first name.

Desperate and emotionally isolated, Truman on one night decides to elude the many cameras that are observing his every move, and he slips out of his house. This sparks a national crisis and, for the first time, "The Truman Show" has to suspend broadcasting.

Cristof launches a citywide search until Truman is spotted sailing away from the pristine town of Seahaven in a small sailboat. To frighten Truman into staying, he creates a torrential storm that nearly kills Truman, but Truman persists in his quest for autonomy. Rather than follow the script preordained for him, Truman wants to live the unscripted life and discover life's truths on his own without filters of any kind.

Judaism is a religion with lots of prescriptions for living. The Sages list not ten, but 613 commandments. Side by side with these rules, however, is the notion that the commandments should not be observed mechanically, without feeling. The letter of the law is important, but so is the spirit. For example, traditional Jews are required to pray three times a day, but the quality of those prayers is measured in terms of the personal intensity with which those prayers are invested. We cannot simply do; we must think and feel. The Sages clearly state that the emotional dimension of prayer is critical to efficacious communication between man and God. Mere recital of the words is not enough.

So too is it with life. *The Truman Show* reminds us that to fully experience the joy of life, we must not just pass through the world like automatons going through the motions. Rather, we will become more complete human beings, more whole in body and mind, when we experience life with all its unadulterated agonies and ecstasies, with all its painful and joyous contradictions.

UNSTRUNG HEROES (1995)
directed by **Diane Keaton**

In 1976, I had a memorable hospital visit I still remember vividly almost forty years later. I was serving as a synagogue rabbi and was making the rounds visiting people in the Veterans Administration Hospital in Atlanta, Georgia. It was there that I met eighty-nine-year-old Aaron.

Aaron told me that he does not mind dying, but the people at the hospital insisted on doing all they could do to keep him alive. He was impressed with their essential kindness. They saw to it that he was served no pork, even though he himself did not request kosher food. When I mentioned that today was Chanukah, the holiday during which we light candles for eight days to commemorate the miracle of the one-day supply of pure oil that lasted for eight, he broke down in tears. He thanked me for bringing this word to him from so long ago. Faced with mortality, religion and God became relevant.

Unstrung Heroes is a moving film about dying and how it changes one's thinking about the world and about one's relationships to both man and God. Selma Lidz is diagnosed with cancer and becomes increasingly weak. Her husband, Sid, an eccentric inventor who sees science as man's salvation, cannot come to terms with Selma's inevitable demise and is having trouble managing the home front, and in particular, his son Steven. Realizing the stress at home, he permits Steven to live with his dysfunctional uncles, Arthur and Danny, who live in an extremely cluttered apartment in a dilapidated hotel. They introduce Steven to their idiosyncratic and unconventional lifestyle, and Steven thrives. He comes to understand that life is not determined by science alone and that there are mysteries that science cannot explain.

Religion becomes a meaningful part of his life, and his dying mother approves. His father sees religion as a crutch, one he does not need, but his brothers see things differently. In one searing scene, Arthur reminds Sid that "a crutch isn't bad if you need it," to which Danny adds, "All of us are cripples in some way." There is an essential humility in what they say, and it takes a while for Sid to understand that life is more than numbers. Life, rather, is meaningful connection with other human beings, something that is not quantifiable.

The *Ethics of the Fathers* tells us to repent one day before your death. The Sages ask: How do you know when it is one day before you die? The answer: You don't. Therefore, live each day as if it were your last. Fill it with meaning, with good deeds, with study of holy text, with fortifying family relationships. There is a quiet but emotionally charged scene in *Unstrung Heroes*, in which Selma kisses each of her children and then passionately kisses her husband. There is a premonition that this might be a final kiss; everyone thinks it and silently treasures that last embrace.

RELATIONSHIPS

I have become a student of boy-girl, husband-wife, relationships as a synagogue rabbi who has officiated at many weddings and as an informal marriage counselor. Moreover, for the last several years I have been a volunteer matchmaker on a Jewish dating site. But my most significant experience is as a happily married husband and father, then as a widower beginning life anew after the sudden passing of my wife when she was just forty-four.

I was blissfully married for twenty-three years, had six beautiful children, and then suddenly my wife died of a brain aneurysm. It was a tragedy that still lingers with me. I did not understand it then nor do I understand it now. Because I was so happily married, I could not understand the single life, and two years after my wife passed away, I remarried – not to replace what could never be replaced, but to begin anew with the next part of my life. With the support of friends and family, and remarriage to my lovely wife Meryl, I was able to move on even though the past was still part of me.

My wife Meryl was divorced. I was widowed. My wife and I come from these two experiences and our perspective on marriage was informed by these previous parts of our lives.

The Torah clearly states that marriage is the normative state of Jewish adults. The fundamental purpose of marriage is to have children, being fruitful and multiplying, but that is not the only purpose. The Torah unequivocally tells us that an unmarried person is not a complete human being, suggesting that the single person lives for oneself and not for others. Ultimately in the Jewish view, to be human is to share with others. Think about the case of Adam and Eve. God tells Adam it is not

good for man to be alone. Therefore, even if there cannot be children, marriage is still an ideal because it creates a community of sharing, not of self-centeredness.

In traditional Jewish circles, marriage is encouraged at a relatively early age. The Talmud mentions the age of eighteen as an ideal. One of the reasons for this is man's desire for physical closeness to a woman as he matures, and the reality that, according to Torah law, there can be no intimate touching outside of the context of marriage. That means no kissing, no embracing, and certainly no intimate relationship before marriage. In this context, dating is basically an exchange of words, thoughts, or lifestyles about shared destinies, common goals.

The end of a relationship, through death or divorce, brings with it tragedy at many levels. There is the loss of physical companionship, and, more important, the loss of the one who shared all of life's dreams with you. One is adrift both physically and emotionally. The Talmud compares the loss of one's spouse to the loss of the Temple – so acute is the pain. Just as Jews cannot be comforted over this national tragedy, so too does the surviving spouse always carry a residue of pain in the heart. A new chapter may begin and time does heal, but the memory is always there and that is normal.

There is a concept in Jewish law known as *ishto k'gufo*, a man's wife is like himself. They are part of one body. Therefore, when a spouse dies or when there is a divorce, the absence of one's significant other is keenly felt by the surviving spouse. It is as if part of you has died. Whether that surviving partner recovers, how that recovery evolves, and how long the recovery takes are all matters that relate to the circumstances in the marriage and the personality of the surviving spouse. It is natural that the world looks dark for one who experiences the divorce or death of a loved one, but how long it takes for the blackness to lift depends on the attitude with which the tragedy is confronted.

When one's spouse dies, the question arises: Can I, should I, marry again? There is a statement in the Talmud that a person who is married in his youth should marry again in his later years: "Rabbi Joshua said that if a man married in his youth, he should marry again in his old age, for it is said 'In the morning sow thy seed and in the evening withhold not thy hand, for thou knowest not which will prosper, whether this or that, whether they shall both be alike good' (Ecclesiastes 11:6)."

The point is very clear. After the death of one's first spouse, the surviving spouse should remarry. This does not mean the second marriage

is the same as the first. It is not. These are two separate life experiences, and the second marriage should not be looked upon as a duplicate of the first. It is with a different person and there is a different context. Clearly, the Torah and the Talmud indicate that being married is better than being single, for it reaffirms the primacy placed on a caring, sharing lifestyle. A husband or wife who remarries following the death of a spouse is not being disloyal to the deceased partner. Remarriage rather confirms that the first marriage was a life-affirming meaningful union and being married is the desired way to live. The marriage was so fulfilling in so many ways that one affirms that positive relationship by entering into a second marriage.

There is an old saying that one's first marriage is *bashert*, ordained in Heaven. In a second marriage, you get what you deserve, which makes this new chapter in one's life more complex in some ways and more problematic.

Generally speaking, in the Jewish view one waits an annual cycle of Jewish holidays after the loss of a spouse before one considers marriage again. Although this is not an absolute requirement, this is the traditional pattern of Orthodox Jews. After that time, the question arises: How does one again involve himself in meeting potential partners? In my particular case, it was even more problematic because of my public persona as a rabbi and school principal. The overall approach was to meet people through personal contacts with friends. These personal contacts led me to date people in the traditional way by meeting them and having conversations with them first via phone and then later over dinner. This was all before the ubiquitous internet emerged with global matchmaking sites.

The initial phone conversation was critical to establish a common ground of interest and the possibility of shared destinies. I soon learned how powerful the human voice can be in terms of giving one an insight into another person's mind and heart. It is more revealing than one might think and many times a phone conversation alone can give you an indication as to whether a relationship is worth pursuing. The unique gift of humans that separates them from animals is the gift of speech, for speech reveals one's essential humanity. It is through conversation that you begin to explore new personalities.

After one loses a spouse and after divorce as well, conversations while dating are more focused. They tend to deal with specific issues. Moreover, both people involved tend to see time as more precious.

In the case of the death of a spouse, in particular, one is left with an overwhelming sense of time passing and treasuring every minute of life. When one first marries, one has the feeling that time is endless. You have a lifetime to work out problems. But in the second marriage, people are generally older, time is more compressed, and there is an overwhelming sense that time cannot be wasted arguing over silly things. What is critically important is using time as productively and usefully as possible and not frittering away precious moments.

Some of the films in this section deal specifically with divorce and death. Others deal with relationships in general and how they are tested in the crucible of daily life.

ANNIE HALL (1977)
directed by **Woody Allen**

I recently went to a physical therapist in Israel. Knowing of my interest in movies, he asked me what I thought of Woody Allen. I told him that I did not agree with his negative take on religion but I admired his comic genius and his ability through film to get people to think about life and relationships. A case in point is *Annie Hall*, winner of an Academy Award for Best Picture.

Annie Hall is the story of Alvy Singer, a New York comedian, and his relationship with Annie Hall, an attractive but insecure and eccentric girl living in New York City. They meet playing tennis doubles with friends and the romance initially blossoms. Over time, however, each person's idiosyncrasies emerge and they fall in and out of love.

Alvy is a neurotic type, prone to obsessing over large metaphysical questions about the meaning of life and death; Annie's conversation is more down to earth. For her, a crisis manifests itself when there is a spider in the bedroom, a crisis important enough to wake Alvy at 3 AM to come over to her apartment to get rid of the pest. As they get to know one another, they share ideas, books, and their respective family baggage. It is love, or so they surmise, but it is messy and punctuated with fits of anger and jealousy.

Their opposite views of life are revealed in a split-screen scene in which both are at sessions with their psychiatrist. Ironically, Alvy, in therapy for fifteen years, has introduced Annie to the therapeutic benefits of analysis and even pays for Annie's sessions. It becomes clear that the relationship that started out with such promise is doomed to end.

The nature of love, what it is that truly brings man and woman together in a lasting relationship, is a common theme in the films of

Woody Allen. *Annie Hall* suggests that in the final analysis, love cannot be understood rationally. Nonetheless we feel driven to strive for love and seek connection wherever we can find it.

It is a cliché that love is blind. Emotion, not reason, rules. In truth, it is hard to distinguish between infatuation and real love. An illusion exists that love brings with it perpetual passion and ecstasy. Such an assumption creates totally unrealistic expectations, for it is impossible to maintain that level of connection on a daily basis.

True love in the Jewish view develops over time, over a lifetime of shared challenges and experiences. There are no Romeo and Juliet stories in Jewish tradition. Instead there are many stories in the Talmud of women of great character such as Rachel, the wife of Rabbi Akiva, who sacrificed their own comfort so their husbands could study God's Torah, God's instructions for living, and so bring holiness into their lives and the life of the community.

When the Bible tells us to "love your neighbor," many of the commentators say this refers to one's wife. Your spouse is your closest friend and that relationship is nurtured through daily acts of love, not occasional fits of passion. Intimacy in Hebrew is referred to as "knowing" the other person. Knowledge means understanding one's mate in a profound way, not only through the body but through the mind as well.

Annie Hall is a funny movie, but in its iconic way is also very scary. It implicitly suggests that marriage, which requires compromise, patience, and kindness, is a last resort and not preferable to the life of a single in New York. There is a shallowness in the relationship of Alvy and Annie which ultimately undermines everlasting love.

FLASH OF GENIUS (2008)
directed by **Marc Abraham**

Many years ago, a friend of mine decided to pursue a doctoral degree. Newly married, he would have to relocate to a new city to attend the university and his earning capacity would not be high. However, his wife wanted him to fulfill his academic dream and so encouraged him to begin what was a five-year program. During that time, his wife also worked, bore two kids, and handled all the mundane household affairs while he with gusto and determination pursued his degree. Eventually he got his doctorate, and his wife wanted to move back to her family and friends. But he had a job offer in another city and wanted desperately to be a college professor. He did not fully understand or appreciate his wife's ongoing support during his student years, so blinded he was by his own quest for personal success and prestige. Sadly the marriage fell apart and his wife and children were the casualties of his selfishness. This is the character arc of Dr. Robert Kearns in *Flash of Genius*, the true story of a man determined to pursue his own dream irrespective of the cost to those who loved him the most.

Kearns is a college professor of engineering. While driving his car on a rainy night, he comes up with the idea of inventing a windshield wiper blade that imitates the human eye. Instead of continuously moving, it blinks allowing for clearer vision while driving. He secures start-up funds and develops a prototype for his intermittent wipers in his basement. He then patents the invention and demonstrates it to Ford Motor Company. After an initial enthusiastic response, nothing happens.

After some time, Kearns visits a Ford dealer convention and discovers his invention is now standard operating equipment on Ford's new model cars. Hence begins Kearn's fight with corporate giants to reclaim

ownership of his invention and to obtain public acknowledgement of his creativity as an inventor. Years of legal battles ensue, placing immense strain on his wife, Phyllis, and family of six children. Along the way, he is offered settlements extending into the millions of dollars, but Kearns refuses them since they don't include an admission of wrongdoing on the part of the corporation. He is man of principle and nothing less than a public apology will do. Eventually the case comes to trial with Kearns defending himself.

Although there is ultimate vindication for Kearns, there is a price for this victory. There is divorce, separation, and a fractured family; but it is a tragedy that perhaps did not have to happen. A rabbi once told me that one of the keys to a successful marriage is that each partner has to see himself as a giver, always ready to help and support the other. Robert Kearns does not understand this truth. The question should never solely be how can I fulfill my personal needs, but also how can I make the life of my spouse more pleasant, more enjoyable, more fulfilling? Marriage is not only about me; it is about us.

I remember visiting the home of a Torah teacher of mine who had twelve kids. All the kids served the meal, and he would not begin eating until his wife was comfortably seated and beginning to eat the meal herself. Only when she began to eat did he place food on his fork. He was sending a quiet but powerful message to his children: Revere your spouse. Do not treat her casually. He wanted his kids to realize that the meal did not appear serendipitously. Your mother spent hours preparing it and making sure the entire household ran smoothly every day of the week. It was this everyday bastion of love and kindness that built the foundation of a happy home, and we cannot take for granted the daily labors of a housewife and mother as Robert did to Phyllis. *Flash of Genius* reminds us that selflessness, not selfishness, is the hallmark of an enduring marriage.

RUBY SPARKS (2012)
directed by **Jonathan Dayton** and **Valerie Faris**

I know some single men who are very self-absorbed. They are successful professionals, but cannot seem to take their female relationships to the next level: marriage. They see the world through their own eyes and the older they get, the more rigid they become, increasingly unwilling to understand that women also have needs, which do not always revolve around men. For example, a fifty-year-old friend has finally decided to get married because he wants children. He assumes that a thirty-five-year-old woman will want to marry him and have kids. He does not comprehend that a thirty-five-year-old woman generally is not interested in a fifty-year-old guy, yet he persists in his quest to find a young bride.

I thought of this unrealistic mindset of my friend as I watched *Ruby Sparks*, a clever, funny, profanity-laden, and very insightful film about relationships in which the male partner always sees things from his perspective and fails to understand the needs of significant others in his life.

Calvin Weir-Fields, a young J. D. Salinger, has writer's block after his first wildly successful novel. Visits to his therapist are helpful, but his inability to write persists, until something amazing happens. A girl, about whom he has been dreaming, becomes a real person and he falls in love with her. Improbable as it may seem, they date, dance together, and get to know one another as friends and lovers.

The conceit that informs the movie is that Calvin can control Ruby by writing about her. She is both real and a figment of his imagination. It takes a while for him to process this conundrum, but he does when other real people such as his brother and his parents are able to actually

see her and talk to her. There is no rational explanation for what happens, but the film manages to say some wise things about relationships between men and women.

Consider these interchanges in the story. When Calvin, a loner, confides to Ruby that she is all he needs, Ruby responds, "That's a lot of pressure." When Calvin feels depressed after Ruby leaves him for short time, he retires to his study and types that Ruby is miserable. Sure enough, she immediately phones to tell him how much she misses him. When Ruby desires to stay close to Calvin and physically cling to him, barely allowing him to breathe, Calvin again goes to his typewriter and types that Ruby is "filled with effervescent joy." This makes Ruby perpetually bubbly and unresponsive to the nuances in Calvin's behavior.

The relationship reaches a dramatic crescendo when Calvin exerts his power to control Ruby in an almost diabolical way, mercilessly informing her of his power to control her. It is an extraordinary scene pitting the controlling male against the defenseless female. How this problem is ultimately resolved is fanciful, but along the way we glean wisdom about what the relationship of a man and woman should be.

Jewish tradition has much to say about the relationship between man and woman. Every Friday night, the traditional Jew sings an ode to the "woman of valor" described in King Solomon's Book of Proverbs. She is independent, wise, and the key to passing down tradition to her children. In a Talmud class, a student once asked the teacher: "How can I get my wife to treat me as a king?" The answer from the teacher: "Treat your wife like a queen and she will treat you as a king." The answer reveals the mutual respect that husband and wife should have towards one another. The issue is not one of control. Rather the relationship should be characterized by each partner giving to the other. The goal of marriage is not to control or change the other; rather it is to lovingly accept the divinity within each other so that there will be mutual respect for one another's uniqueness.

FILL THE VOID (2012)
directed by **Rama Burshtein**

As a young teenager who went to public school, romance to me was an emotional and physical response to a pretty girl. I did not think much about the mental component of a relationship. The ideal date in my juvenile mind was to go see a great movie, then to an ice cream parlor where we would talk about "things we had in common," and end the evening with a goodnight kiss. The kiss was a sure indicator that she liked me and that I could call her again. If someone had asked me what were the "things we had in common," I would have been hard pressed to articulate a coherent answer.

As I evolved in my religious growth, I began to realize how shallow was my high school understanding of romance and love. I remember how my inner light bulb turned on when I was studying Isaac's courtship of Rebecca as described in the Bible, which focused on finding a kind girl of good character. Achieving a romantic epiphany of love came only after marriage, as the Bible states "Isaac brought her into his mother's tent, and he took Rebecca and she became his wife, and then he loved her."

Fill the Void is a love story but without the heat of a physical relationship. Shira Mendelman, an eighteen-year-old religious girl living in Tel Aviv, is looking forward to an arranged marriage with a young man to whom she is attracted. However, tragedy strikes when Shira's older sister Esther dies in childbirth, leaving a son, Mordechai, who is tended to by Shira in the aftermath of this family crisis.

When Yochai, Esther's husband, is approached to marry a girl from Belgium, Shira's mother suggests that he marry Shira instead. This will allow the baby to remain close to her grandmother and provide the best

situation for the child. Yochai and Shira first reject the suggestion, but as time goes on they begin to consider the possibility.

Obstacles intervene and the possible match is terminated when the family rabbi senses that Shira is not emotionally committed to Yochai. The rabbi will not bless the match unless Shira genuinely desires it. Shira, in truth, has free choice and does not have to marry someone unless she wants to. The resolution of this dilemma provides a window into a world where physical love is real, but is only one facet of a complicated life decision.

The Orthodox world in which Shira lives is bound by many rules. Yet within that world, there is room for free choice and for the manifestation of love before marriage, albeit without physical expression. This love, however, is no less potent. Shira is a sensitive soul who weighs the wishes of her mother, the needs of her deceased sister's child, and her own desire to determine her own destiny as she navigates the complex emotional landscape in front of her. Her needs are important, but they are not the only needs to consider. Her decision-making process is very mature and thoughtful.

Judaism values physical love between husband and wife. It is the rock upon which true love is built and nurtured after matrimony. There are many Jewish sources that extol the power of physical love, most notably the Song of Songs written by King Solomon, which, in graphic terms, describes the passion of two lovers as they manage a tumultuous relationship.

But there is no Tristan and Isolde narrative in Jewish tradition. Indeed, Judaism views with suspicion the undisciplined sexual drive. It is noteworthy that the Biblical Hebrew term for sexual intimacy in marriage is *yadah*, to know. Adam knew Eve, says the Bible, because intimacy implies a profound knowledge of one's spouse both intellectually and emotionally. It is an experience involving mind, heart, and body. *Fill the Void* reminds us of this basic human truth.

HOPE SPRINGS (2012)
directed by **David Frankel**

I recall that, as a teenager, I felt ready to get married at age fourteen. The hormones were operating at a high level and dating in my own mind was serious. Fortunately, I did not act on impulse and I matured, realizing that marriage was a serious and sacred enterprise that required a commitment of soul, not just bodies.

Now that I have entered the ranks of senior citizens, I understand better that love within marriage grows in many ways: physical, emotional, and spiritual. Marriage counselors of all stripes advise couples to work at marriage even in the senior years to keep it fresh and alive. That essentially is the narrative arc of *Hope Springs*, a thoughtful film about seniors dealing with a changing relationship that needs an infusion of passion at all levels to prevent the marriage from atrophy.

Empty nesters Kay and Arnold Soames, after thirty-one years of marriage, have fallen into a rut. Their marriage is devoid of passion and even simple connection. They sleep in separate bedrooms and their conversation is perfunctory. On one fateful day, Kay buys a book about how to keep a marriage fresh written by Dr. Bernie Feld, who runs a marriage-counseling center in a remote coastal town in Maine. Kay signs up for a week-long therapy session and Arnold reluctantly goes. So begins an engaging account of Arnold and Kay's attempt to rekindle the love that once was and seems to be no more.

The therapy involves Dr. Feld asking many candid questions about Kay and Arnold's views of marital intimacy and how they feel about one another now. Touching one another for extended periods of time is the first exercise by Dr. Feld, and things progress from there to greater intimacy in all manifestations.

Kay and Arnold make progress and then return to Omaha, their home. At first, things begin to unravel, but when Kay and Arnold realize how much is at stake for both of them at this time of their lives, they recommit to working at their marriage. The two gifted actors who play Kay and Arnold, Meryl Streep and Tommy Lee Jones, enable the film to achieve a depth and honesty that is extraordinary and separate this film from others that also deal with an aging husband and wife adjusting to their changing minds and bodies.

The Sages of old tell us that although the primary purpose of marriage is to have children, intimacy within marriage is considered good even after a couple has children because it fortifies the marriage bond. The human touch is critical at all stages of marriage. It is interesting to note that during the childbearing years, traditional Judaism requires husband and wife to observe a separation during the wife's menses and for seven days afterward. Practically speaking, this means that intimacy does not occur for approximately twelve days per month. After menopause, husband and wife can be intimate with one another all the time, as if to teach us that more touching is needed as one gets older so that one continues to feel desired.

Hope Springs reminds us that love springs eternal only if we work at it. Keeping busy with the technological conveniences of modern life, with cell phones, with computers, with surfing the internet, allows us the freedom to communicate with the world; but the most important communication, suggest our Sages, is on the home front where we need to prioritize our communication efforts. A perfunctory kiss in the morning and a quick "I love you" is not enough. True love takes time to nurture and grow, but it can bring great rewards. Happily, Kay and Arnold make the investment that can save their future.

MUD (2012)
directed by **Jeff Nichols**

When I was fourteen years old, I dated seriously. I had a girlfriend and I thought I was going to marry her. In those innocent years, thoughts of sexual intimacy were not in my head. My emotions were clear and pure. Linda Sue was the girl I would marry. My fantasy came crashing down, however, when I travelled by subway from Mt. Vernon to the Bronx where she lived to surprise her. There I found her wooing another boy. I was speechless, devastated, and felt betrayed. Tears streamed down my cheeks as I made the lonely return trip to my home.

In hindsight, I can only thank God for not answering my prayers about Linda Sue. Indeed, she was a sweet and pretty girl, but I was clueless about what real love is at that tender age. Moreover, my own identity was as yet unformed. I did not know who I was, let alone who Linda Sue was. That fateful day, my illusions about love began to give way to reality and a wiser view of what lasting relationships are all about.

Mud on one level is a film about a criminal on the run. But on a deeper level, it is a wise film about coping with life once our illusions are shattered.

The story opens as two teenage boys, Ellis and Neckbone, arrive at a small island in the Mississippi River. There they hope to acquire a boat stuck high in a tree, but they are frightened when they discover that someone is actually living in the boat. The occupant is Mud, a personable fellow who engages them in conversation, but who, in fact, is a fugitive on the run for murder.

Mud wants to reunite with his girlfriend Juniper and then leave town as soon as possible. To accomplish this, he enlists the aid of the two

boys, who convey messages from him to Juniper about Mud's intentions to meet her. The boys do not reveal Mud's hiding place either to parents or police. They like him, and therefore, they trust him.

As this narrative is unfolding, there is a parallel plot involving Ellis and his parents, who are headed towards divorce. This is an unsettling reality that leaves Ellis emotionally confused. His house may be sold and his parents who once were in love are now out of love, something Ellis cannot comprehend. Moreover, Ellis thinks he is in love with May Pearl, a high school girl several years older than him; and when she rejects his overtures in front of her friends, he is mortified.

In the midst of his own psychological turmoil, he is enthralled with Mud's passionate devotion to Juniper, which motivates him to facilitate their reunion, naively thinking that love will conquer all. Ellis steals machine parts and other junkyard supplies to help Mud repair the boat stuck in the trees so that Mud can escape his pursuers.

Things, however, do not work out as planned and Ellis discovers that in the real world, one has to accommodate to the changing nature of human relationships. Separation and divorce may signal tragedy and the shattering of illusions, but not necessarily the end of loving connections.

Jewish tradition frowns upon marital separation and divorce. Marriage is considered a holy bond, and divorce has many negative connotations. The Talmud actually says "even God sheds tears when someone divorces his wife." Sometimes, however, divorce is necessary for a variety of reasons. The aftermath of such a tragedy does not have to be negative. It can mean a new, more fulfilling destiny for many, and a second chance at a successful life. Both Mud and Ellis, each at vastly different points in life and facing very different challenges, finally understand that separation can ultimately be good and allow people to re-emerge from darkness into light.

PROOF OF LIFE (2000)
directed by Taylor Hackford

Over the years as a rabbi, I have done some marital counseling. One standard piece of advice I give to couples of all ages is never go to bed angry, never leave a problem hanging and allow it to fester overnight. The consequences can be far-reaching and potentially devastating. My wife and I do not agree on everything, and we probably never will. But we both understand that it is foolish not to resolve a divisive issue as soon as possible. We have learned that there are three very important phrases in any marriage: "I'm sorry," "forgive me," and "I love you."

Proof of Life is about a marriage under stress. On the surface, it is an action film about a kidnapping in a South American country, which introduced me to something that, thank God, I know little about; namely, how a hostage release is negotiated with a kidnapper. It is scary, but fascinating. Based on a true story that appeared in *Vanity Fair* magazine, it recounts the tense ordeal of Alice Bowman and her husband Peter, who is kidnapped by guerilla rebels and taken into the country's mountains for a number of months.

What makes the kidnapping especially worrisome is the conversation that Alice and Peter had the night before. Peter's company is in financial straits, and yet Peter wants to stay in the country. Alice, who suffered a miscarriage when they were stationed in Africa, is emotionally spent and wants to return to the States. Peter, angry with his lot in life, tells her to take a break and leave the country by herself; he will stay here. It is an emotionally wrenching scene to watch as the fabric of a relationship between a loving couple, once devoted to one another, begins to unravel.

It is against this emotional background that the kidnapping takes place. What ups the ante is the fact that Peter's company has no insurance coverage for kidnapping, placing his wife Alice in the unfortunate position of personally hiring a hostage negotiator to achieve her husband's release, all the while knowing that Peter feels ambivalent about the marriage. After a false start, she engages Terry Thorne, an expert in kidnapping and ransom cases, to help her.

The beginnings of rapprochement and reconciliation occur when Peter asks his captors if he can take a picture of his wife out of his wallet to bring with him on his trek into the wilderness. It is a photo that both comforts and inspires him throughout his ordeal. Alice, too, begins to sense that her husband still loves her when a fellow prisoner who has escaped tells her of Peter's devotion to her, and how it enabled him to survive pain and humiliation.

Peace between husband and wife is the bedrock of a Jewish home. So precious is spousal harmony that the Bible speaks of a ritual in which God's holy name is erased in order to promote marital harmony and save a marriage in peril. Moreover, the classic dictum of "loving your neighbor as yourself" refers specifically, says the Talmud, to the relationship between husband and wife who are not only lovers, but the best of friends.

Proof of Life on one level refers to the proof that the hostage negotiator wants before transferring money to kidnappers. On another level, it refers to the deep love that asserts itself when marriages are being tested. Resolving disputes, daily expressing love in word and deed to one's spouse, are an affirmation that, in spite of adversity, love will endure. Love itself is proof of life.

SAY ANYTHING (1989)
directed by **Cameron Crowe**

A female physician, who married a number of years ago, recently introduced me to her husband. I expected to meet a college grad in some white-collar job, but I did not. Instead, I met a very sweet guy who worked as an auto mechanic in a local service station. I wondered what prompted each one to connect with each other, but soon realized that just because two people have similar educational backgrounds does not mean they are compatible intellectually and emotionally. Sometimes, opposites do attract. That is at the core of *Say Anything*, a teen romance between a class valedictorian and an affable young man who has no idea of what he wants to do with his life.

Lloyd Dobler, an average student who envisions kickboxing as a possible career, one day decides to date the brilliant Diane Court immediately after they graduate from high school before she leaves for college. *Say Anything* follows their relationship as it waxes and wanes through the prism of teenage angst.

It is 1988 and Diane is practicing her valedictorian speech. Although the talk is humorless, Lloyd still wants to date her, and so he asks her to come with him to a graduation party. Surprisingly, she accepts even though she has little idea of who Lloyd is. When she attends, she has a great time and feels more integrated into the world of other teenagers, who are more socially adept than she.

Diane continues to date Lloyd and they both enjoy one another's company. When Diane learns that she has won a prestigious scholarship in England, Lloyd wants to come with her, much to the chagrin of Diane's father. Plot complications ensue as she and Lloyd travel their rocky road to love in spite of their disparate backgrounds.

Jewish tradition is very clear on who has the final say when it comes to compatibility between couples. They are encouraged to consult with parents and trusted friends, but the final decision is the couple's. The Talmud records that "it is forbidden for a man to marry off his daughter when she is young, until she is older and says, 'He is the one I wish to marry.'" Moreover, even arranged marriages were never forced. The consent of a Jewish young man and woman was required as a precondition for the match. Furthermore, the biblical story of Isaac and Rebecca indicates that their wedding was not considered a done deal until Rebecca had given her consent. As the Torah says, "Let us call the maiden and ask her" (Genesis 24:57).

This principle of mutual consent was later made part of Jewish law. The great medieval sage Maimonides in his code of Jewish law declares that "a woman cannot be married unless she consents to the match of her own free will." The Talmud thoughtfully mentions the following precautions before marrying: "Buy land quickly but be deliberate in finding a wife, don't betroth a woman you have not seen, find a woman close in age to you, and do not marry for money."

Lloyd Dobler is very deliberate in his quest for Diane's affection. Both Diane and Lloyd possess independent minds. Lloyd is not interested in money. He likes her looks but also admires her braininess and her good character. That is what sets Diane apart from other girls. She is a thinker who both examines and experiences life. This is what brings them together in spite of their different social and educational histories. The fact that they can be honest with each other and "say anything" makes their relationship special. Both Lloyd and Diane are without pretense, and that paves the way for an enduring relationship.

SPLENDOR IN THE GRASS (1961)

directed by **Elia Kazan**

I saw *Splendor in the Grass* in 1961 when I was nineteen years old. I was in college taking a course in English Literature and we had just read Wordsworth's "Ode to Intimations of Immortality" focusing on the classic lines which make up the title of the movie: "Though nothing can bring back the hour of splendor in the grass, glory in the flower, we will grieve not; rather find strength in what remains behind." The lines penetrated my psyche, and I had one of those "aha" moments as I connected the words to my own experience. I was not in love with anybody at the time, but I still had memories of my ninth grade infatuation that ended badly when I was rejected by my then-girlfriend for another boy. It was devastating and it took me a long time to recover my psychological equilibrium. I too had come to the realization that I could not recapture the past; all I could do was "to find strength in what remains behind," and reconstruct myself emotionally.

Splendor in the Grass is a sad but very wise movie. Although it ends with a piece of senior wisdom, a lot of teenage angst is portrayed along the way in all its raw emotion. Bud Stamper, the high school jock, cannot have an honest conversation with his father who wants to make Bud in his image rather than allow Bud to discover who he is on his own. Deanie Loomis, his girlfriend whom he loves dearly, cannot have a conversation with her mother without her mother depositing a truckload of guilt behind.

"What we've got here is a failure to communicate" is the famous tagline from the popular film *Cool Hand Luke*, but it fittingly describes the relationship between Bud Stamper and his father, and Deanie Loomis

and her mother. Parents talk at their children but do not see beyond their own perspective and interests.

The story begins in 1928 in Kansas. Deanie and Bud are in love, and as a teenager in love once myself, their love seems real – not deep, but definitely real. Bud's dad does not want Bud to marry right after high school. He wants him to attend Yale and then embark upon a career. He even encourages Bud to be promiscuous, naively thinking that Bud's desire for love can be assuaged with a coarse physical relationship. Dad, in truth, has little understanding of true love as can be seen from his loveless relationship with his own wife.

Bud and Deanie feel a strong physical attraction, but Deanie wants to remain virginal, and Bud thinks of Deanie as a "good girl." Inwardly, he does not want her to be like others who might compromise their innocence. All this leaves them passionately connected to one another, but under enormous emotional stress. Eventually, they break up with catastrophic consequences.

Years later they meet. Both have moved on with their lives, but they recognize the specialness of what they once had. They know that their strong affinity for one another cannot be resurrected, but that does not diminish the possibility of each one having a happy life with someone else.

In Jewish matchmaking, there is the notion of one's *bashert*, one's destined one or soul mate. I have wondered what happens when you meet your destined one, but do not recognize her or lack the will to move forward. Time passes and your destined one marries another. What are you left with? Many Sages think that the notion of *bashert* is not part and parcel of Jewish law and should be applied only metaphorically. Rabbi Josh Yuter opines that *bashert* applies to how you view your spouse after marriage. In other words, when married couples go through rough spots, they should view their spouse as their destined mates and resolve to work through their problems rather than escape from them. Alternatively, one can say that the bottom line is that you have to seek out someone who fits with you emotionally and intellectually as well as physically.

One cannot be fatalistic in Judaism and just wait for the right one to appear. Rather we should find the missing part of ourselves that Adam lost in Eden and build our lives using the best information we can obtain at the time. *Splendor in the Grass* reminds us to do our best at whatever stage of life we are. Let us find glory in the flower even in the autumn of our lives.

WHEN A MAN LOVES A WOMAN (1994)
directed by **Luis Mandoki**

A friend of mine employed in a large non-profit organi-
zation from time to time discussed in an anonymous way
some of the challenges he is facing at work. He confided to me
that his wife, whom he loves dearly, always has a suggestion to fix the
problem and this frustrates him. All he wants is for his wife to listen to
him as he unburdens himself from a thorny problem at the office. He
does not want his wife to fix it. When his wife offers unsolicited advice,
he takes it negatively as evidence that his wife does not think highly of
his professional ability to solve the problem on his own.

This communication problem is at the heart of a very touching fam-
ily drama about alcoholism, *When a Man Loves a Woman*. Alice Green,
a school counselor, has a serious drinking problem. Married to Michael,
an airline pilot, she is a loving wife but subject to unpredictable mood
changes brought about by her secret, but obsessive, drinking. Her life
begins to fall apart dramatically when she slaps her daughter, Jess, in
a rage and soon after shatters a shower door as she falls down in an
unconscious stupor. Jess contacts Michael, who immediately returns
home to care for his wife.

During her recuperation, Michael and Alice for the first time con-
front the reality of Alice's alcoholism, and conclude that Alice must get
professional help. This decision to enter rehab means that she will be
away from family for a significant length of time, and Michael will now
be in charge at home.

As Alice recovers, she finds new friends at the rehabilitation center
who are also working through their alcohol problems. As she over-
comes her alcohol dependency, Michael feels increasingly isolated and

disconnected. In the past he has always been a player in handling family matters, but now he is confused and ill at ease with his wife's new-found identity. In desperation, Alice asks Michael to go with her to a marriage counselor and he agrees, but it is not a quick fix.

One of the beauties of this film is its verisimilitude. Problems are not always resolved neatly. Things take time, and spouses say hurtful things even during the healing process, especially if they are emotionally fragile. Michael loves his wife and wants to fix things; but Alice does not need a husband who fixes things, and who, by implication considers his wife incompetent to take care of her home and her children. Alice, instead, wants a husband who listens, who acknowledges her problems, and who gives her space and trusts her to solve her problems on her own.

A Judaic Studies teacher once told me that man is born with two ears and one mouth to teach him that he should listen more than talk. Listening is an art, and it is a pillar of the Jewish faith. When God tells the Jews to obey his law or suffer punishment, the Bible uses an unusual double phrase of the Hebrew word for "listen." Loosely translated, it means "if you will surely listen." The commentators point out that this double language means that one has to listen with great attention. Listening is not a casual activity. It means you have to engage your mind and heart and pay attention to what is being said. This is the kind of listening that Michael eventually does in *When a Man Loves a Woman*, a deeply honest film that encourages husbands and wives to listen attentively to one another to maintain and fortify their marriage.

SWEET LAND (2005)
directed by **Ali Selim**

About a month before Harry Chapin, the famous song-writer and balladeer, was killed in a car accident on the Long Island Expressway, I saw him in concert in Atlanta. A high-light of the show was his rendition of "Mail Order Annie," a song about a man in the Far West who sends for a mail-order wife to share his lonely, pioneering life. It is a beautiful lyric that expresses the nuanced adjustment that both husband and wife make to each other as they navigate a new relationship. A virtual stranger is now a spouse.

I thought of this song as I watched *Sweet Land*, the heartfelt nar-rative of a mail-order bride who comes from a foreign country to Minnesota to start life anew as the wife of a farmer. It is a microcosm of the American immigrant experience.

Inge arrives at her new home in 1920 to marry Olaf, a young Norwegian farmer. It is soon after World War I, and Inge's German ancestry and lack of proper immigration papers cause her to be to be viewed as an outcast by her new neighbors. The local minister even refuses to marry them. Until this problem can be resolved, Inge lives with the family of Olaf's friend and neighbor. It is here where she learns English and the American way of doing things.

Over time, Olaf and Inge get to know one another and they do fall in love. Tested by the forces of nature, they labor relentlessly to withstand the elements and bring in their crop successfully without the aid of sophisticated machinery. At the end of a long day, they rest peacefully with the sense of a job well done and a mutual love and respect for each other.

Their acceptance by the community is not as simple. It is only when

Olaf makes a magnanimous gesture to save a friend's farm that the neighbors rally around to support him. Until that moment, he and his wife are outsiders.

Judaism is very sensitive to the plight of the outsider, the immigrant, the stranger in our midst. Indeed, the Bible refers to Jews as strangers living in a strange land when they were sojourning in Egypt. Experientially, historically, Jews know what it means to be unwelcome, and we are bidden not to treat others as pariahs. The Bible, in fact, mentions thirty-six times the exhortation to be kind to the stranger. That is more than the Bible speaks of loving God or keeping the Sabbath.

When I immigrated to Israel almost four years ago, I had some initial difficulty making an adjustment to a new land. What made it manageable was the fact that many people were kind to me, helping me with all kinds of issues. So sensitive and caring were they that I was confused as to which synagogue to join, since my friends belonged to many different ones. When I finally did become a member of a synagogue, a neighbor asked me why I chose that particular synagogue, as it was not the closest to my home. Since one has to walk to synagogue on the Sabbath, one generally chooses the closest, yet I did not choose a house of worship based upon proximity. I told my neighbor that I chose the one where many congregants smiled at me. They made me feel at home and that made all the difference.

Sensitivity to strangers is a hallmark of the Jew. The Egyptian experience laid the groundwork for ingraining the attribute of kindness to strangers in our emotional DNA. A kind word, a smile, can brighten the day of those who are on the outside looking in.

TOOTSIE (1982)
directed by **Sydney Pollack**

I grew up in a home where my father had a great deal of respect for my mother. I never heard them argue, although I am sure they had disagreements from time to time. My father appreciated the fact that my mother worked and helped out financially, but he always saw himself as the primary wage earner and never pushed my mother to enter the workplace. He not only loved her; he revered her. Furthermore, a hallmark of my home was the total absence of crude language. There was a certain sense of propriety that governed family behavior. All of these things contributed towards my own attitude towards women as I grew up. I always took women seriously; and even when I was in ninth grade, I dated a girl thinking that she would be my wife one day. I never thought of women in a casual or demeaning way and didn't fully realize that others did until many years later.

A cavalier attitude towards women is the subtext of *Tootsie*, a hilarious look at what happens when an out-of-work actor, Michael Dorsey played by Dustin Hoffman, assumes the role of a woman on a daytime soap opera. Callous towards women himself, Michael, for the first time in his life, observes how women are often treated in the workplace. The director calls him Tootsie instead of Dorothy and treats him as a cipher with no intellect, always presuming to know what's best for her and the show. Moreover, the director treats other female cast members as familiar sex objects, not as independent people with brains and sensitivities. This discovery begins to affect Michael so much that his fictional counterpart, Dorothy Michaels, becomes a champion of women's rights on the show. She is an assertive hospital administrator who will take no offense from any man. Dorothy veers from the script

to be true to herself as a woman, and the public idolizes her for it. She appears on magazine covers and becomes the talk of New York. In true comedic fashion, complications ensue when Dorothy's contract is extended and when Dorothy (who is actually Michael) falls in love with one of the actresses on the show.

Eventually, there is a day of reckoning and Michael's hoax is revealed. In the last scene of the film, he confesses to Julie, his love, that he has become a better man by being a woman. Seeing things from the other side of the table has made him a more sensitive human being, better able to empathize and understand the perspective of a woman on love and life. This sensibility is hinted at in the Hebrew term for intimacy, which is "*yadah*," "to know." The Bible says that Adam *knew* Eve. He knew her intimately say the Bible commentators, not only in a sexual sense, but in an emotional sense. He understood her as a person and, therefore, the intimacy expressed a profound knowledge and understanding of the other. Sex was not exploitative, but rather an expression of two souls comprehending one another in the deepest way possible.

Tootsie reaffirms the notion that for there to be true love, there must first be respect for the other. Romeo and Juliet are not the Jewish paradigms of love. Rather the paradigms are the patriarchs and matriarchs: Abraham and Sarah, Isaac and Rebecca, Jacob and Leah and Rachel. In all of these matches, what counts is character, not appearances. Proverbs tells us that outward beauty is false; what really counts is inner beauty – beauty of character and beauty of soul. It is this that enables relationships to blossom and endure, and this finally is what enables love to take root in *Tootsie*.

THE YOUNG VICTORIA (2008)
directed by **Jean-Marc Vallee**

A number of years ago, I wrote a book called *Kosher Parenting*, in which I pointed out that parenting is never finished. As one of my mentors once told me, "when you have small children, you have small problems, and when you have big children, you have big problems." The difference between parenting young children and parenting older children, however, is that small children generally listen to you and big children think for themselves. Older children will not simply follow your recommendations. They need to discover their own truth, their own path, not necessarily the one that well-meaning adults choose.

Nowhere is this more relevant than when children are choosing someone to marry. Jewish law wisely tells us that final decisions about marriage partners should be left to the principals, not to parents. Parents and elders can only provide guidance; children have to make the ultimate choice.

This dynamic is in evidence in *The Young Victoria*. Elders and wise men are ubiquitous, constantly theorizing about possible marriage choices for the young Queen Victoria. However, she thinks for herself and chooses a companion not based on political gain, but on emotional compatibility. Prince Albert, her chosen one, understands her origins, her aloneness, and her desire to be a good monarch and work for the welfare of her people. Their minds are on the same frequency, and it is instructive to observe their growing attachment to one another. They are honest with one another, they respect one another, they do not take advantage of one another, and they share common aspirations.

But their journey is not a smooth one. They have to learn to com-

plement one another to achieve their goals and dreams. Victoria is a queen and initially expects obedience from her husband. Albert, however, does not see himself as a tourist or subject in the Queen's palace, but rather as her husband and life partner. It takes time for Victoria to appreciate this aspect of her married life; but once she does, she fulfills herself both as monarch and as loving wife. One of her trusted advisors counsels her: "The Prince is able, clever, faithful. Let him share your work." She recognizes his wisdom and in a private moment with her husband tells him, "I hope you don't mind. I had your desk brought in." When she finally invites Albert to bring his desk into her office, it signals an understanding that they are in this together, that they willingly share their destinies, that they both want the best for England.

In a coda at the end of the film, we learn that Albert and Victoria championed reform in education, welfare, industry, and the arts, and that she reigned over England for almost the entire century, a remarkable feat for a monarch. Moreover, she was a mother to nine children.

The story of Albert and Victoria reminds us that enduring love is based not only on physical attraction, but on shared goals and dreams, the feeling that a common destiny unites a couple. This is a Jewish approach to marriage. When I speak to my children about marriage, I remind them that when two people are ideologically on the same page, when they share a common goal, then all problems are solvable.

Albert and Victoria's love represented the ideal synthesis of physical attraction and common purpose. As such it was the kind of love about which the Talmud writes: "When our love was strong, we lay on the edge of a knife." No matter what adversities they faced, they were confident they could be overcome because they shared one another's goals and dreams. This is a key component of a successful marriage.

ENOUGH SAID (2013)
directed by **Nicole Holofcener**

After my wife died suddenly of a brain aneurysm almost twenty-five years ago, my world fell apart. Emotionally adrift for a year, I then decided to remarry – not to replace what could never be replaced, but to begin a new chapter in my life. After a year of traveling from Atlanta to New York to date women, I married a divorcee. I had six kids and was busy working as a high school principal.

Marriage at that time in my life was entirely different from what I experienced in 1965 when I got married for the first time. Now I needed not only companionship, a friend and confidant, I also needed someone to help me manage my stressful professional life, and to help me with my children still living at home. These were complications and challenges that I did not imagine as a twenty-two-year-old getting married. Watching *Enough Said*, a story of two divorced people trying to connect romantically when they are both mature and wise in the ways of the world, reminded me that love at midlife is totally different from the star-crossed love of youth.

In *Enough Said*, Eva, a masseuse and a divorced mother of a teenage girl, meets Albert, also divorced and the parent of teenage daughter. Although not initially attracted to one another, they date and a relationship develops. Concurrently, Eva takes on a new client, Marianne, a poet who has also been through an unpleasant divorce. Eva and Marianne commiserate with each other, during which Marianne unloads all the idiosyncratic shortcomings of her ex. Eva and Marianne become fast friends until Eva discovers that Albert is Marianne's former husband.

Instead of revealing this to Marianne, she prods Marianne with questions about her ex-husband to learn more about Albert. She is

worried that Marianne may be right in her assessment of Albert and she may be wrong. Having gone through divorce once, Eva does not want to set herself up for another mistake.

Things come to a head when Eva's duplicity is revealed to Marianne and Albert, whereupon Eva's relationship with both of them dramatically changes. *Enough Said* begins as a comedy, but becomes a serious meditation on second marriages and honest communication between couples and friends.

Second marriages pose special challenges. Both parties come with lots of baggage from the previous relationship. Moreover, stepchildren are a wild card since they often are unwilling to accept the new spouse. In divorce, you are building upon an edifice of ruins. In a first marriage, two people often are driven by intense emotion in response to physical desire and do not fully consider compatibility of dispositions and shared values. An unsuccessful first marriage may be a reminder that passion alone does not make for a happy union. The first match may be ordained from Heaven, but that does necessarily mean it will be a happy union.

The Sages say that the success of one's second marriage is dependent upon one's merits, and it may be a more accurate indicator of long-term stability and happiness if it is not defined by the body, but by the mental and emotional components of a relationship. Albert is overweight and Eva is no longer the svelte person she once was, but both recognize at this point in their lives that marriage transcends the physical. It endures when it connects the mind as well as the flesh. Interestingly, the commandment to love one's neighbor as oneself is interpreted, in the view of the Talmud, to refer to one's spouse, who ideally should be one's best friend, not only one's lover.

It is not good for man to be alone, says the Bible. Solitude breeds all kinds of emotional distress. Whenever possible, say our Sages, one should remarry after divorce or the death of a spouse. Connection with other human beings enriches life, for it reminds us to focus not selfishly on oneself, but on significant others in our lives. *Enough Said* cautions us that relationships can weather many storms when they are founded on emotional, not just physical, compatibility and on honest communication.

SPORTS

Sports have always been an important part of my life. Basketball was a major preoccupation in high school and remained so until my 40s. Then recurring injuries plagued my game, since I could not keep up with the younger players. Running took the place of basketball and I ran five or six days every week for close to twenty years. I remember vividly how I made the transition from the contact sport of basketball to the solitary exercise regimen of running.

I was badly injured in a game of pick-up basketball because I could not switch directions quickly enough to avoid being hit by an oncoming player. During my recuperation, Hal Krafchick, the sports director at the Atlanta Jewish Community Center, recommended running as an alternative to basketball and suggested a particular brand of running shoe. I began to run short distances and slowly increased my mileage. Dr. Steve Kutner, a friend, introduced me to the Peachtree Road Race by running the course with me one Sunday morning, and Ray Taratoot, another friend, encouraged me to run the Atlanta Half-Marathon. I have never run a marathon, although many years ago I thought it was a possibility. Throughout my middle years, I enjoyed the simple pleasures of running.

I felt religiously motivated to run. The Bible tells us that we should live by the commandments. Our Sages explain that this means that in order to do God's will, we need to be alive and we need to be healthy. Since doing God's will is the purpose of life, I felt it was important to do whatever I could to preserve my health so I can perform good deeds. Running was the way in which I enhanced my physical well-being. Just as I studied Torah every day, I set aside time every day for my afternoon

run after the work day was done. Learning Torah nourished me spiritually and running nourished me physically.

The running life also afforded me time for contemplation, for relief from the stresses of the day, and to engage the imagination. When I ran, I let my mind wander. As I reached a comfortable stride, ideas ebbed and flowed in my mind, and oftentimes solutions to problems came to me as if in a reverie.

I viewed running as a form of self-therapy. Racing was not important, but running celebrates the active life and that inspired me to run and to encourage others to do the same. Although I never met him, George Sheehan, the cardiologist guru of running, was a mentor. He placed running in a spiritual context. There is a wonderful scene in *Chariots of Fire*, which captures this ethereal pleasure. When Eric, the Scottish running sensation, contemplates the idea that it is God who made him fast, we are drawn into the spiritual ecstasy that he is feeling. In a similar sense, running animated my soul. Later on, participating in a spinning class helped me to retain my fitness.

What running did for me can be replicated in other sports as well. Sports, in general, create a healthy mind and a healthy body. Moreover, as a kid, I was impressed with the positive effect on good character that sports promote. Whenever a basketball game was over, I remember the coach telling us to shake the hands of the opposite team whether we won or lost. I also remember him telling us not to argue with the referee. Following the rules was an important part of the game. Most of the films in this section demonstrate the power of sports to develop good character.

42 (2013)
directed by **Brian Helgeland**

Anger is a terrible trait. I was blessed to be raised by parents who seldom if ever argued. Tension was not a part of our household ambiance. But I did know people who argued constantly. There were the tenants who lived above us in our three-story house in Mt. Vernon, New York. Every day I could hear the hollering between husband and wife, parent and child. As I kid, I didn't know what to make of it except that it was not pleasant to listen to.

When I was courting my wife in the 1960s, we occasionally double-dated with another couple, who were constantly arguing with one another. They eventually married. At the time I was shocked since the arguing never seemed to stop. Someone always had to be right and the other wrong. Divorce came several years later and it did not surprise me at all.

The stirring *42*, the story of black baseball player Jackie Robinson, is a classic illustration of successful anger management, controlling one's emotions in the face of extreme provocation. Branch Rickey, President and General Manager of the Brooklyn Dodgers, wanted to bring African-American players into major league baseball. To accomplish this, he offered a contract to Jackie Robinson, who would become the first black to break the baseball color barrier. The film describes Robinson's year in 1946 with the Montreal Royals, the Brooklyn farm team, and his rookie year, 1947, with the Brooklyn Dodgers, as they fought for the National League Pennant.

Racism at that time was very much part of the country's landscape. Subjected to taunts from adults and children, who followed the bigoted example of their elders, Robinson endured much abuse. He knew it

would happen. Rickey, before employing him, informed him of the controversy that his hiring would generate. Moreover, Rickey told him that to be a success, he would have to control his temper. Robinson realized the historic nature of his employment and agreed to Rickey's terms.

Not only did some of the fans express racist rants to Jackie, but some of the players and managers did as well. In one particular game, the manager of an opposing team used racist epithets to unsettle him, but Jackie responded by hitting successfully, stealing a base, and scoring the winning run.

Although some of Jackie's own teammates were unenthusiastic about his joining the team, most supported him and championed his participation in the game. In one very touching moment, Pee Wee Reese, the team's shortstop, demonstrates his support of Robinson in a public way before a hostile crowd in Cincinnati, earning the kudos of Branch Rickey, the one responsible for bringing Robinson into the organization.

The *Ethics of the Fathers* defines the hero, the truly strong person, as one who can control his impulses. Strength in the Jewish view is not manifested in physical terms by muscle size or by possessing a large body. Rather it is defined by character, an inward quality.

Because we are all tested every day by irksome comments from business associates, acquaintances, friends, and family, Jewish tradition encourages us to control our anger in order to reach our potential as a holy people. Every day in my private prayers, I pray to God to help me control my reactions to provocations. As a teacher, I am tested in the classroom. I know that an inappropriate response to a child's problematic behavior can hurt the child and hurt me for a long time afterward. Words are like arrows and cannot be retrieved once released. Therefore, I have to think deeply before responding. *42*, in its depiction of the remarkable strength of character of Jackie Robinson, serves as an object lesson in restraint that demonstrates true strength.

A LEAGUE OF THEIR OWN (1992)

directed by **Penny Marshall**

When I lived in the United States, I taught high school students and adults. In Israel, I teach sixth grade middle school students, which I find very problematic. The kids often behave like kindergartners, uttering distracting irrelevancies like "he is sitting in my chair" or "he hit me first," thereby preventing me from teaching and preventing more serious students from learning. They test my patience as I try to teach them reading comprehension, grammar, and literature. In truth, my greatest challenge teaching them is not transmitting the material, but rather not losing my cool when I am confronted with their silly and immature behavior. I recognize that if I lose my temper, I will no longer be fit to teach them. As the classic Jewish text of wisdom literature, the *Ethics of the Fathers*, states, "An intemperate person cannot be a teacher." Teaching requires a calm demeanor for a teacher to be successful.

I was reminded of this as I was watching *A League of Their Own*, an entertaining film about the first ever women's professional baseball team. Created during World War II when many of baseball's stars enlisted in the Armed Forces to fight Hitler and Nazi Germany, the new league was intended to keep interest in baseball high by allowing women to play, thus generating excitement among fans and more revenue for owners.

The teacher in this story is Jimmy Dugan, the manager of the Rockford Peaches. A former baseball star with many home runs to his credit, he is now an alcoholic down on his luck. He has never coached girls before and takes the job because the only expectation of management is that he comes out of the dugout and wave to the fans. When,

after many weeks of ignoring his managerial responsibilities towards the team, he does attempt to give direction to the team, he is impatient with them and unforgiving when they make mistakes. His harsh and sarcastic tone demoralizes one player who breaks down in tears, to which Jimmy sarcastically and angrily responds: "There is no crying in baseball."

As the season wears on and Jimmy becomes more empathetic as a human being, he tries very hard to control his temper. He eventually understands the words of an umpire who once admonished him when he saw Jimmy treating a player badly: "Perhaps you chastised her too vehemently. Good rule of thumb – treat each of these girls as you would treat your mother." Jimmy finally accomplishes this. In spite of his disappointment, anger, and frustration when a player makes an error in a critical game, Jimmy uses all of his psychic energy to control his response. It is a triumph of will over emotion, and we admire his supreme effort.

In life we are constantly faced with these kinds of tests, in the home and at the workplace. Our Sages tell us that the truly strong man is not the one with these biggest muscles or the most deadly weapon. Rather it is the one who is able to control his emotions. *A League of Their Own* offers as an object lesson in self-control through the character of Jimmy Dugan, who with determined effort overcomes an insensitive and boorish past to become a man of feeling, devoted to the well-being of his charges. His prayer with the girls in the locker room before the championship game expresses his new found wisdom: "Lord, hallowed be Thy name. May our feet be swift; may our bats be mighty . . . And God, these are good girls, and they work hard. Just help them see it all the way through."

CHARIOTS OF FIRE (1981)
directed by **Hugh Hudson**

When I was first becoming an observant Jew, I found it difficult to wear a yarmulke (skullcap) in public. The head covering identified me as an Orthodox Jew. Although I was growing religiously, I still wanted to blend in and not be different. So I struggled inwardly. Sometimes I wore it, sometimes I donned a baseball hat, and sometimes I did not wear a head covering. My religious ambivalence came to the forefront when I accepted a role in our high school production of *The Diary of Anne Frank*. I played the part of Peter Van Daan, Anne's romantic interest; and in one climactic scene, I had to embrace Anne and kiss her. From an Orthodox perspective, this was a no-no, but I was full of myself and my acting ability and did not pass on accepting the part nor the kissing that went along with it.

The play was presented on Friday night, the Sabbath, as well as on Saturday night, and my synagogue rabbi came to see the play on Saturday night. I sensed an oncoming crisis. I was going to kiss a girl publicly in front of my rabbi. What to do? The answer: I did it and my face turned beet red from the embarrassment. Trying to live in two disparate words was impossible for me, and that play became my last foray into acting in a play with a coed cast. My approach to my growing religious observance was inconsistent, and it was not until years later that I had the courage and wisdom to live a consistent religious life in which my actions in life mirrored my ideology. Which is why I became enamored with *Chariots of Fire*.

I first saw *Chariots of Fire*, a drama about the nature of sports, the competitive drive, and the consistency of religious convictions, in 1981 when I myself was running five or six times a week. The film is about

two men who are running in the 1924 Olympics: Eric Liddell, a young Scottish preacher, and Harold Abraham, a very competitive British Jew. The story chronicles their journey to Olympic glory, and in the process contrasts the worldviews of these two men.

The crux of the movie occurs when Liddell is asked to compete in an Olympic event on Sunday, his Sabbath. He has to wrestle with his desire to compete on the one hand, and his desire to be faithful to his religious beliefs on the other. In the end, he places principles before personal gain. Moreover, he understands that all his strength comes from God, and that all his earthly activities should express his connection with the Divine.

Jewish tradition tells us that whatever we do in this world should be done to glorify God. In the classic *Ethics of the Fathers*, it states: "All that the Holy one, Blessed is He, created in this world, He created solely for His glory." The rabbis deduce from this that even mundane acts can acquire sanctity if we perform them with the right attitude. Eating can be a good deed if we eat to be strong to serve God. Sleeping can be a good deed if we sleep in order to give our bodies needed rest so that we can rise like a lion on the morrow to do God's work.

This is the mindset of Eric Liddell. Running serves as an opportunity to glorify God, and he reminds us to place spiritual integrity over worldly glory.

FACING ALI (2009)
directed by **Pete McCormack**

When I began my rabbinic career, I had two options: to be the head rabbi at a synagogue or to be the assistant to a veteran rabbi and learn the ropes under his mentoring. I chose to do the latter, feeling that as a rookie rabbi I would glean much wisdom from being in the shadow of a successful rabbinic leader, wisdom that would make me a better rabbi once I took on the mantle of synagogue leadership on my own. It was a career move I never regretted. In fact, my lifelong connection with the senior rabbi always enhanced my reputation in future career positions.

I thought of this as I watched *Facing Ali*, a compelling story of the men who fought Muhammad Ali, the great boxing legend. Although each fighter was a champion in his own right, the moments of glory when they were in the ring with the "greatest" was a treasured vignette of their boxing careers, which influenced their lives not only at that moment, but for many years afterward.

The documentary recounts the career of Muhammad Ali through archival footage and then switches to the real life narratives of the men who fought him in the ring. Each story is compelling, especially when one compares the contemporary footage of the fight with where these men are today. No longer are they the perfect picture of health and physical power. Now they are older men, vastly wiser through the crucible of life experience. George Chuvalo, a very articulate senior citizen, witnessed the death of three of his sons to drugs and his wife's suicide after the death of his second son, yet he remains accepting of these major tragedies in his life. He is sad, but not bitter. He shares with the viewer how important are one's loving relationships in life. Love, he

observes, makes you feel strong, tender, secure, and important. This is the wisdom of man who has become, through adversity, very reflective about what is truly valuable in life.

Many of the fighters sound one recurrent theme; namely, that it was poverty and lack of education that led them to take up boxing as a way to break down barriers and gave them a chance to make a lot of money. Some admit to not being able to handle the notoriety of winning a fight against "the greatest." They acknowledge many mistakes in their lives, but all of them still look fondly upon their moment in the sun fighting for the heavyweight championship against Ali.

One of them even notes that, if not for the Ali fight, no one would be interested in him during his retirement years. Certainly he would not be in a movie if he had fought ordinary mortals. It was Ali's aura that rubbed off on them and gave them the chance of a lifetime to improve their reputations and their finances. Here are some of their comments: "fighting Ali changed my life," "to be in the ring with him was an honor," and "I can't thank him enough for giving me the chance."

The *Ethics of the Fathers* tells us that we should rather be the tail of lions than the head of foxes. The Sages explain that this means it is good if we associate with great thinkers who possess sound morals rather than with the unlearned and unsavory. We naturally adapt to the environment around us, and we learn from our surroundings. If those around us are philistines, then there is a likelihood that we will be too. If, however, we are in the company of refined and ethical people, we will develop ourselves simply by being in their proximity. The lesson: We grow more in every way when we align ourselves with greatness.

Although the world of professional boxing does not represent the pinnacle of intellectuality or morality, there is in the world of professional sports the notion that there is much to learn from the masters of any sport. *Facing Ali* reminds us of the value of encountering greatness and the lasting positive impact it can have on our lives.

HOOSIERS (1986)
directed by **David Anspaugh**

I first met Demetry, a twelve-year-old Russian émigré, when he enrolled as a student at Denver Academy of Torah, a Jewish elementary day school of which I was the principal. He encountered formidable educational challenges because of his lack of English language skills, and teachers were worried that he would not survive in a dual-curriculum Jewish day school. And then something extraordinary happened. We instituted a "Shakespeare Festival" for the seventh and eighth grade students in which they would perform an abbreviated version of one of the great bard's plays. Demetry was given a speaking part, and he surprised us all. He read his lines with the proper pronunciation and with a clear understanding of the power and meaning of Shakespeare's words.

Watching him underscored the maxim in the *Ethics of the Fathers* that "one should never disparage any man, for every man has his hour." Too often we quickly stereotype people when we first meet them and that first impression becomes our only impression of that individual. Demetry's blossoming at the school play reminded me to withhold judgment when meeting people, for we do not know who they really are after only one or two superficial encounters. Demetry astonished us all; and from that moment on, teachers and fellow students viewed him differently.

I recalled Demtery as I was watching one of the iconic scenes in *Hoosiers,* the story of a small school's basketball team in the Midwest that made it to the state finals and won. The movie recounts the narrative of Coach Norman Dale who turns around the school's athletic fortunes by stressing fundamentals and good character. The iconic

scene to remember depicts a lowly bench player, someone everyone expects will perform poorly, coming in late in the game and making the winning foul shot. It is one of those fictional moments to savor in one of the great sports movies of all time.

The movie also brought back memories of my own teenage basketball career in Mt. Vernon, New York, where I played basketball at the JCC every Sunday. My team was the Spartans, but we did not play like warriors. I do remember on several occasions that I had an opportunity to make an easy foul shot or lay up and win the game; but unfortunately, I usually missed the crucial shot and left frustrated and disappointed. I also vividly recall that one year during high school, I was chosen to be on the JCC All-Star team. It was an honor, but one that did not auger well for my basketball career. The coach had his favorites and I never got into any game until the last game of the year. I sat on the bench for almost the entire season and when he finally called me in, I froze and lost the ball on my first possession. So much for All-Star teams.

That is why I identified with the hero of *Hoosiers* who came off the bench to score the needed points at the critical moment. The image of the ball going through the net – sheer sports poetry – still resonates in me twenty-five years after I first saw the movie. It is clear that the underdog succeeded because the coach had confidence in him and treated him like a winner. The lesson: If we treat people like winners, they will often surprise us. The Talmud tells us of scholars who started with little knowledge or background who became spiritual giants because someone saw greatness in them. Rabbi Akiva was one of these, and it was because his wife Rachel believed in his potential that he broke with his humble and unlettered past to become one of the greatest minds in Jewish learning.

The messages in *Hoosiers* are obvious ones. The movie is not subtle. In truth, sports films are often a metaphor for life, and watching *Hoosiers* can give us lots of spiritual direction and inspiration.

THE NATURAL (1984)
directed by **Barry Levinson**

As a young boy, I loved basketball. My favorite Bar Mitzvah present was a basketball. My father even erected a backboard and hoop with a net in my backyard, and I played regularly with my buddies, enjoying the sound of swish when the ball fell through the net without touching the backboard or rim. The backboard was affixed to the roof of a free-standing garage and hung down from there. The problem: the top half of the garage had glass windows and every once in a while an errant ball would shatter the glass. That did not stop us from playing.

On Sundays I played at the local JCC on my team, the Spartans, and felt great delight and contentment when I scored a few points. I liked to play the forward position since I was closer to the basket and had more opportunities to score. On rare occasions, I experienced the athlete's high, an almost transcendent feeling of satisfaction after winning a game and knowing that I contributed to the victory. I was reminded of those golden moments as I watched *The Natural*, an almost mythical narrative of baseball hero Roy Hobbs.

Roy's love of baseball originates with his father, who encouraged Roy to develop his God-given talents. After his father dies, Roy experiences an epiphany when a lightning bolt strikes a tree in his backyard, splitting it in half. From that tree, Roy whittles a baseball bat that he names Wonderboy, which functions as a symbolic Excalibur as Roy hones his magical baseball skills.

Several years later, Hobbs has a chance to play in the big leagues. On the train to his interview, he meets a beautiful but strange woman

who invites him to her hotel room in Chicago. There she shoots him and kills herself.

Flash forward fifteen years and Roy Hobbs, after drifting from one job to another, finds an opportunity to play professional ball again for the New York Knights. He is paid a pittance, but now he has a chance to play the game he loves. His ability is questioned by the team's manager who, when he first meets Roy, exclaims: "People don't start playing ball at your age, they retire!" Although viewed at first like a senior citizen whose best years are behind him, Roy's manager and teammates eventually recognize his talent and rally around him as their hero.

Politics and greed enter the picture when the last place Knights begin to win games and make a serious run for the pennant. Unsavory people attempt to bribe Roy, but to no avail. When bribery does not work, they poison his food in hopes to prevent him from participating in a critical pennant game. The tension mounts as Roy struggles to play in spite of the doctor's counsel that he is risking his life and health by playing.

In a magical moment of cinema, Roy shows his best self, determined not to repeat the mistakes of the past. The climactic scenes are sheer poetry, evoking a transcendent aura as Roy becomes the savior of the New York Knights. Every time I watch these closing frames of the movie, which in essence evoke the redemptive power of sports, I choke up with tears.

Roy Hobbs climbs a mountain to achieve the success that eluded him as a young man. Moses also climbed Mt. Sinai twice. The first time he was greatly disappointed after his mission was compromised by the sin of the Golden Calf. The second time he was successful when the children of Israel wholeheartedly accepted the yoke of the commandments.

Moses found an opening to rededicate himself to his original goal, for a do-over, and he was determined to achieve it. Moses, too, understood that no matter what his past mistakes were, there is always an opportunity to begin again. Hope does, in fact, spring eternal as it did for Roy Hobbs.

Roy's journey towards self-fulfillment reminds us of the hidden message of the proverbial spring training season, when one begins anew regardless of one's lack of success during the prior season. The mantra "wait till next year" is a clarion call to tell us that past failure and even advanced age do not preclude us from advancing in life.

CINDERELLA MAN (2005)
directed by **Ron Howard**

A few years ago, a friend of mine wanted to borrow some money from me. Ordinarily, I would have been happy to give it to him. But there was one problem. I lent him a substantial amount of money a year before and he never paid me back. I told my friend that I could only lend him a small amount this time because of what happened in the past.

Everybody understands that people go through hard times and they may need help to survive a financial crisis. However, lenders lose patience with people who do not make a good faith attempt to pay back their debts. I shared with my friend my experience serving on school scholarship committees. Committee members all want to help, tolerating low payments as long as they are made regularly. But when the debtor does not pay even a small amount, the mood changes. Committee members get angry when people stop paying altogether. Our Sages reinforce this approach to borrowers when they tell us that a person who borrows and does not pay back his debts is a bad person.

Cinderella Man, the fact-based narrative of boxer James Braddock, is about a man who pays his debts. After a successful beginning in his boxing career, Braddock loses everything in the Great Depression. He is so desperate that he begs for money from old friends in order to pay a heating bill to keep his children warm in the dead of winter. He dilutes milk with water so that his kids can have some nourishment in difficult times. Reluctantly, he asks for government relief money when he confronts extreme poverty. All this he does to provide for his family. However, when he achieves a modicum of success after a number of years, he returns the welfare money even though he is not required

to do so. When a reporter asks him why he did this, he says: "I believe we live in a great country, a country that's great enough to help a man financially when he's in trouble. But lately, I've had some good fortune, and I'm back in the black. And I just thought I should return it."

Jewish tradition says that one must do everything one can to avoid becoming a burden on the community. James Braddock lived by this creed. In fact, the Talmud states that a man should flay a carcass in the street, never feeling that work is demeaning, no matter how great a scholar he may be. The Talmud actually mentions many great sages who did manual labor in order not to become a burden on society.

We can also admire Braddock as a parent. When times are tough and his son steals salami from a local vendor, he takes him to the butcher to confess his sin and to return the stolen meat. What he says to his son is instructive: "We don't steal, no matter what happens. There are people who are worse off than we are." Braddock recognizes the value of a teachable moment.

In a coda at the end of the film, we are told that Braddock "served honorably in World War II, later owned and operated heavy equipment on the same docks where he labored during the Great Depression, bought a house in New Jersey with the winnings from his celebrated come-from-behind victory over Max Baer, raised his children in that house, and lived there with his wife Mae for the rest of his life." Success never went to his head. He remained a modest man, content to live quietly and productively for the rest of his life. Our Sages tell us that we can learn from every man. James Braddock was such a man.

REMEMBER THE TITANS (2000)
directed by **Boaz Yakin**

It was in the 1950s. I was attending a public junior high public school in Mt. Vernon, New York. There were two high schools in town, Edison and Davis. Edison focused on vocational training and Davis focused on getting kids into college. Most blacks went to Edison and most whites to Davis. But it was a time of civil unrest throughout the United States, and there was a drive to create one large Mt. Vernon high school that would be more fully integrated. Nationally, there was a movement to change the stereotypical view of blacks as low achievers and encourage more blacks to attend university.

My junior high was predominantly black. My childhood neighborhood changed once low income housing for the area was built. Whites moved away in droves and I was the only white kid on my block. My parents could not afford to move even if they wanted to, so I developed friendships with the black kids in my school. Many had exotic names and I was fascinated by their distinct personalities. I remember with fondness Linwood Lee, gentle and soft-spoken; Wendell Tyree, strong and boisterous; and Quentin Pair, a thoughtful and brainy young man.

It is with this background that I watched *Remember the Titans*, a rousing and inspirational sports film with a subtext of racial tension, a tension that influenced what happened on the football field in Alexandria, Virginia in 1971. T. C. Williams High School has just been integrated, and the favorite to become the new coach of the team, Bill Yoast, is passed over to allow Herman Boone, a successful black coach, to take charge of the football program. In spite of his initial disappointment, Yoast stays on to become Boone's assistant so that the boys he worked with for so long can fulfill their athletic and scholastic potential.

During training camp and the football season, the players work with one another, get to know one another, and in most cases, finally accept one another for who they are, not for what they may or may not represent. What matters is performance, not race, and the boys bond during a challenging season in which they are tested both on and off the field. Ultimately they understand that welcoming the stranger, the one who looks different, into your midst brings godliness into the community, for all men are images of the Divine.

The Bible is filled with references encouraging us, and even mandating us, to be kind to the stranger, to the outsider who is different. It is connected to the Jewish experience in Egypt, about which Exodus states: "You shall not wrong a stranger or oppress him for you were strangers in the land of Egypt." Moreover, there is a classic adage in the Talmud that "we are all responsible for one another." This emerges from the basic notion that we all are created in God's image and we are all part of the one family of man. We are all brothers regardless of the color of our skin.

The Kabbalists write that the commandment "love your neighbor as yourself" has mystical meaning numerically. The phrase "as yourself" in Hebrew is the numerical equivalent of the word "*Elohim*," one of the names of God. This numerical equivalency indicates that when you love your neighbor, you are in essence manifesting your love of God.

Interestingly, we see that the biblical story of Abraham stresses the priority of being nice to the stranger over praying to God. Abraham interrupts his prayers when three strangers come to the door of his tent, for welcoming the stranger takes precedence over conversing with God.

Remember the Titans, based on a true story, reminds us that great things can happen when we approach a situation without the baggage of prejudice and old memory tapes, when we welcome the stranger in our midst to the family of man.

DECISIONS

When I served as a synagogue rabbi, I was often asked by congregants to listen to a dilemma they were facing and then to offer some guidance. As they explained their situations to me, I often felt I needed more information to give them sound advice. Sometimes the problems were straightforward; other times I counseled congregants to wait until more information was available before making a decision. I rarely regretted telling them to wait a little longer before adopting a particular course of action, but I would regret offering advice prematurely before all the facts were in.

Jewish tradition encourages debate when the way forward is unclear. The Talmud is the quintessential text embodying the argumentative spirit searching for truth. The classic examples are the debates between Hillel and Shammai, two giants of Torah scholarship. They provide a model to emulate. They both want what is best for the community and they are devoid of personal agenda, so their disagreements are viewed positively. They may arrive at different conclusions, but both are animated by the same quest for truth.

The creation narrative provides a good example of thoughtful decision-making. There, God says, "Let us make man." The commentators ask: To whom is God talking? Who did God have to consult with before creating the world? In truth, God did not have to consult with anyone, but the Bible here is teaching us an important life lesson; namely, that before embarking on any important task, we should always consult others. God wanted to teach us that no matter how important and knowledgeable we think we are, we should seek counsel with others to make better decisions.

As I get older, I realize how little I know. As a young man, I thought there were only two ways to see things: the right way and the wrong way. With the benefit of life experience, I have learned that there are a variety of different approaches to life's challenges.

There is a Talmudic calculus for decision-making, which, in simplified form, was transmitted to me by my Torah teachers. Decision-making rests on three basic givens: there is a God in the world, He gave us instructions for living, and there is reward and punishment – accountability if not in this world, then in the next. Flowing from those givens are some key questions, such as what is my mission on this earth, what does God want of me, and what is my purpose in life? If I can answer all these questions clearly, then I have a basis to make a good decision.

If after answering all of these questions, I still am confused, there is a hierarchy of intellect and wisdom I can go to get guidance – namely, my Torah teachers who are older and wiser than I. If someone asks me to help him or her make a decision, I try to avoid responding under the pressure of the moment. My favorite response is "give me or day or two to think about it." In this way, I can more carefully analyze the situation and come up with suggestions that will be helpful.

The films in this section often deal with questions of morality, making good choices in a confusing ethical climate. There are no easy answers.

A MAN FOR ALL SEASONS (1966)

directed by **Fred Zinneman**

When I assumed my first position as a synagogue rabbi, I was a man with many opinions. Fresh out of rabbinical school, I felt I had access to the whole truth and nothing but the truth. If someone wrote an article with which I disagreed, I wrote back a sharp response to indicate the intellectual weakness of the writer's argument and the truth of mine. I could not resist not being silent. I knew the right answers and it was my mission to let everyone else know of the correctness of my position as well.

Very soon, thankfully, I became aware of the arrogance and silliness of my ways. I received an acidic letter from someone whose article I took issue with. He accused me of narrow-mindedness and insensitivity. As I reflected on his comments, I realized he was right. There was no reason for me to publicly criticize someone else just to demonstrate the correctness of my position. I forgot the maxim of our Sages that silence is a fence to wisdom, and that my overall success in the rabbinate did not depend on my diminishing the reputation of others. There was no point to my diatribes. I should have remained quiet, and from then on, I did.

The issue of silence is critical in *A Man for All Seasons*, the story of Thomas More and his quarrel with Henry VIII, King of England, who wanted More, in his capacity as Lord Chancellor of England, to ask Pope Clement VII to annul his marriage to Catherine of Aragon, who did not bear him a male child. More resigned rather than take an Oath of Supremacy declaring the King as Supreme Head of the Church of England, an oath that would allow the King to dispense with the need to ask the Pope for the annulment.

More decides that silence will be his response to the political pressures around him. He is cautious about his words and serves as a sterling example of the man who measures carefully each and every word he utters, knowing that the wrong word can ruin him in this world and possibly in the next.

However, he cannot escape the entreaties of the king, and ultimately More is branded a traitor for his unwillingness to take an oath supporting Henry's new marriage to Anne Boelyn. More's silence is construed as high treason against the king.

At his trial, the matter of silence is a key argument of Cromwell, the prosecutor, who explores the different interpretations of silence: "Gentlemen of the jury, there are many kinds of silence. Consider first the silence of a man who is dead. What does it betoken, this silence? Nothing; this is silence pure and simple. But let us take another case. Suppose I were to take a dagger from my sleeve and make to kill the prisoner with it; and my lordships there, instead of crying out for me to stop, maintained their silence. It would suggest a willingness that I should do it, and under the law, they will be guilty with me. So silence can, according to the circumstances, speak." Cromwell then attacks More by suggesting that his silence is a clever denial of Henry's authority as Supreme Head of the Church of England.

More responds that his silence should not necessarily be interpreted as denial, but rather as the silence of consent. In truth, he should be acquitted for he has never said a word against the King.

Jewish tradition has much to say about silence. The *Ethics of the Fathers* offers several pithy statements: "There is nothing better for a man than silence. Silence is a fence to wisdom. He who increases his words increases sin." Clearly, the thrust of Jewish tradition is to weigh one's words. Once uttered, they cannot be recalled. Therefore, it behooves us to carefully consider the value and purpose of our speech before opening our mouths to offer an opinion. I am thankful I learned this lesson early in my career.

127 HOURS (2010)
directed by **Danny Boyle**

My wife and I enjoy visiting America's national parks and going for short hikes. I am a bit impulsive on the trails and am ready to start walking at almost any trailhead. My wife is more methodical. She wants to know if the trail is a loop, how long the hike will take, and whether we have enough water to sustain us for the duration of the hike. As I get older, I realize the wisdom in her words, and now I plan carefully for such adventures to insure that I do not put myself at risk. I thought of my own hiking experiences in the Canyonlands in Utah as I watched *127 Hours,* the true story of Aron Ralston, an extreme sportsman who finds himself trapped in an isolated canyon in Utah after a boulder falls on his arm.

The story begins on Friday, April 25, 2003, when Aron is preparing for a day of hiking in Utah's Canyonlands National Park. Excited about his upcoming adventure, he is careless about his preparation. A clever camera shot of his hand trying to find stuff in a closet reveals that he forgets to take his trusty Swiss knife with him, a fact that will have consequences later on.

Once into his hike, Aron climbs over and through narrow stone passageways, and then tragedy strikes. He dislodges a large boulder, which crushes his right arm against the canyon wall. He calls for help, but no one can hear him. He is in a remote section of the park with no one nearby. Moreover, he has told no one where he was going that day, and his situation soon turns desperate. Realizing that his fate is in his hands only, he begins a video diary with his portable camera and starts to ration his water and food.

As his strength ebbs away, he understands that the sole way to survive

is to amputate his arm, a near impossible task with a dull-bladed knife on a multi-tool device. With each passing hour, Aron gets groggier, and thinks about his friends, his family, and his uncertain future. Finally, he accepts the reality of his situation and methodically plans to amputate his arm with the crude devices he has available. It is both wrenching and riveting to watch his ordeal.

The ordeal changes Aron. Instead of being the independent adventurer responsible only for himself, he now understands that he needs others. His tortured cry for help at the end of his trial is a recognition that living for oneself is ultimately a lonely existence.

On another level, Aron's ordeal reminds us of the importance of properly preparing for a dangerous trip, letting people know of your whereabouts, and evaluating the inherent risk before attempting a perilous task. Furthermore, it reminds us to think about the definition of an acceptable risk when it comes to engaging in problematic behavior that may lead to loss of life.

Jewish law is prescriptive regarding the notion of acceptable risk. The Bible says "you shall guard your souls," which means that we should not do anything that jeopardizes our health and safety. The Talmud even instructs us not to walk next to an unstable or shaky wall. Furthermore, if we build a house, we have to ensure that it is safe. If it has a roof that people can traverse, the roof must have a fence. If we own a dog that bites people, we have to make sure that the dog is in a secure location so that guests to our home are free of danger. Recent codes of Jewish law forbid smoking under the same guideline. Smoking is hazardous to your health and, therefore, is considered an unacceptable risk.

127 Hours is a gripping narrative of survival. Embedded within the story are many life lessons. It encourages us to celebrate and enjoy life, to value the presence of significant others in our lives, and not to be careless in our decision-making and place ourselves in unnecessary danger.

A FEW GOOD MEN (1992)

directed by **Rob Reiner**

A Few Good Men is an outstanding courtroom drama with a complex agenda. On one level, it tells the story of two marines who assault another marine, resulting in his death. What were their motives? Did they attack him because someone higher up in the chain of command ordered them to do so? Most important, is a marine expected to follow an order even when it goes against his moral sensibilities? Indeed, these are heavy questions; and the answer in part lies with what kind of conduct is expected of a marine. He is a soldier fighting to protect his country, a noble cause. But in the process, he may lose his moral rudder and begin to devalue the life of others. There are no easy answers; and the film, in general, presents a balanced view of a very complicated topic.

On another level, *A Few Good Men* considers the question of whether people are willing to listen to the truth when it contradicts the very way they live.

Several years ago, a good friend of mine lost his job and wanted to borrow some money from me to use as a bridge until he found another job. I gave him the loan, but inwardly felt uncomfortable. I knew that my friend was a dreamer, not rooted to reality. He had moved from job to job, always in search of the perfect position, but he never found it. Moreover, he had a reputation for being wasteful with his money and, in fact, had no savings after being employed for fifteen years. I debated in my own mind whether I was an "enabler," indirectly encouraging my friend to continue with his irresponsible and self-destructive ways. I wanted to tell him the truth, but I was not sure he could hear what I had to say and so I remained silent.

A memorable scene in the movie – ask anyone who has seen it – addresses this very issue. A courtroom confrontation between Tom Cruise, playing the defense attorney for the accused soldiers, and Jack Nicholson, playing General Jessup, the general who gave the questionable command, describes the sacred duty of a marine to defend his country. This depends upon following orders, orders that, at times, place the marine on a slippery moral slope but which must be carried out nonetheless. This is Jessup's truth, which guides him as a military man devoted to defending the country. When skillfully provoked by the defense attorney, however, he loses his composure and shouts to the courtroom: "You can't handle the truth." Handling the truth means accepting complexity, realizing that in the pursuit of a noble cause, there may be collateral damage that may be unwelcome but necessary. Tom Cruise may have won the case, but Jack Nicholson's assessment of his military reality is not to be dismissed.

Watching *A Few Good Men* reminded me of the difficulty all of us have in hearing the truth. To hear the truth, we must be willing to accept discomposure, complexity, and the reality that truth can be painful even as it enables us to grow. The Torah tells us that we have an obligation to reprove people, to tell them the truth about their character inadequacies so that they can improve. But the commentators make an interesting point based on the unusual language of the biblical imperative "you shall surely reprove." In Hebrew this is expressed by a doubling of the verb for "reprove." The double term indicates that we should only give reproof if the recipient will listen. Sometimes it is wiser not to reprove if the listener is not ready to hear it.

MONEYBALL (2011)
directed by **Bennett Miller**

I like teachers and have great respect for them. This is why in my early years as a school principal, I always found it difficult to fire a teacher even when it was clear to me that it had to be done. One particular case still haunts me. The teacher was a wonderful person, but was boring. After much observation, I knew I would have to terminate him but I was conflicted. He had a large family and my firing him would have great consequences for his family. I agonized and finally called a mentor for advice. He was quick and to the point. He said: "You are not an employment agency. You must do what is in the best interest of the students." It was one of those whip-lash moments. Everything became clear. Students come first, and that conversation guided much of my subsequent decision-making in my professional career.

I was reminded of that conversation as I watched *Moneyball*, a smart, insightful movie about the business side of baseball. Billy Beane, general manager of Oakland Athletics, must release a player and he does it with intelligence and style. He knows that his goal is to win games, and he will do whatever is necessary to achieve his end. He never loses his focus. He calls the player into the office and with a smile informs him: "Jeremy, you've been traded to the Phillies. This is Ed Wade's number. He's a good guy, he's the GM. He's expecting your call. Buddy will help you with the plane flight. You're a good ballplayer, Jeremy, and we wish you the best." The parting is necessary, but it is humane and brief.

Beyond serving as a model of management, Billy Beane's story also has other important life lessons. Billy determines that players are valued incorrectly and that even a team with limited financial resources can

find undervalued players who can be melded into a winning team. His strategy: Select players with the highest on-base percentage. Don't buy players; buy runs and you will win ballgames. The strategy is successful, setting a precedent for how players will be recruited in the future. The lesson: Sometimes we have to shift our paradigms in order to be successful at solving problems.

I had to shift my paradigm when I first began teaching. At first, my primary concern was teaching the material. In a few years, I realized that to be successful, I needed to alter my perspective. The successful teacher focuses on students, not just on information. That paradigm shift would make a dramatic difference in the way I taught and the way students learned. I was now teaching people, not facts, and the classroom dynamic changed.

Another life lesson: Statistics alone cannot predict the future. Scouts saw Billy Beane as a first round pick and they offered him a huge contract with a major league team right out of high school. Billy then came to the proverbial fork in the road. Should he go to Stamford on a full scholarship or sign with majors? He chose the latter, but never fulfilled the potential that scouts saw in him. Money and fame were the allure; but when he left professional baseball, he vowed never again to make a decision based upon money alone.

These lessons reflect Jewish sensibilities. The ability to see alternate points of view, to shift paradigms, is the essence of Talmudic learning. The great rabbis Hillel and Shammai looked at the same realities but possessed vastly different approaches to solving problems. Moreover, King Solomon reminds us at the end of his life that wealth does not bring happiness. The truly wise man is the one who is happy with what he has.

SAVING PRIVATE RYAN (1998)
directed by **Steven Spielberg**

My father served in the United States Navy in World War I. He came to America from Russia, fleeing the violent pogroms, in which his own father had been murdered. Enlisting in the Navy partly because he felt a great sense of gratitude to the United States, he was very appreciative of this country that welcomed him and provided safe haven.

Our family was very patriotic. We would always "buy American." It was unthinkable for us to even consider buying a foreign car, and we regularly attended the Memorial Day parade in which my father and other veterans marched.

Watching *Saving Private Ryan* rekindled that deep sense of patriotism that I felt as a child. It is a moving story of soldiers banding together to protect America and its values of democracy and to destroy an evil enemy. Center stage is Captain John Miller played by Tom Hanks. Captain Miller is an exemplary soldier and human being, a man who assumes a leadership role not because he wants the glory, but because fate has placed him here. A school teacher by profession, he now finds himself leading a group of soldiers into battle. It is not where he wants to be, but it is where he needs to be. He understands the aphorism of the *Ethics of the Fathers*: "In the place where there is no man, strive to be a man." Circumstances have placed him into a leadership position he did not seek, and now he rises to the occasion to fulfill his mission.

Miller's private and public personas are striking. To his charges, he is the wise and experienced leader. In private, however, he reveals his self-doubt and anguish over the loss of his men. There is a moment when he, alone at night, cries like a child, all the while looking over his

shoulder to make sure no one sees him in this vulnerable emotional state. Leadership requires this dual sensibility, to project strength while at the same time feeling the pain and uncertainty of your charges.

Miller doubts himself; but, in spite of it, he accepts responsibility when he realizes that this is what is required to achieve success. He even places his own life in danger to save the lives of others. Moreover, Miller is a humble man, self-effacing, never lording over his men; rather he asks them for counsel in the process of his own decision-making. He does not assume that he knows it all, but rather wants the best advice available before giving his men orders. Here, too, he models the wisdom of Jewish sages who say that "man should never act as a judge alone," but always consult others before deciding important issues.

The *Ethics of the Fathers* tells us the wise man is he who learns from every man. Observing how John Miller deals with crisis on a daily basis provides us with a role model of how to be a *mentsch*. Both by profession and by personal inclination, he is a teacher, always conscious of his own obligations and the expectations and needs of others. He knows that a teacher is responsible for his students in many ways. He not only transmits knowledge to them, but he also mentors them, giving them wisdom for life so that they can grow into responsible adults. His life reminds us to ask a question of ourselves: What do my words and actions, especially at moments of crisis, convey to those around me, who look to me for guidance and support? What do people learn from me?

MARGIN CALL (2011)
directed by **J.C. Chandor**

During my years in Jewish education, there were stressful moments when I felt a need to take counsel with someone older and wiser than me. Fortunately, experienced lay leaders in the community often provided me with a fresh perspective on an issue as I navigated my school through a challenging time. One lay leader, in particular, was skilled at enabling me to shift my paradigm and arrive at sound decisions. His conversations would always begin with the phrase: "Conventional wisdom says . . ." and then he would launch into his own analysis of the situation. Talking with him was helpful because his valuable insights helped me see beyond the obvious.

There is a mesmerizing scene in *Margin Call*, a profanity–laced story of a Wall Street meltdown with moral ambiguities at its center, which reveals senior wisdom at work. Although it is a negative example applied to the world of finance, it demonstrates how an older person sees things differently from a younger person.

Seth Bregman, an engineering PhD from MIT who now works as a risk management analyst, discovers that his firm is on the verge of a total financial meltdown. He shares the information with his superior, who in turn shares the information with his superior. A middle of the night meeting of all the senior executives is called to determine how the company will deal with this impending crisis. One suggests selling off the toxic stock before the market can react to news of their worthlessness. Another feels that this approach will forever ruin the company because people will never trust the company again. And so the issue is debated throughout the night until the moment of reckoning when

the stock market opens and we witness the consequences of decisions made in an environment of moral compromise.

It is fascinating to observe the way John Tuld, the CEO, approaches the problem. He does not ask for the minutia, but rather wants to understand the big picture. When Seth attempts to explain the crisis, Tuld tells him: "Speak as you might to a young child, or to a golden retriever, and tell me the nature of the problem." He informs the group that he gets paid the big bucks because he can predict the future of the company, not because of his everyday scrutiny of details. The details are best left to the analysts like Seth who can understand the numbers in sophisticated ways.

What emerges from this scene is an understanding of the radically different approaches of the young and the old to the same problem. Both kinds of wisdom are useful. The young man knows facts and figures. The old man sees beyond the detail and into the heart of the matter. His desire for a simple explanation of why this calamity has occurred reflects his profound grasp of the problem and its ripple effects both now and in the future. In my own memory, I can recall many board meetings that meandered until one senior member of the board asked the simplest of questions to bring everyone back to the core issue being discussed.

The *Ethics of the Fathers* teaches us that the wise man learns from every man, but there is a cautionary note: "Learning from the young is like eating unripe grapes, whereas learning from the old is like eating ripe grapes or drinking aged wine." The Sages suggest that one should favor the wisdom of the older man who speaks from experience as well as from knowledge.

Moreover, the Talmud tells us that as man ages, he becomes fit for attaining deeper levels of wisdom. For example, at five years of age, he may know Scripture, but it is not until age forty that he really begins to understand it. *Margin Call* reminds us that considering things from a senior's point of view, even if we disagree with him, may enhance our own understanding of a problem.

EQUILIBRIUM (2002)
directed by **Kurt Wimmer**

When I was in college in the 1960s, it was acceptable and fashionable to be a liberal arts major. I had friends who majored in Philosophy, History, Music, Art, and English. Studying the liberal arts was cool because it meant you were a Renaissance man prepared for everything life had to offer. Liberal arts majors understood the past and were better able to navigate the future because of their well-rounded education. I remember hearing a lecture by Rabbi Joseph Soloveitchik, a master of philosophy as well as Torah, in which he said that some of the most important decisions that one makes in life are not based on calculations, but on emotional leaps of faith. He cited the decision to get married to a particular person as one example. All this ran through my mind as I watched *Equilibrium*, a violent science-fiction thriller which posits that human emotion is the root cause of war and that the way to guarantee a peaceful future is to suppress all emotions.

Equilibrium takes place after a Third World War, when a totalitarian state emerges from the ashes with a philosophy that human feelings are the primary cause of conflict in society. Therefore, the way to prevent war in the future is to ban all emotion, to make sensitivity a crime punishable by death. In this society, "sense offenders" are persecuted and all emotionally stimulating material, most of which is under the rubric of the liberal arts, is forbidden. To control people, everyone is required to take daily doses of Prozium, which suppress all emotion.

John Preston, a high-ranking officer and enforcer in this new government, notices that his partner has taken a book of poems from a sense offender rather than incinerate it. For the offense, Preston kills him. Before dying, his partner confesses that the feelings he experienced

through reading the poetry were worth the cost of dying for it. When Preston accidently breaks his daily vial of Prozium, he too begins to feel and is remorseful over executing his partner. As time goes on, he deliberately skips his daily dose and becomes a more sensitive, more emotional man.

A crisis occurs when Preston arrests Mary O'Brien for sense offense. In a searing conversation, she asks him why is he alive, to which he responds: "to safeguard the continuity of this great society." She reminds him of the circular nature of his response: "You exist to continue your existence. What's the point?" Stymied, Preston asks: "What's the point of your existence," to which she answers, "To feel . . . it's as vital as breath. And without it, without love, without anger, without sorrow, breath is just a clock ticking." Preston's epiphany is now complete and he allies himself with the Underground Resistance forces to overthrow the government. The man of cold intellect is now the man of feeling.

When I first started learning the Talmud, I was impressed with the braininess of the Sages who debated and analyzed the intricate text. It seemed to me that the Jewish people had created an aristocracy of intellect where the wise man's opinion was the one that counted. As I matured in my studies, however, I realized that the Sages were not robots who simply knew all the answers. Rather, they were masters of human psychology, who comprehended not only text, but understood in a deep way the thoughts and emotions of man. This is perhaps why one of my instructors told me that he would ask his teachers for advice not only because they were knowledgeable men, but because they understood him as a person as well. They understood his heart as well as his head, and that makes for true wisdom.

THE UNTOUCHABLES (1987)
directed by **Brian DePalma**

I was in the middle of my afternoon prayers when the doorbell rang. My guests had arrived and I was faced with a dilemma: continue to pray, or interrupt my prayers to welcome guests? I took my cue from the great patriarch Abraham, who stopped his conversation with God to tend to his guests. The Sages comment that this was a good thing, for Abraham was setting a paradigm for how we should welcome the stranger. The codes of Jewish law express this concept succinctly: If we are busy with one commandment, we are exempt from the other. Ideally, we should do both if at all possible. But if we cannot, then we have to prioritize and perform the time-sensitive or more important one.

The best cinematic example of this dilemma of facing two tasks at the same time and having to choose between them occurs in *The Untouchables*, a violent crime drama about the war between Eliot Ness, an FBI agent, and Al Capone, the king of the Chicago mobsters during the Prohibition Era. Capone's street-wise philosophy reveals a ruthless approach to anyone who stands in his way. In a stunning opening scene that reveals a bevy of lackeys surrounding Capone as he gets a shave, he tells them: "I live in a tough neighborhood, and we used to say you can get further with a kind word and a gun than you can with just a kind word."

Ness is portrayed as a family man, honest, and morally untouchable. He lives by a code of personal integrity. But he faces an enemy who lives by corruption and brute force. It is a classic confrontation between good and evil. In this often brutal story is a scene that encapsulates more than any other the quandary of Eliot Ness: Can I retain my humanity in the

face of an overwhelming evil that wants to break the law and murder innocent people?

The critical scene takes place in a train station where Ness has gone to intercept Al Capone's bookkeeper, who possesses information that could send Capone to prison for tax evasion. Suspense builds as the train is due to arrive momentarily. Before the train arrives, a young mother burdened with two suitcases attempts to negotiate a baby carriage with a crying infant up a steep flight of stairs. Ness, ever the family man, decides to help her. The young mother is appreciative and tells Ness, "You're such a gentleman, so kind." At that moment, the accountant finally appears with an escort of armed thugs. Here is Ness's challenge. He wants to help the mother and child up the stairs and get them out of harm's way. However, any delay could cause him to lose his prey. Putting Capone behind bars has been his all-consuming mission for months and this is his only chance for success. Ness tries to do both; and, in an amazingly choreographed scene, he loses control of the carriage and guns begin to fire all around him. Will the baby be another innocent casualty in the war against Capone, or will Ness apprehend the accountant with no harm to the child or its mother?

The movie does not provide clarity or solutions to his dilemma; rather it illustrates in a dramatic way the dilemma we all face at different times in our lives. We have two worthwhile things to do, and we have time for only one of them. Jewish law mandates that a preoccupation with one deed exempts us from the other. Although we should try to do both, we recognize that this is not always possible. Therefore, the lesson is to stay focused and prioritize our choices.

SECOND CHANCES

Max came to me looking for answers. He graduated high school several years ago, and since then has had trouble finding himself. He went to college for a year, found it boring, and dropped out. He then decided to open up his own moving company, but without success. Strapped for money, he used his father's credit card information to open up a personal line of credit at a local bank and to obtain a number of credit cards. With this and with money he earned from small part-time jobs, Max even bought a car. After a year or so, he couldn't make payments and asked a local synagogue rabbi to lend him money from the synagogue's charity account. The rabbi gave him the money.

But this didn't stop Max's downward spiral. Finding himself unable and unwilling to take a conventional job, he fell increasingly into more debt until creditors began to call. It was then that Max paid me a visit. While in high school, he was in one of my British Literature classes, and we had developed a nice relationship over the years. Max felt he had betrayed his father's trust and was unable to reveal his indiscretions to him, and so he came to me, his former principal and teacher, looking for advice.

I listened to Max's story and then asked if I could be perfectly straight with him. He said yes. I then told him that in Jewish law, everyone has a presumption of honesty, until we know otherwise. The reality is that he no longer has this presumption operating for him. What you say now is not to be trusted. You have to earn back your reputation as an honest person. You can do this if you sincerely repent. Maimonides, a great Torah scholar, informs us that what you have to do is honestly regret your past actions and resolve not to repeat those negative behaviors in

the future. Moreover, you have to begin talking to creditors and making arrangements to pay back your debts, and you have to confess your misdeeds to your parents and ask for their forgiveness. They probably will be upset and even angry, but down deep they love you and will support your desire to turn your life around.

I shared with Max my own impatience with school as a student, and I told him that this was a natural feeling. However, the reality is that we often have to do things we don't like to do. We simply do them because we have a larger goal in mind. In my own case, I wanted the freedom to do what I wanted; however, I recognized that I would have to pay my dues first. I may not have enjoyed all my college classes, graduate school classes, and rabbinic studies; but I knew that if I endured a present hardship, I would have the freedom to do what I wanted down the road. I understood early on that not everything I wanted could come immediately. I told Max that with consistent effort and patience, he could achieve his goals; but it was critical that he be grounded in the realities he created for himself, and that he deal in an honest and forthright way with his problems.

There is a law referred to in the Bible as the law of the Second Passover. Basically, it says that if you are unable to observe the Passover holiday in Jerusalem at the proper time because you are far away geographically, you can observe it a month later. The Sages, however, say that the term "far away" can refer to emotional distance. This means that if you are religiously alienated, you can always return. God wants to give you a second chance to do the right thing and, therefore, He instituted the law of the Second Passover. This concept is embedded in spiritual life and serves as an encouragement to people like Max, who want to turn their lives around.

The films in this section profile people who have made mistakes, who realize the folly of their choice, and who want to lead wiser and better lives.

TENDER MERCIES (1983)
directed by **Bruce Beresford**

When I was a synagogue rabbi in the early 70s, one of my most unsettling moments occurred when I had to officiate at the funeral of a teenage boy who died in a horrific accident. It was a rainy day, as if God Himself were weeping. What made it especially painful was the fact that the father of the boy was a Holocaust survivor. I was amazed when I looked at the family during the eulogy. There was palpable, overwhelming sadness in the air; but the family's faith in the face of terrible tragedy was manifest. A number of years later, this man's wife was murdered in a random act of violence, and I could not help but wonder how the family could survive such a progression of tragedies. And yet they did. The *Ethics of the Fathers* tells us that man can never understand the ways of the infinite God, and so we move through life with unanswered questions all around us. The pain never goes away, but we find ways to cope.

Tender Mercies, a beautiful story of personal redemption in the face of adversity, reminds us that we can never know why things happen. All we can do is appreciate the tender mercies God grants to us in our lives that are filled with interludes of happiness and sadness.

Mac Sledge, played by Robert Duvall, is an over-the-hill country music star whose alcoholism has ruined his career. He awakens one morning in a forsaken Texas roadside motel and meets the owner, Rosa Lee, a young widow who has lost her husband in Vietnam, with a son named Sonny. She offers him room and board in exchange for his work at her motel and gas station on the condition that he does not drink while he is working for her. Over time, their feelings for one another grow and Mac eventually asks Rosa Lee to marry him. They attend

church regularly and Mac finds that life is now full of promise. His emotional baptism ceremony represents his break with the past and his resolve to see life anew. Rosa Lee is largely responsible for his spiritual conversion. In a poignant scene, she tells Mac, "I say my prayers for you and when I thank the Lord for his tender mercies, you're at the head of the list."

With such love and encouragement, Mac's life slowly turns around. His reputation as a songwriter inspires young musicians, and Mac decides to resurrect his career as a country music artist in a modest way. Secretly, however, he yearns to reconnect with his daughter, Sue Anne, whom he has not seen for many years. When the meeting occurs, it is filled with the hope of reconciliation; but tragically Sue Anne is killed in an automobile accident only days after they meet.

The trajectory of Mac's life is a mystery to him and he wonders aloud to Rosa Lee: "I don't know why I wandered out to this part of Texas drunk, and you took me in and pitied me and helped me to straighten out, marry me. Why? Why did that happen? Is there a reason that happened? And Sonny's Daddy died in the war, my daughter killed in an automobile accident. Why?"

In the final scene of the movie, Mac has an epiphany. While throwing a football with Sonny, he smiles. He finally comprehends that finite man cannot know the answers to the riddles of life. Mac has lost a daughter, but he can still be a father to Sonny. A feeling of purpose animates his life in spite of personal failures and family tragedies. His story echoes the adage from Proverbs, which says that "seven times the righteous will fall, and then they will rise again." In the Jewish view, it is important to fail forward, to use failure as a way to stimulate emotional growth and understanding.

CATCH A FIRE (2006)
directed by **Phillip Noyce**

Three times in my career spanning over forty years, I had the unpleasant feeling that the people who disagreed with my positions on certain issues were deliberately trying to hurt me professionally. Although their nefarious intentions never were actualized, the psychic pain from these encounters lasted for a very long time. There were opportunities for "payback" from time to time, but I never succumbed to those sinister emotions. I even called one of the offenders and wished him a happy new year, assuring him that I valued his friendship no matter what our tumultuous past had been.

Deep inside, I knew that God is in charge of the world and whatever difficulties I had at the time were ordained by Him, not by the human adversary in front of me. Moreover, my religious training taught me that there is reward and punishment, accountability, for everything we do or do not do in this world; and that God in His infinite wisdom will make sure everything turns out all right if not in this world then in the next. So it was gratifying for me to see the magnanimous gesture that Patrick Chamusso does at the end of the gripping drama of apartheid *Catch a Fire.*

Catch a Fire is the story of Patrick Chamusso, a young African working as a foreman at the Secunda fuel refinery in South Africa. When the plant is bombed, he is accused of carrying out a terrorist attack and is picked up by Afrikaner police officer Nic Vos. The problem is that Patrick has no alibi for where he was on the night of the bombing. In his spare time, he is a soccer coach and he had taken a group of boys to a soccer match in a distant town. Then, he mysteriously disappeared after he dropped off the boys at their sleeping quarters. We learn that Patrick

is having an affair with another woman and does not want to reveal his indiscretions to his wife, Precious. In order to shield his wife from pain and to protect his family from shame, he confesses to the crime. It is a courageous and painful decision with dire consequences.

The authorities, under Vos, torture Patrick and his wife, and when he is released he is now radicalized and wants revenge against those who wronged him. He soon joins a radical group and begins to plan another major attack on the refinery. Having been employed there, he is knowledgeable about the intimate details of the site and is uniquely positioned to cause maximum damage with minimum harm to the workers. In a suspense-filled series of events. He matches wits with Nic Vos, each one trying to anticipate the other's moves as they both race to the plant for different reasons, Patrick to destroy and Nic to save.

Many years later after apartheid has been abolished, Patrick has a chance to kill Vos. However, he decides against it. He is inspired by Nelson Mandela who argued that, after apartheid, Africans now have to live with the white man and forgive him. Moreover, influenced by his own mature perspective on life, Patrick does not want to leave a legacy of revenge and murder to the next generation. And so he foregoes his opportunity for vengeance.

In a coda at the end of the movie, we learn that Patrick remarried after serving substantial prison time, had three children, and opened up an orphanage to serve many children who were children of victims of apartheid. Out of the ashes, a phoenix of salvation arose. Patrick Chamusso reminds us of the power of forgiveness to free us from the past and to allow us to build our lives anew.

THE MASK (1994)
directed by **Chuck Russell**

When I entered sixth grade, my crowded elementary school transferred its sixth grade to a Jr. High School with a varied school population. No longer was I in a safe cocoon; I now roamed the halls with kids from different neighborhoods who, in the 1950s, were considered "wild and dangerous." Being a young boy wanting to impress his peers, I gradually grew side burns and affected an Elvis Presley haircut and a Marlon Brando attitude. Outwardly I was cool, but inwardly I was still the same kid I was before changing schools. I recall very clearly that I was placed in classes with low achievers because of the way I presented myself, and the teenage girls in my school thought I was mysterious. It was a mask, and eventually I removed it and became my real self.

I thought of this as I watched *The Mask*, the story of Stanley Ipkiss, a shy, confused bank employee who serendipitously finds a mask that gives him a new identity, much more aggressive and unpredictable than his true self. How he deals with his split personality and how others view him in each of his different incarnations is the subject of this very silly movie that is slightly redeemed by a few funny lines of dialogue delivered by star Jim Carrey impersonating several Hollywood icons such as Clint Eastwood, James Cagney, and Edward G. Robinson.

Stanley Ipkiss is taken advantage of by everyone around him: his boss, his landlady, and even his car mechanic. His only friends are his dog Milo and his co-worker Charlie. Things change, however, when Stanley finds a strange wooden mask near a pile of garbage. In jest, he tries it on, and discovers that wearing the mask gives him superpowers. He becomes an aggressive trickster who can twist his body like

rubberized plastic and is impervious to physical harm. Moreover, he is without any inhibitions. All this allows him to take revenge on those who have hurt him and to act in ways totally foreign to him as Stanley Ipkiss.

For a time, Stanley loses the ability to control his use of the mask, and he seeks the guidance of a health care professional to assist him in dealing with his alter ego. Dr. Neumann tells him a profound truth that Stanley begins to grasp: "We all wear masks . . . metaphorically speaking." When Stanley asks him what mask he should wear on his date later that night, Dr. Neumann sagely counsels him to do two things: to be himself and to wear the mask, because the mask is part of him. His alter ego may need to be repressed, but it is a part of Stanley that needs to be integrated into his entire personality for him to be a whole human being.

Jewish tradition has an interesting take on human nature. It recognizes that each one of us is composed of good and bad personality traits. Broadly described, they are the good and evil inclinations of man. In the Talmudic tractate of *Shabbat* there is a provocative statement that someone with a warlike personality will be a shedder of blood, but not necessarily a soldier. He can be a surgeon, a thief, a ritual slaughterer, or one who circumcises children. The key point is that we are able to sublimate our base instincts in the service of good. That is our everyday challenge: to employ the negative forces within us for good purposes. We can do very bad things if we let our evil inclination rule. Alternatively, we can become strong by ruling over it. Stanley Ipkiss's ultimate recognition that he can triumph over his evil inclination allows him to remove his mask and be the good person he really is.

THE WORDS (2012)

directed by **Brian Klugman** and **Lee Sternthal**

I have a friend whose favorite phrases are "would have, should have, could have." He is always revisiting his decisions, thinking about how life would be different if he had made a different choice. If he had only gone to this restaurant instead of that one, if he had bought this car rather than the other one, if he had bought this blue shirt instead of the white one – the second guessing is never ending, and it reflects a self-doubt that is at times debilitating.

I hear a similar refrain from students who receive low test grades. They tell me what they would have written had they understood my question better. Rarely is there an acknowledgement of a mistake and a readiness to accept consequences. Instead there is prevarication and avoidance of responsibility for doing wrong. So it is refreshing to watch a film in which a character makes a moral mistake, actually acknowledges it, and attempts to correct it.

The Words is about Rory Jensen, an aspiring writer who is trying to get an agent for his first novel. After repeated rejections, he serendipitously finds an old manuscript in a used briefcase his wife bought for him when they honeymooned in Paris. The manuscript is extraordinary and brings tears to his eyes. It is a powerful narrative that touches his heart and soul. Rory makes a decision to present the manuscript as his own to a literary agent who, after reading the book, feels convinced that the novel will be a resounding success. The plot takes some winding turns when the real author of the book surfaces, and Rory is faced with stark moral choices.

Conversations with the real author deepen Rory's understanding of life, and encourage him to move on with his life after failing himself and

others who trusted him. The author counsels Rory: "We all make our choices in life. The hard thing to do is live with them."

The great eighteenth century English poet Alexander Pope wrote: "To err is human, to forgive, divine." The line evokes the Jewish approach to moral failure. We all fail on occasion, but what is important is what happens in the aftermath of failure. The biblical story of Judah and Tamar is one model to observe.

Judah is the father-in-law of Tamar. Tamar's husband dies and she is supposed to marry the brother of her deceased husband to perpetuate her husband's name. But Judah neglects to arrange this. Tamar, as a desperate remedy, cloaks herself as a harlot and entices Judah to have relations with her. Later when Tamar is taken out to be executed for harlotry, Judah discovers that he is the man with whom she has been intimate, and it is his irresponsible neglect that was the catalyst for Tamar's behavior. Judah offers no excuses. He confesses publicly to his indiscretion and wants to make amends, no matter the social cost.

Another aspect of a personal moral failure that permeates the film is the consequence to friends and family who trust us. In Jewish jurisprudence, we see that part of the repentance process is to ask forgiveness from those we may have hurt. The codes of Jewish law state unequivocally that, if asked for, we should forgive and not hold grudges that prevent us from resurrecting our love for and friendship with those we have wounded.

The Words is an engaging narrative that depicts a major moral flaw and one person's attempt to make things right, to admit a mistake, and to fashion a wiser version of himself, ready to move onward with his life.

SEARCHING
FOR SUGAR MAN (2012)
directed by **Malik Bendjelloul**

I know a serious artist who creates beautiful renditions of nature scenes. In fact, he recently had an exhibit at a well-known New York gallery. He often debates within himself whether he should do more to promote his art or whether he should just create and leave the rest to God's intervention. In the inspiring documentary, *Searching for Sugar Man*, Rodriguez, a Detroit folksinger, resolves the question of how much an artist should promote his work by disappearing into the woodwork and letting fate determine his destiny.

Sixto Rodriguez's story is fascinating and wondrous. He recorded two albums in the 1970s, *Cold Fact* and *Coming from Reality*, which sold only a few copies. Singing and writing songs in the style of Bob Dylan, Rodriguez impressed early impresarios with his smooth blend of thoughtful lyrics and catchy melodies, and they thought he was the genuine article who would be famous. However, as Rodriguez himself says, the music business is unpredictable and no one can predict with accuracy who will succeed and who will not.

In spite of not making musical waves in America, his albums seren-dipitously reached South Africa and there, Rodriguez became a musical icon comparable to Elvis Presley. His music became the national anthem of the anti-apartheid movement. His lyrics, in particular, were liberating and inspiring to the Afrikaner protest musicians of the 1980s. Ironically, Rodriguez was totally unaware of this and was living the blue-collar life of a construction laborer in Detroit. Sadly, he never received any of the royalties for the 500,000 albums he sold.

Rumors abounded about him in South Africa. Some said he committed suicide publicly by lighting himself on fire; others said he shot

himself or died of a drug overdose. No one really knew him. But two of his fans decided to investigate what really happened to Rodriguez. They began looking for clues to his roots in the lyrics of his songs. Eventually, the cities mentioned in his songs led them to find Rodriguez's origins at Motown Records in Detroit, the birthplace of many successful rock stars.

The eureka moment arrived when the fans discovered that Rodriguez was still alive and living the simple life of a day laborer in Detroit with his daughters. This revelation motivated his South African fans to arrange a concert tour in South Africa in the 1990s, where he played to thousands of fans of all ages, many of whom knew his songs by heart. Reports of his successful shows reached his friends in Detroit who could not believe that their quiet and unassuming friend was a real rock star with a massive following.

The coda at the end of films informs us that even when Rodriguez made money at his South African performances, he gave it all away to family and friends. For him, it was enough to share his music with his adoring fans. He did not seek fame; rather he sought human connection with his admirers. He wanted fan and artist to symbiotically commune through the language of lyric and song.

The *Ethics of the Fathers*, a classic of Jewish wisdom literature, tells us that when man seeks fame and recognition, they will elude him. Rodriguez, by living an unadorned life away from the bright lights of celebrity and by eschewing materialism, provides a thoughtful model for us to emulate in our acquisitive age. Our Sages tells us that the truly rich man is the man who is content with what he already has. *Searching for Sugar Man* reminds us that it is who we are that give us our identity, not what we possess.

ROCKY (1976)
directed by **John G. Avildsen**

My good buddy Jerry never fails to miss an opportunity. Although talented and possessing charisma, at age forty-five he is still single and without a steady job. Occasionally, he asks me for a loan and I give him small pocket change; but his life, on the whole, is a mess.

At age forty-two, he decided to leave his regular job and explore becoming a real estate agent in Chicago, where he was born and raised, but now he has neither a job nor steady income. Instead, he has lots of stress and an unpredictable paycheck.

A year ago, he had a chance to take a high-paying job in the hotel industry where his superior people skills would in all likelihood make him successful, but he hesitated. In the interim, the job was offered to someone else and his job prospects turned increasingly bleak. I thought about him as I watched *Rocky*, a film about a loser who has the good sense not to let a one-time opportunity pass.

Rocky is an iconic story because it touches on the insecurities of every man who is mired in a mediocre reality, but who wants more out of life. Rocky serendipitously is given a moment when he can change his life for the better and he takes advantage of it, and that decision makes him an inspiration for many.

We first meet Rocky in November of 1975 as a small-time fighter and collector for a local loan shark in a seedy neighborhood in Philadelphia. He is a man with no prospects. But fortune shines on him when the heavyweight champion of the world, Apollo Creed, needs a replacement for the boxer who has dropped out of a glamorous New Year's title defense because of a hand injury. Apollo turns to a local underdog

with the flashy pseudonym of "the Italian Stallion," to generate interest in the fight, and so Rocky Balboa has his chance of a lifetime to come out of obscurity and into the limelight.

The *Ethics of the Fathers* reminds us that a person should never disparage another man, for every man has his hour. Although Rocky is at first dismissed by many who see him as a failure in life who never capitalized on his talents, they reassess him when he reinvents himself as a serious contender for the title.

No longer casual about his training, he realizes what is at stake and resolves to go the distance with Apollo. All this happens because Rocky is blessed with a mentor, Mickey Goldmill, who initially calls Rocky a bum, but then has a change of heart and mind, visioning Rocky as a potential champ who simply needs to get rid of his old habits and re-dedicate himself to the sport of boxing. It is this mentoring that makes all the difference. Rocky understands that he does not know everything and that he needs guidance, which is the first step to self-knowledge. Under Mickey's guidance, Rocky emerges as a real threat to Apollo, and what subsequently happens is the stuff of boxing legend.

Rocky has lots to recommend it. It reminds us to appreciate the talents that God has given us and to use them to become the best that we can be in spite of setbacks and limitations. Furthermore, it encourages us to find a mentor who will give us the wisdom to make good life decisions. It is noteworthy that *Ethics of the Fathers* specifically recommends that we acquire a teacher. This is a priority in a world that can be confusing and damaging to us if we insist on going it alone.

LES MISERABLES (1998)
directed by **Bille August**

A friend of mine who gives parenting workshops recently counseled a parent whose teenage son was giving her lots of grief. She told her that she should give her child oodles of care and love. The parent retorted: "But what if that doesn't work," to which my friend replied, "Then give him a double dose of care and love."

I thought of this interchange as I watched the 1998 version of *Les Miserables*, an accurate but abridged cinematic rendition of Victor Hugo's classic novel. The well-known plot centers around Jean Valjean, a starving pauper who is given a prison term of nineteen years for stealing a loaf of bread. When finally released on parole, he cannot find a place to lodge. Facing continual rejection because of his criminal past, he thinks that he will have to resort to a life of crime to survive. Fortunately, he finds refuge for the night at the home of Bishop Myriel who feeds him and offers him shelter. However, Jean responds to this kindness by stealing the bishop's silverware. The next day Jean is caught and brought back to the bishop by the police. In a surprising gesture, Bishop Myriel tells the police that Jean is an old friend to whom he has given the silverware, and he also gives Jean silver candlesticks as a further demonstration of his friendship. It is truly a double dose of love.

When the authorities depart, the bishop tells Jean that he will become a new man the next day, no longer a criminal, but a person of genuine worth. Jean is overwhelmed with his kindness and resolves to change. The next scene takes place nine years later. Jean is now a wealthy businessman and mayor of the town, a man who clearly has repented and is now a new man.

The story of Jean Valjean is an epic narrative of repentance. Not only

does he become an upstanding citizen, he also does charitable works that benefit the underprivileged and poor as well. His rehabilitation begins, however, when one man – the bishop – shows confidence in Jean, when he sees Jean for what he could be and not for what he was. Looking towards the future, the bishop showers Jean with respect, with kindness, and treats him as an equal and friend. He then encourages him to become a new man with a new destiny.

Jewish tradition describes Aaron, the brother of Moses, in similar terms. Aaron loved peace and pursued peace, says the Talmud, and did whatever he could to make people feel good about themselves. He even went out of his way, says the Midrash, to connect with people on the margins, the outsiders, and to befriend people of less than reputable character, all of which he did because he understood that it is easier for people to do good when they possess self-esteem, when they see themselves as people of worth and integrity. This was Aaron's specialty: to make people feel important and valued. He was so good at this that when he passed away, the Midrash informs us that the people mourned for him more than for Moses. The character of the bishop reminds us of Aaron, the man of the people who, in his own quiet way, challenged people to become the best that they could be.

Two valuable life lessons emerge from *Les Miserables*. Firstly, that it is possible to change, to repent and begin life anew. Secondly, to motivate people to repent, we must show them that we believe in them, that we believe in their basic goodness and their infinite value, which transcends any mistakes they may have made. Jean Valjean's personal odyssey is a living testament to these psychological truths.

TIME

I used to take time for granted. As a teenager, I possessed the illusion of immortality. Thoughts of death never entered my mind. But things changed when I entered Yeshiva University as a freshman. It was there that I heard a loud and consistent message from all my Torah teachers: Time is precious so do not waste it. I observed my teachers and saw that they walked the talk. Their minds were always active, constantly busy with study and doing good deeds. Few of them had a television. It was hard for me to imagine them sitting on a couch watching the boob tube. Even the time they spent in recreational activities was circumscribed. Play was fine, but it was not limitless.

The value of time is a topic I return to often in conversations with my children. Time cannot be recaptured. Once gone, it is irretrievable. Let me share a couple of stories with you.

In 1976, after working for six years in the pulpit rabbinate, I decided to change my career path and become a high school principal. To prepare myself for the job, I visited my good friend, Rabbi Pincas Bak, who was the successful head of the Ohr Torah High School in New York City. He shared with me his wit, his wisdom, and his wonderful insights about Jewish education. He truly helped me get a jump-start on learning how to be a principal. Six months later, he tragically died of a brain aneurysm. When Rabbi Bak died, many felt a great void. His happy face and his dynamic spirit were no longer there to inspire us. Lessons to learn: Be thankful for each and every day, for we know not what tomorrow will bring. Make each day count by living a meaningful life.

The second story. I am one of many people who do not enjoy flying. When I was about to leave for Israel for a sabbatical in 1997, I had a

conversation with one of my sons about dating and what to look for in a spouse. As I spoke, I was overtaken with the thought that this might be my last time I spoke with my son, and I immediately began weighing each one of my words. I wanted to give him my very best wisdom and to reaffirm my love for him. Like all parents, I wanted my son to listen to the voice of my experience and to know how much I loved him. I reflected inwardly how different we might act if we saw every conversation with a loved one as possibly our last.

These kinds of stories and my exposure to teachers and mentors who valued time make me sensitive to this topic in movies. Films that focus on the value of time, of each and every moment, speak to my heart and my soul, reminding me that a minute can change one's destiny.

BACK TO THE FUTURE (1985)

directed by **Robert Zemeckis**

Time is relentless. Rational people understand that you cannot turn back the clock. Sometimes, however, there are moments in your youth when you summon up the strength or courage to do things that actually help you better navigate the future. Which is why I look back fondly at my foot race with John King in the sixth grade.

My neighborhood had changed because low-income housing was built nearby and now my school's population changed. Instead of attending a school with affluent, college-bound kids, I attended a school with many low achievers and discipline problems. Like many kids, I rose to the level of expectation of my teachers, who now viewed me as mediocre instead of the academic star I was in my mother's eyes. My self-esteem plummeted, even in gym class, where I was overshadowed by some genuinely gifted athletes.

So it was a special day for me when I was pitted against John King, one of the tough and cool kids who smoked cigarettes in junior high school, in a 220-yard dash in my PE class. I was nervous, but on that day I was very fast and won the race. Winning did remarkable things for my self-esteem. I was who I was, but now I felt I could seriously compete against anyone in my school. I might not win every race, but I thought of myself as a potential winner and it did marvelous things for my ego.

That kind of personality transformation is at the heart of *Back to the Future*, an escapist fantasy of time travel, in which Marty McFly travels thirty years into the past and orchestrates the encounter in which his parents, George, a shy, bookish teenager, and Lorraine, meet and fall in

love. Marty discovers that if his father becomes more assertive, Marty can alter his destiny and that of his parents as well.

The film opens in the home-laboratory of Dr. Emmett Brown, an eccentric scientist who prides himself on creating inventions, one of which is a time machine whose exterior is a DeLorean automobile. Through a series of improbable events, Marty jumps in the car to flee Libyan assassins and accidently is catapulted back to 1955, and that is when the adventure begins.

Marty meets his parents before they got married and realizes that unless he intervenes in their lives, they will not marry and he never will be born. The problem is that George McFly, Marty's dad, is extremely introverted and devoid of self-esteem. He simply lacks the courage to ask Lorraine, Marty's future mother, out on a date. Moreover, he is subject to the constant bullying of Biff Tannen, who often threatens him with violence. To complicate things, Marty's mother as a teenager is infatuated with Marty rather than her destined husband, George. How everything is sorted out and how George and Lorraine finally meet and fall in love is the narrative arc of the film. In the end, we see that decisions and actions made as a youth can have profound implications for the rest of one's life, especially in the life of George McFly.

Time is an eternal value in Jewish tradition, encapsulated in the maxim of the *Ethics of the Fathers*: "If not now, then when?" Everyday should be filled with achievement and spiritual growth, not procrastination. Furthermore, the Sages say that one should think that each day is potentially one's last day. Therefore, one should think about how to conduct oneself every day of one's life. *Back to the Future* reminds us that how we act today can influence our tomorrows. Therefore, let us be wise and make the decisions today that will enable us to have a successful future.

CAST AWAY (2000)
directed by **Robert Zemeckis**

In the high school yearbook in one of the schools where I served as principal, students would write a quote beneath their photo that would epitomize the student's guiding philosophy. One student wrote, "Time is precious so don't waste it." Then, to my chagrin and disappointment, he proceeded to lead a life in which time was squandered and misused on countless occasions. He started and stopped his college career several times in order to "find himself," and after college moved from job to job at the first sign of stress or difficulty. He was engaged three times, over two years to each girl, always using the mantra that "I want to be sure that I am making the right decision." I saw him again in his 40s, still single and moving from job to job. It was very sad. As a young man, he espoused the value of time; but in practical terms as an adult, he did not fully grasp that time is our most precious commodity. Once gone, it cannot be recaptured and we cannot do a "do-over." It is a profound, inescapable lesson of life that can haunt us as we get older.

The opening scenes of *Cast Away* set the stage for a meditation on time. A FedEx pickup rolls into a rural Texas farm and picks up a package that is destined for Moscow. We follow the package as it journeys to Russia in the dead of winter. In Moscow, Chuck Noland, a company exec, is lecturing Russian workers in the Russian FedEx facility about the need for timely delivery. He shouts: "We live or die by the clock." He tells them that losing time is a sin, and he berates them for not being more conscientious.

On his return flight to Russia, he overhears that his friend's wife has cancer and her future is uncertain. Chuck contemplates for a brief mo-

ment the precariousness of life, and decides to marry his long-standing girl friend Kelly. Work, however, intervenes and Chuck has to leave before popping the question. Ironically, his last words to her are "I'll be right back."

Tragically, Chuck's plane crashes, and he is marooned on a remote island for four years. At home in Memphis, Kelly, thinking that Chuck is dead, gets married and has a child. Life has moved on.

The narrative arc of the movie concludes in Texas, where Chuck, played by Tom Hanks, delivers a package that was on the plane the day of the fateful crash. After he delivers it, he returns to a desolate country crossroad, the proverbial fork in the road; and the film closes with Chuck looking out at the various roads he can choose. He is now a wiser man contemplating which direction to take, considering how to make the most out of life and the time he has left.

A fundamental Jewish idea is embedded in this film: the value of time. The *Ethics of the Fathers* strongly remind us that we should not procrastinate. "If not now, then when," say our Sages.

Moreover, Rashi, the celebrated medieval Torah scholar, quotes a Talmudic passage in Tractate *Pesachim* (48b), which urges us to take advantage of every opportunity for a good deed that comes our way. He compares the words *"matza,"* unleavened bread, and *"mitzvah,"* good deed, and derives that both are intrinsically connected to time. The *matza* must be prepared in a timely way, and so too should we perform *mitzvoth*, good deeds, in a timely way, immediately, and not postpone doing them. Marriage is defined as a good deed in Judaism. *Cast Away* reminds us of the fleeting nature of time, implicitly encouraging us not to delay life's important and most satisfying obligations.

THE CURIOUS CASE OF
BENJAMIN BUTTON (2008)

directed by **David Fincher**

In the early 1970s, my late wife and I would regularly visit The Great Southeast Music Hall, an inexpensive music emporium that showcased up-and-coming artists. One night as we exited, I looked at the billboard announcing next week's artist. He had a new album called "Cold Spring Harbor," but I decided to pass on this unknown talent. And so it was that I missed an opportunity to hear Billy Joel at the beginning of his celebrated career.

Flash forward to today and *The Curious Case of Benjamin Button*, an unusual narrative about a person who is born as an old man and grows progressively younger, compelling the viewer to think about time in unconventional ways. The narrator, Benjamin Button, observes that "our lives are defined by opportunities, even the ones we missed."

Missing the Billy Joel concert did not define my life, but *Benjamin Button* reminded me of the special opportunities that all of us have in our life's journey. Our sages tell us: "When an opportunity for a good deed comes to us, we should do it with alacrity." There are moments in life when time and circumstance meet, when we have an opportunity for greatness, for success, or to simply change our life's direction, an opportunity that may not ever come again. How do we capture those moments?

Benjamin Button offers suggestions. When Benjamin is abandoned as a baby, a young married black couple finds him on their doorstep. Queenie, the wife, decides that she will take care of this child of God. Since the woman has been unable to bear children, she sees finding Benjamin as an opportunity to be a mother. It is an opportunity she will not let pass.

Benjamin, himself, takes advantage of opportunities. His changing body daily reminds him of the fickle nature of time and circumstance, and when a tugboat captain is looking for volunteers, Benjamin signs on immediately. This leads to a series of maritime adventures in World War II, and to a life-long interest in travel and discovery. It also broadens his view of the world. Having been born and raised in New Orleans, he now feels comfortable in foreign lands.

The film's central story is the love between Benjamin and Daisy, a girl whom he first met at a retirement home when she was visiting her grandmother. She thought him an old man but connected to him because of his boyish ways. Their relationship evolves over the course of time as Benjamin gets younger looking as she gets older, until they reach an interlude in time when both are about the same age and can relate to one another romantically. It is a moment of opportunity and they marry and have a child.

Benjamin Button asks us to contemplate how we capitalize on the moments of opportunity that arise in our lives. When I was twelve, my synagogue rabbi gave my parents an opportunity to send me to a religious camp. They said yes, and so my life was forever changed. At first it was isolating, but I soon found new friends who were on my wavelength and life was good, fulfilling, and purposeful. My parents were wise; they saw that, as a teenager, I was coming to the proverbial fork in the road and they gave me the opportunity to take the less traveled road.

As a rabbi and educator, I witness many people failing to take advantage of a particular moment in time, and this affects the rest of their lives. Having missed one opportunity, sadly they miss many others. *Benjamin Button* reminds us to be aware of precious moments of opportunity and to take advantage of them in order to enrich our lives.

INCEPTION (2010)
directed by **Christopher Nolan**

In my volunteer work for an international Jewish match-making site, I work with many dreamers. The people who dream the most are single men over fifty who want to marry girls under thirty-five because they would like to have children. On the surface, the dream makes sense, but the reality proves otherwise. Most girls in their thirties do not want to marry men in their fifties. And the dream gets scarier with advancing years. Men in their late fifties and even men over sixty cling to the dream while life is slipping away. It is very sad, because the dream prevents them from dealing with reality. I sometimes suggest to my "clients" that they should at some point reconcile themselves to the reality of just having companionship into their senior years, rather than cling to an impossible dream that, in the final analysis, will leave them isolated and alone as mature adults. God tells us that "it is not good for man to be alone." Companionship, even without the possibility of having kids, is superior to being by oneself.

Our tradition tells us that a shared life refines a person. Being married compels one to think of another, not just of oneself, and that paradigm is Torah-based. The Torah tells us to "love your neighbor as yourself," and the penultimate neighbor is one's spouse. Therefore, it is good occasionally to dream, but it also good to live in the real world.

To dream excessively is dangerous, for it can make you lose touch with reality. This is the crux of *Inception*, a wildly imaginative thriller that deals with dreams and their consequences.

The story line of *Inception* is almost impossible to summarize. In simple terms, it involves a plot to plant a dream in someone's mind in order to change an oncoming reality. In the course of the film, reality

KOSHER MOVIES

and dream are constantly intertwined, so you have to pay close attention to determine which parts of the narrative are real and which are projections of the subconscious. It is this confusion that is at the core of the relationship between Dom Cobb and his wife Mol. Dom is involved in corporate sabotage, extracting valuable secrets from vulnerable subjects who are dreaming. He is so expert at this that he introduces his wife into the world of dreams, but it comes with terrible consequences. Mol loses touch with reality because of her deep and extended exposure to the dream state of awareness, and their life together is transformed from a dream into a nightmare.

The only salvation for Dom is to return home to reality, a reality that requires him to leave his wife in her world of fantasy. In a wrenching climactic scene, Mol asks Dom to remain with her in her dream world and grow old with her there. Dom responds that they did grow old together in their dream world, but now he must leave that world in order to enter reality and survive.

This willingness to accept reality even though it is not ideal reflects a mature outlook on life. We all need to dream, but the dream has to be tempered by a true comprehension of the real world around us. This perhaps is emblematic of the dream of Jacob's ladder. Alone in the wilderness at night, Jacob had a dream of angels going up and down a ladder; but the ladder, which soared into the heavens, had its feet firmly planted on the ground.

SOURCE CODE (2011)
directed by **Duncan Jones**

As the years go by, I have become more conscious of time. I count my minutes. It is a mantra that I share with my students as well. When I begin the school year, I inform them that there are two rules in my class: Do your best and don't hurt other people. This means do not prevent other students from learning. When a student talks without raising his hand, when he interrupts another student who has the floor, he is, in effect, preventing other pupils from learning. Furthermore, he is stealing precious time from class, preventing me from maximizing class time for teaching. I tell students that I count my minutes because time is precious. A minute can be an eternity. Consider for a moment the two-minute warning in a professional football game. Destinies can change in a matter of seconds.

This is one of the themes of *Source Code*, a science-fiction thriller cast in the present, which describes a bold and innovative attempt to avoid a major disaster by injecting a person into a continuum of events eight minutes before one calamity strikes, in the hopes of averting a second disaster in the future. Sounds weird? It is. But it also provides a meditation on what living in the moment really means. Amazing things can happen if one is aware of the consequences of each passing minute. *Source Code* reminds us that the same basic events can be experienced in different ways if we will it so, if we truly understand the consequences of each one of our actions.

The movie also addresses a seminal question we have all asked ourselves at one time or another: "What would you do if you knew you had less than a minute to live?" The question forces us to focus on the present moment. Will it be our last? The *Ethics of the Fathers* does not

ask that question, but it does suggest a similar mindset. We are advised by the rabbis to think of every day as potentially the last day of our lives. This is not to encourage pessimism or depression, but to spur man on to live life to the fullest, to make every day count, to make each day meaningful.

There is a corollary to understanding the value of time. If there is enmity or ill will between friends, between spouses, between parent and child, reconciliation is a priority. Time does not allow for a slow resolution to conflict. In *Source Code*, this desire for reconciliation finds expression in the fractured relationship of the hero Captain Colter Stevens, played by Jake Gyllenhaal, and his father. Their last conversation was difficult and strained; but now both want to be at peace with one another. Both want emotional wholeness. Colter Stevens now understands, in his heightened state of awareness somewhere between life and death, that if he knew when he spoke with his father that it would be their last communication, he would not have argued with him. He would not want to leave a legacy of bad feelings between them. He would want to tell his father that he loved him just as his father would want to reaffirm his love for his son in any time of crisis. Facing death also gives Colter a greater appreciation of life. He looks around and remarks, "Such a beautiful day." He sees people laughing and it makes him treasure moments of happiness.

Source Code demonstrates the power of a minute. It implicitly implores us not to waste time, our most valuable commodity, and to repair our damaged relationships without delay.

STRANGER THAN FICTION (2006)
directed by Marc Foster

As a rabbinical student, I would often have discussions with teachers about free will. Simply put, if God is in charge and knows all, how can man have free will to choose? One response that a teacher gave to me made some sense and I share it with you.

We are finite creatures who only live in the present. In this life, we are watching a video that opens with the caution: *formatted to fit your screen*. In contrast, God sees past, present, and future. He sees the wide-screen version, for He exists in all three time periods. This is why He knows all and we cannot. Yet in spite of God's knowledge of our future, Judaism believes that God, in his infinite kindness, limited Himself and gave man free will. This problem of free will versus destiny is the crux of *Stranger than Fiction*, which depicts the ordinary and extraordinary life of Harold Crick.

Harold Crick is a lonely IRS agent whose life is defined by numbers. One morning as Harold is getting ready to go to work, he begins to hear an authorial voice narrating what is happening to him at that very moment. The conceit of the film is that an author, Karen Eiffel, is actually writing his life, leaving him with little free will to exercise. It is frightening when Harold realizes that he no longer is in control of his destiny, especially when Karen Eiffel writes that he will die "imminently."

This realization that life will end soon moves Harold to be more proactive in the life he has left. He begins a romantic relationship and even learns to play the guitar. Our Jewish tradition tells us that we do not know the day of our death; it could be any day. For example, our Sages teach us to "repent one day before your death." The commentators

explain this to mean that since no man knows the day of his death, he should repent every day. In other words, value time and make every day a special day, filled with meaning.

Harold understands this life lesson. One of his mentors poetically observes that only *we* can determine if our life will be a comedy or a tragedy. Will our lives affirm the continuity of life or the inevitability of death? The believing Jew lives with this constant dialectic as he makes daily decisions.

Moreover, the film presents a morally sensitive character in the author, Karen Eiffel. She decides to change the tragic ending of her novel, changing it, from a literary perspective, from a masterpiece to just an average work of fiction, in order to protect and save someone. What is paramount to her in the final analysis is not fame, but doing the right thing. Morality trumps personal ego.

The movie concludes with Eiffel reminding us that we need to thank God for the small pleasures of life that we often take for granted, for the "accessories of life" that are here to serve nobler causes and save our lives emotionally and spiritually. She speaks of the importance of the loving gesture, the subtle encouragement, the warm embrace. These little things make life precious. Harold Crick appreciates this truth when he finds life after almost losing it.

THE ADJUSTMENT BUREAU (2011)
directed by George Nolfi

As a rabbi, I have often been asked questions relating to destiny versus free will. Can we change our destiny by exercising our free will? It is a complicated question and, from a theological perspective, not easily answered. It seems, however, that Judaism has an approach to looking at the problem. Let me explain. I have been involved in cases in which congregants have someone in their family facing death. One traditional response to such a dire situation is to change the name of the person in a life-threatening situation. By doing so, we create an alternative ending, namely, life instead of death. I asked one of my Torah teachers how this works, and this is what he told me.

In the Divine scheme of things, John Doe is destined to die at a certain time. However, John and his friends and relatives want him to live. Therefore, they change his name to John Raphael ("*rapha'el*" means "God heals" in Hebrew), to change his fate. No longer is he John Doe. He is now John Raphael Doe, a new man with a new name and hence, a different destiny. Obviously, it is not a failsafe ritual. Only God is in charge of life-and-death matters, but there is a suggestion that free will can intervene to change one's destiny. This is the premise of *The Adjustment Bureau*, a romantic thriller with a clever take on destiny versus free choice in the choice of a marriage partner.

Congressman David Norris, a Brooklyn Congressman running for the New York Senate in 2006, loses the race, but in the process meets Elise Sellas, who captures his attention and imagination. She gives him her phone number but he loses it, and for three years afterwards he tries to find her. Meanwhile, he launches his campaign for the 2010

Senate race. Then he serendipitously discovers her as she is walking along a downtown street, and emotion takes over.

But fate again intervenes through a group of men in suits known as the Adjustment Bureau. They confront David and inform him that his destiny to not to pursue a relationship with Elise according to the plans of the "chairman," a person whose identity is ambiguous. They warn him that failure to abide by their suggestion or revealing the existence of the Adjustment Bureau will result in catastrophic consequences.

David resists their threats, deciding he has a right to choose his own destiny. He therefore continues pursuing Elise with whom he feels a natural rapport. The narrative details his attempts to connect with her in the face of obstacles placed in their way by the supernatural Adjustment Bureau, an entity which has the power to change the respective schedules of David and Elise, such as the time and places of their rendezvous, to prevent them from meeting.

Because of David's erratic behavior and mysterious absences, Elise feels that the relationship is doomed and she therefore accepts a marriage proposal from an ex-boyfriend. When David hears of this, he is determined to intervene. Desperate to marry her, he frantically contacts her and reveals to her the intentions of the Adjustment Bureau. He begs her to trust him and follow him as he tries to elude the Bureau, which is pursuing him in light of his rejection of its preordained plan.

Jewish wisdom clearly states that man has free will. Several times in the Bible, there is a reaffirmation of this notion. The Bible directly commands man to "choose life," because implicitly man has free choice. However, free choice does not mean that we can understand the Divine intention or the Divine plan. The *Ethics of the Fathers* openly remarks, "Everything is foreseen, yet freedom of choice is given." *The Adjustment Bureau* reminds us that even though destiny plays a role in our lives, it is not the final arbiter.

MINORITY REPORT (2002)
directed by **Steven Spielberg**

Several years ago, I went to a wedding of a friend in the Midwest. There I met a number of teachers who taught in the local day school. One introduced himself and reminded me that he was once a student at Yeshiva High School of Atlanta and had actually dormed at my home for half a year. I did not immediately recognize him, but when he told me his name, a flood of memories rushed through my head. I remembered that he came from a small southern town and that his parents wanted him to take advantage of high school Jewish education and so they enrolled him at my school. Although he did well academically, he never subscribed to the ethos of the school and regularly challenged authority. Upon graduation, I felt sure that he would abandon whatever Judaism he possessed.

But my prediction was all wrong. At some point, he was "born again" and blossomed as a student of Torah. Never would I have guessed that he would eventually make Jewish education his career. The entire encounter reminded me that one snapshot in time is not a reliable indicator of one's future success or failure. The future is ultimately unknowable.

Minority Report, a dark and very tense science-fiction thriller, suggests the opposite, that you actually can know the future of a person and can even intervene to prevent him from committing a crime. In the year 2054, there is a "PreCrime" program that is operational in the nation's capital, in Washington, DC. John Anderton and his team of "PreCrime" police officers are able to act on information obtained from "precogs," three mutated humans who can see into the future. They can predict the date and time of the crime, the culprit, and the intended

victim. Once this is known, the data is forwarded to the police who proactively intervene to prevent the crime.

Because the country is poised to take the program nationally, the United States Justice Department sends its own investigator, Danny Witwer, to evaluate the program. Danny discovers some internal inconsistencies in the program and determines that PreCrime is flawed and subject to human manipulation. At first he sees John Anderton as the prime suspect, but eventually his attention turns elsewhere as he doggedly pursues his leads. The film raises the provocative question of whether one should take action against people you view as criminals, even if they have yet to commit the crime.

Interestingly, the Bible speaks of a pre-crime scenario in which capital punishment theoretically is meted out to one who will commit a crime in the future, even though in the present he may be guiltless. This is the instance of the "wayward and rebellious son" who is brought to the court by his parents for capital punishment. Although his behavior at present is gluttonous and he is guilty of thievery, he has not yet murdered anyone. Yet the Bible prescribes the death penalty.

The Talmud, however, in the final analysis is inconclusive on this matter, stating that the case of the "wayward and rebellious son" never actually occurred and, indeed, will never happen. Then why, ask the Sages, do we have the law on the books? One answer is that the passage teaches us lessons about parenting and serves as a warning to children to listen to parents and to voices of authority in general. *Minority Report*, which explores the notion of pre-crime punishment, concludes that no one can truly know the future; and, therefore, we can only respond to infractions in the here and now, not future ones. This, indeed, affirms the Torah value of judging people as they are now, not as the villains they may become.

ETHICS

As a parent and as a rabbi, I think of ways to teach people how to make good ethical decisions in a world that is increasingly chaotic and devoid of moral values. How can we give our kids direction when they are bombarded by the media, TV, and movies, which project all sorts of immoral behaviors to them? What was once unthinkable at first becomes the topic of acceptable conversation, discussed over and over, and then may even become acceptable. So much of our values have become relativistic. It is hard for kids and even for adults to know what is right. Even people in leadership positions offer confusing statements.

My rabbinic training conveyed the message that there are moral absolutes: Thou shall not kill, thou shall not commit adultery, thou shall not steal. In the abstract, they all make sense, but in the practical world of everyday life, they are sometimes difficult to implement. There often seems to be a plethora of extenuating circumstances that generate situational ethics and moral relativism.

An antidote to this way of thinking is the belief that there is a God in the world, that He revealed Himself at Sinai and gave us His Torah, and that there is accountability for what we do. Furthermore, the Torah states that we are created in God's image. This means we are unique, we possess an intellect, we are different from animals and can transcend our basic instincts. We have the power of reflection.

Moreover, the Torah is precious to us because it is not just a book of rules and not just a history book. It presents us with a series of biblical archetypes, models of Jewish living, who, by example, can tell us how to live our lives, how to make good decisions in the midst of chaotic times. In the book of Genesis, for example, we have the stories of the

patriarchs and matriarchs, all of whom faced challenges and were able to make moral decisions. It is the story of great individuals.

The Talmudic statement that the actions of the forefathers are a sign for the children indicates there are timeless verities that apply to contemporary issues. Consider the story of Abraham in the Bible. When the shepherds of Lot, Abraham's nephew who lived with him, began quarrelling with the shepherds of Abraham, the reaction of Abraham is swift. Rather than fighting the possible negative influences of Lot and his shepherds, Abraham immediately orders his nephew and shepherds to leave his household and part company (Gen 13:7–9). Abraham gives Lot the pick of settling in the choicest land and Abraham agrees to take second best. He makes it clear that he would head in the opposite direction and have nothing more to do with his nephew. Here we can see the fear of peer pressure that Abraham displayed. Rather than try to combat Lot's beliefs, he simply ordered Lot to leave, because he feared that Lot's negative values could be acquired by his own household. Abraham sets an example of how to deal with negative influences in our lives.

The Talmud is replete with similar stories that teach us how to negotiate life when morality is at stake. Rabbi Yose ben Kisma is afraid of possible negative influences if he moves to a city without Torah. He is offered the equivalent of a million dollars to move from his city filled with scholars and pious people to a city without righteous people. But he refuses, stating that he has to live in city filled with people who take good morals seriously. He understands that the potential negative influence of those around him would have a great impact on his life, even though he was an adult and supposedly set in his ways.

The films in this section consider the powerful impact of contemporary moral relativism and how it can influence people to do very bad things.

THE BOURNE LEGACY (2012)

directed by **Tony Gilroy**

I was blessed to work in Atlanta from 1970 until 1998, first as a synagogue rabbi and then as principal of Yeshiva High School of Atlanta. My role at Yeshiva was primarily that of a builder, whose job it was to lay the foundation for a Jewish high school in Atlanta and to ensure that it would grow over time.

After I left Atlanta, I assumed a number of principalships where my role was to improve the situation or to solve a particular problem. I was Mr. Fix-it or Mr. Hatchet Man, depending on your perspective. In one school, I was told there was a major problem with the librarian who was focused on books, not people, and that she had to go. I was to be the agent of her removal. Board members and other staff told me the same story, and I was mentally prepared to make the change. But then I checked the evaluations of the staff person over the past ten years, and there was not one negative comment in her file. When I observed her myself, she was engaging her students and I was faced with a dilemma. How could I in good conscience fire her in the absence of negative comments in her record and when her current behavior was satisfactory?

I thought of this incident as I watched *The Bourne Legacy*, which details a far different crisis of conscience, not one as mundane as the one I faced in dealing with a librarian who was targeted unjustly for firing. Rather, *The Bourne Legacy* explores a grand crisis of conscience in the life of Aaron Cross, a special-ops soldier who is given assignments to assassinate people who are a danger to democracy. He is charged with doing a good deed, but the means to accomplish it are morally repugnant. As his superior tells him, "We are morally indefensible and absolutely necessary." Brutal killing in the name of a worthy cause

repulses him; and after fulfilling a number of assignments, he feels morally adrift. Unwilling to obey future orders, Aaron goes AWOL and tries to find solace. But problems arise.

Aaron's elite team of assassins has been provided with meds that enhance physical and mental abilities. When his superiors realize that the program may be revealed to the public, they decide to abort this clandestine program and kill all the remaining assets. When Aaron becomes aware of this, he determines that his only salvation is to secure more of the drugs so that his enhanced abilities will prevent him from being killed or captured. Alternatively, he learns that he can "viral off" the drugs and retain his enhanced abilities for the rest of his life without taking any more pills. Thus begins an exciting chase with the government in pursuit of Cross, as he tries to find a way to elude assassination and preserve his mental and physical edge.

Aaron Cross's moral dilemma parallels a fascinating Talmudic discussion about whether a person who steals a palm branch to observe the Festival of Tabernacles gets credit for performing the *mitzvah*, the good deed. Simply put, can a person do a good deed by committing a sin? The overwhelming consensus of opinion is that one cannot.

Implicit in this Talmudic debate is the notion that in all areas of life, one should be careful not to commit a wrongdoing in order to do a good deed, for it places you on a slippery moral slope. Many years ago, a donor anonymously sent large sums of money to the school of which I was principal, to assuage his guilt for profiteering from selling drugs. His charitable instincts were laudable, but his nefarious way of supporting the school tainted the school and him. *The Bourne Legacy* reminds us to be mindful of the motives and manner of those who would encourage us to compromise our honesty for the sake of a noble cause.

THE BOURNE SUPREMACY (2004)

directed by **Paul Greengrass**

Confessing is cathartic. Every Yom Kippur in our home, I confess my shortcomings to my wife and my children. I apologize to them for raising my voice to them, for being unnecessarily critical of them, for not always understanding their personal challenges. I feel better after I do this because it helps me renew my spirit and become, I hope, a better person in the coming year. Yom Kippur, after all, is a day of forgiveness when God forgives us for our sins. But our Sages emphasize that God does not forgive us unless we first make amends for the sins committed against our fellow man. Confessing our mistakes and apologizing to our loved ones brings us closer to them and closer to God, who desires our contrition, especially at this time of year. Such a personal admission acknowledges that we are imperfect, yet sends a signal that we desire to improve our relationships and ourselves. It is noteworthy that a confessional scene in *The Bourne Supremacy* humanizes the hero in a way that connects him to all of us who have made regrettable mistakes in life and want to become better.

The Bourne Supremacy is a great action movie; but what sets it apart is not only the superbly choreographed action sequences, but the humanity of its hero, Jason Bourne, a man searching to discover his lost identity. We believe his confusion. We believe that, in spite of his job as a professional assassin, he is essentially a good man. Jason Bourne's humanity is exquisitely captured in a touching scene towards the close of the film in which he contacts the daughter of a Russian diplomat and his wife, whom Bourne has assassinated. He shows up at her apartment unannounced and in a soft voice informs her that, contrary to what she thought, her mother did not kill her father and did not kill herself. He

confesses in slow, carefully deliberate language: "I killed them. I killed her. That was my job. But it was my first time. Your father was supposed to be alone, but then your mother came out of nowhere and I had to change my plan. It changes things, that knowledge, doesn't it? What you love gets taken from you. You want to know the truth. I'm sorry." The confession purges Bourne of some of his guilt. He cannot retrieve the past, but he has come to terms with it by admitting his crime to the child who was a survivor.

Moreover, confession works in more than one direction. It is cathartic for the one who confesses, for he is changed by speaking the words that indict him. Additionally, it changes the reality of the one to whom the confession is addressed. Acknowledging the words of a penitent can alter the life of the one who was hurt as well. The truth that Bourne reveals to the daughter of his victims frees her from a past filled with guilt, deception, and lies.

It is a brief scene but its impact is powerful. No longer is the film just a robust and entertaining thriller. It is also a commentary on the human cost of leading a violent life, even when the violence is for the just cause of protecting a nation. Good people can sometimes do very bad things. This vignette reminds us that we can sometimes be cruel inadvertently. Thoughtlessly, we can hurt those we love most. *The Bourne Supremacy* reminds us that confession of our sins to those we care about can open a door to our own self-renewal and, just as important, it can allow others to move on with their lives, free of the negative baggage of the past.

ALL THE PRESIDENT'S MEN (1976)
directed by Alan J. Pakula

Every day I pray that I will have a sense that God is always in front of me, that He is always in the room. It helps me control my thoughts, my actions, and my speech. When things irritate me, I think long and hard as to whether I want to respond to a provocation or to an unkind word. In general, I do not regret being silent, but I do regret a hurtful word that I may have uttered to someone, even when my intentions were noble.

I was reminded of the power of words as I watched the gripping political thriller *All the President's Men*, which portrays in detail the intense investigative newspaper work of Bob Woodward and Carl Bernstein as they painstakingly researched the Watergate burglary, eventually leading to the resignation of President Richard Nixon.

Woodward and Bernstein seem like two Talmud study partners who continually probe each other to ascertain the truth. Each questions the other and is unafraid of challenging or criticizing his friend. Their frank criticism of each other is not personal, but rather a sign that each one trusts the other to be honest and not to advance any personal agenda. Their shared mission, to discover what the Watergate burglary was all about, makes their egos subservient to the greater purpose of their work. It is this understanding of their common goal which is at the heart of their friendship and their search for truth.

They analyze and debate the significance of the words of everyone they interview. What do the words mean on a superficial level? What do the words imply? What does a response of silence indicate? There is a fascinating scene in which Carl Bernstein needs to confirm the truth of an article that is about to appear in the morning newspaper. No one

wants to be quoted, so Bernstein comes up with the following proposal as he talks to his contact on the phone: "If what I say is true, then I will count to ten, and if you do not hang up, I will assume my article is true. If it is not true, then you hang up before I reach the number ten, and I will assume that what I wrote is false." Here, interestingly, everything hangs on what is not being said.

Ben Bradlee, editor of *The Washington Post*, the paper that employs Woodward and Bernstein, is also extremely sensitive about words and continually reminds the ambitious reporters that he cannot agree to print something in his paper unless they get confirmation of more of their facts. The paper cannot besmirch someone's reputation based upon hearsay evidence or theorizing about what might have happened.

In the world of Jewish jurisprudence, the laws of slander and the gravity of hurting someone with words is the topic of many volumes written by sages of the past and present. These laws are carefully codi-fied because of the essential concern that, as the Psalmist writes, "Life and death are in the power of the tongue;" for one negative comment about a person might ruin his life professionally or personally. As a rabbi and school principal, I have been tested many times when people ask me for recommendations about people I know. It may be a recom-mendation for a job, for acceptance to an academic institution, or for a marriage partner. My general approach is to say what needs to be said without embellishment, for words are like arrows. Once uttered, they cannot be retrieved.

As we speak to the people around us, it is wise to weigh our words so that we do not hurt anyone inadvertently and in order to ensure that our words will always be in the service of society and sanctity.

INCENDIES (2010)
directed by **Denis Villeneuve**

Many, many years ago when I was a student in an afternoon Hebrew school, we would misbehave and cause grief to our well-intentioned teachers. I remember vividly that one day when the teacher left the room, we started to have a catch not with a ball, but with a *tefilin* bag with *tefilin* inside of it that gave the bag weight. *Tefilin* are the black straps and little black boxes filled with biblical quotations on parchment which male Jews over the age of thirteen wear at the morning weekday prayer service.

Our teacher suddenly returned and his face turned ashen when he realized what his charges were doing in his absence. He said nothing. He didn't have to. We were desecrating that which he felt, and what we should have felt, was holy.

Later we found out that our teacher was a Holocaust survivor, and we immediately sensed the folly of what we had done. He had never spoken about his past; we just assumed he was another teacher to harass. That indelible scene of so many years ago still lingers with me today, and I recalled that event of long ago as I watched *Incendies*, a film that reminds us of how little we know of the many people who occupy our lives.

Incendies opens with the reading of the will of Nawal Marwan, a Christian woman raised in a turbulent Middle East, where Christians and Moslems war with one another. She has lived in Canada for the past eighteen years as a legal secretary working for one employer, yet her employer barely knows her other than as a loyal and dependable worker. He is now functioning as the executor of her estate and informs her twin son and daughter, Simon and Jeanne, of an unusual request

made by their late mother. Her mother wants them to deliver two let-
ters, one to their father, whom they have never seen, and one to their
brother, about whom they have never heard. Although her son, Simon,
considers this request a sign of his mother's madness, her daughter sees
it as an opportunity to uncover the truth about who her mother really
was. She accepts the assignment from the executor and this sets in
motion a journey to a war-torn country in the Middle East to discover
the past of Nawal Marwan.

When Nawal's son dismisses his mother as unstable and reclusive,
he naively assumes that he knows who his mother was. Because of his
youthful arrogance and insensitivity, he does not yet understand that
his mother's quiet demeanor, her silence, may have been her strategy
for survival.

As the narrative unfolds, we discover that Nawal's life consisted of
unspeakable horrors, and yet she somehow survived and outwardly
lived a normal life. Her demons continued to haunt her and her re-
sponse was silence, never confiding in her children or revealing to them
anything about her past.

Jewish tradition echoes her response of silence in the face of tragedy.
The mourner in his first meal after the death of a loved one eats a hard-
boiled egg, perfectly round, without an opening, without a mouth as
it were. This reminds the mourner that in confronting the finality of
death, the most appropriate response is silence. There are no words to
make things better.

One of my teachers, Rabbi Aharon Lichtenstein, gave me another
perspective on silence that relates to Narwal's reticence to reveal secrets
to her children. Sometimes silence will contribute more to a situation
than speech, and that it is often more wise to "strangle the shout" than
to engage in a conversation, the consequences of which are unclear.
Our Sages tell us that "there is nothing better for a man than silence,"
implying that sometimes it is through restraint from speech that our
goals are best accomplished.

THE KING OF COMEDY (1983)
directed by **Martin Scorsese**

When I was eleven or twelve years old, I visited a Times Square Army recruiting booth at which Audie Murphy, a celebrated war hero who won the Congressional Medal of Honor and a movie star in Grade B westerns, spoke and gave out autographs. He was an early role model and I left the recruiting station elated that I had in my hands the autograph of an American hero. Many years later, I introduced my sons to a sports celebrity. I ran a two-week camp for a synagogue in Atlanta, and arranged for admittance to an Atlanta Hawks practice session where we could watch the great Pete Maravich in action. He was very accommodating to the campers and signed their scraps of paper with his name. It was a heady moment for many of the kids to be in the presence of a basketball legend.

Flash forward to the year 2012, and our adulation of celebrities is no longer so innocent. Just ask any parent or educator. Celebrities, actors, politicians often grab our attention due to their nefarious activities, including dishonesty of all types, illicit sex, drugs, and the list goes on. *The King of Comedy*, appearing in 1983, gave us a prophetic hint about the craziness surrounding celebrity that was to come.

In a brilliant opening scene, Jerry Langford, a late night TV host, is bombarded with fans as he exits the studio. One obsessed fan tries to get close to him, but Rupert Pupkin, ostensibly trying to protect him, slams the door in her face, and we are left with a freeze frame of hands pressing against the window of the limousine. It is an image representing the intense longing of an obsessed fan for access to a celebrity. Life is nothing unless there is connection with fame. It is sad and it is frightening when the entire thrust of one's life is to live through others.

Rupert Pupkin is determined to become a TV celebrity like Jerry, and the movie chronicles his fantastical and obsessive quest for fame. Rupert keeps cardboard figures of Jerry in his basement and has imaginary conversations with him and Jerry's guests. His friend Masha, a celebrity stalker, will stop at nothing to get close to Jerry, her idol. She ultimately helps Rupert break the law in order to compel the studio to grant him a guest appearance on Jerry's show.

Rupert receives a prison sentence of six years for his crime, but is freed after serving less than three years. He goes on to write his memoirs and becomes a celebrity in his own right, which echoes what happens so often today. The criminal is released, writes a book, and becomes a fixture of talk shows as he rehabilitates his public image.

The Torah view of celebrity is clear. The *Ethics of the Fathers* instructs us that fame is elusive. The more one chases it, the more it eludes him. Gaining celebrity is not a Jewish goal. Moreover, the object of Torah adulation is not the actor or the athlete. Rather it is the scholar or the doer of good deeds. In the end, we cannot live vicariously through others. Each of us is an image of the Divine, totally unique with our own respective missions. No one else can live our life for us because we are accountable for our own destinies. God only wants us to be ourselves, not an imitation of someone else. At the end of 120 years, God will not ask me if I was as great as Moses or Abraham; instead He will ask me if I was the best "me" I could possibly be.

CRIMES AND MISDEMEANORS (1989)
directed by **Woody Allen**

As principal of a budding Jewish day school, part of my job was to raise money as well as be the educational leader of the school; so it was with great joy when out of the blue I received a number of envelopes in the school mailbox with thousands of dollars of cash. Over several months they mysteriously appeared, and I attributed the gifts to an anonymous admirer and supporter of Jewish education. Several months later, the gifts suddenly stopped.

Soon after, I read in the local newspaper about the incarceration of a friend of mine for selling drugs. I never made a connection between the gifts of money and my friend's crime until I visited him in prison some months later. It was then he confessed to me that the money he gave the school was from the profits of his drug sales. He wanted in some way to assuage his guilt and giving money to a Jewish day school was his atonement.

I was reminded of this incident as I watched *Crimes and Misdemeanors*, the disturbing story of ophthalmologist and philanthropist Judah Rosenthal. Judah has had an affair with a woman for several years, and she now threatens to ruin his life if he does not marry her. His brother Jack suggests having the woman killed, and this presents Judah with a major question of conscience: allow his life of wealth and privilege to continue or hire a hit man to murder her. He reminisces: "I remember my father telling me that the eyes of God are on us always. What a phrase to a young boy. What were God's eyes like? Unimaginably penetrating, intense eyes, I assumed." At first the idea of murder is abhorrent to him, but then he equivocates. He has committed adultery, he has made incredibly stupid mistakes, but he knows that the

revelation of his indiscretions to his wife will ruin him both in the eyes of his wife and the greater community. And so he decides to authorize the murder.

A parallel plot of the movie concerns Clifford Stern, a documentary filmmaker who is trying to produce a film on a great scholar who, in spite of personal tragedy, is able to affirm life with honesty, optimism, and courage. It is his philosophy that counterbalances the sordid narrative of Judah Rosenthal. Professor Levy, the subject of the documentary, says in an interview that "we are all faced throughout our lives with agonizing decisions. Moral choices. Some are on a grand scale. Most of these choices are on lesser points. But we define ourselves by the choices we have made. We are in fact the sum total of our choices."

Although *Crimes and Misdemeanors* plays like a comedy in many ways, at its core it is a deep philosophical meditation on the nature of morality in the contemporary world. In the Talmud, our Sages tell us one sin leads to another. Once we cross the line of morality and decency, we traverse a slippery slope and many sins are committed in the wake of one transgression. This is why the rabbis of the Talmud, who understood human nature profoundly, often set up protective fences or decrees around the law to ensure that the primary biblical law is not broken.

Judah Rosenthal rationalizes his crime and it is unsettling to hear his self-analysis. First plagued by an overwhelming guilt, he hears the voice of his father who gave him a sense that God is watching him, and Judah feels that he has violated the moral universe. On the verge of a breakdown, he awakes one day and his moral crisis has vanished. Life goes on. There is no Divine retribution and he returns to his normal life.

Jewish tradition argues that guilt is sometimes good for a person and can even be redemptive. King David used guilt to spur him on to a life of good deeds and accomplishment. But David admitted his faults and did not rationalize his behavior when he sinned. It is this model that serves as a positive example for all of us who stumble occasionally as we navigate the moral choices that confront us.

A CRY IN THE DARK (1988)

directed by **Fred Schepisi**

At conventions of educators, school principals often share their personal "war stories" with colleagues either to unburden themselves, to gain insight into a problem, or perhaps to find a remedy for a difficult professional situation that threatens to hurt them or their school. I remember vividly one principal's narrative about a parent who wanted so much to remove the principal from his position that he spread a rumor that he had fired one of the beloved veteran administrators of the school. Another principal confided in me that he was falsely accused of being lax in enforcing the school's no-tolerance drug policy. In both cases, the accusations were false; but, nevertheless, the rumors damaged the reputation of two outstanding professionals in Jewish education. I considered myself very blessed to be in Atlanta as a school principal for many years where the lay community supported the professional leadership of the school, even when I occasionally made unpopular decisions. Hearing the narratives of my colleagues reminded me of the terrible harm that slander and gossip can do.

It is the power of slander that is the topic of *A Cry in the Dark* starring Meryl Streep as Lindy Chamberlain. The movie is based on a true story of an Australian murder trial of a mother accused of killing her own daughter. The body is never found, but a bias against a woman who is seen as cold and unfeeling by her peers creates a mob hysteria that destroys her reputation. Our tradition tells us that every person is presumed to be an upright individual unless proven otherwise. The Torah commands us in many places not to be a talebearer, not to embarrass someone, to always give someone the benefit of the doubt. Yet this is

difficult to do when the object of our comments is someone whom we dislike. The fact is, however, that this is precisely the time when we have to overcome our instincts to judge someone unfairly. This is the time when we have to withhold judgment until we have all the facts.

The destructive effects of prejudice are grippingly dramatized in a pivotal scene in which Lindy, exhausted from the trauma of losing a child and then being suspected of murdering it, gives testimony in a courtroom in a cold, dispassionate way. The jurors see her as an insensitive mother who might, indeed, have murdered her own child. As the prosecutor relentlessly cross-examines her, the interrogation is intercut with scenes of ordinary people in the street commenting on her guilt, offering interpretations of why she did it, and feeding the publicity frenzy. As one watches the montage of images, one gets a real sense of the emotional pain Lindy is suffering when giving evidence of her dead child's death by a dingo, a wild dog, before a mistrusting audience of jurors and lay people who have come to watch the spectacle with detached amusement.

A Cry in the Dark on a literal level refers to the cry of a baby in the night. On a thematic level, it refers to the cry for compassion and understanding in a world that is often insensitive to the emotional pain of other people, where the public desire to know trumps sensitivity towards other human beings. The obvious message: Death and life are in the power of tongue, so we have to be very careful about what we say about other people. Speech distinguishes man from animal; it is a gift that should not be abused.

THE HOAX (2006)
directed by **Lasse Hallstrom**

Part of my job as principal of Yeshiva High School of Atlanta was to raise funds for the school. One fundraising effort was to sponsor an artsy event in the city; and in April of 1979 we chose to buy all the seats for a performance of Shakespeare's *Othello* at the Alliance Theatre. Our goal was to sell them at premium prices to generate revenue for the school. Shakespearean tragedy was not an easy sell, but God was shining His face down upon us when we got the news that Richard Dreyfuss and Paul Winfield, well-known actors, would be the stars of the play. Tickets were gobbled up and people were sitting in the aisles. In fact, Richard Dreyfuss's father and brother came and I gave up my seats so his family could enjoy Richard's performance. The event reminded me that celebrity sells. People want to be where the famous are, and they are willing to pay a steep price to be close to the stars.

The desire to be close to celebrity is at the core of *Hoax*, a gut-wrenching narrative of moral turpitude based on the true story of Clifford Irving, an author who wrote a fictitious autobiography of Howard Hughes. Irving sees himself as a great writer, but he has had little financial success. One day he comes up with a scheme to write "the book of the century" about Howard Hughes, the eccentric millionaire who is known for his reclusive behavior. Irving, together with his devoted researcher Richard Suskind, assume that Hughes's desire for privacy and to avoid legal action will trump all other concerns, and that Hughes will not go public to deny the veracity of the book. Thus, Irving's hoax will be perpetrated with ease.

Things go as planned for a while because everyone is thirsty for

details about Howard Hughes, the celebrity. When the possibility of actually meeting him presents itself, people cease questioning the truth of Irving's narrative. All they think about is finally seeing the mystery millionaire. They believe the story even when critical pieces of evidence about its truth are missing.

Eventually, Irving's charade is tested in the crucible of investigative journalism and Irving must invent lie after lie to perpetuate the ruse. Both his financial situation and his marriage unravel under the intense pressure of him having to prove the authenticity of his information about Howard Hughes. The Talmud aptly observes that telling one lie leads to more lies. The slippery slope inevitably leads to a fall from grace.

The *Ethics of the Fathers*, a classic of Jewish wisdom literature, contrasts the attributes of Abraham, the patriarch of the Jewish people, with Bilaam, one of the arch villains of the Bible. Abraham possesses a good eye, a humble spirit, and is content with little physical enjoyments. In contrast is Bilaam, who possesses an evil eye, a haughty spirit, and an acquisitive soul. The commentators explain that this refers to a person who is jealous of others' success and who does not take joy in the achievements of others, who is arrogant, and who yearns for luxury and physical pleasure. Such is an apt description of Clifford Irving.

The Hoax is a morality play about the worship of celebrity and the pitfalls of duplicity. The Torah instructs us to do the right and good thing. This is a general command to be honest, to be concerned with the welfare of others, and to conduct oneself in a way that brings honor to you and to God. Lying as a way of doing business in the contemporary world may bring us some short time gains, but, from the aspect of eternity, it is a road to perdition.

THE HURT LOCKER (2008)
directed by **Kathryn Bigelow**

As a rabbi, as an educator, and as a parent, I have been asked many times for advice when friends and loved ones are going through stressful times. Sometimes I can help them, and sometimes their situation is so complex that I do not have a suggestion or answer that works for them. I want to help, but there are situations in which my counsel is inadequate. I see the oncoming train wreck and I am powerless to change things or to prevent the damage from occurring.

Watching *The Hurt Locker* gave me a visceral understanding of this feeling. It is a stomach-churning war movie filled with profanity, extreme tension, and violence that deals with soldiers trained to disarm improvised explosive devices such as roadside bombs. The film vividly details the enormous risk they take on a daily basis to do their job. In one particular scene, Sergeant William James is called to a public square where a man is strapped in an explosive vest. The vest was placed on him against his will, and the man desperately wants someone to save him by removing the vest. The problem is that the vest is attached to his body with numerous locks. The crisis is compounded by a timing device on the man, which indicates that the bomb will explode in a matter of minutes. What to do? Sergeant James does his best but he cannot remove the locks in time. We are left to watch the bomb detonate and the man disappear into dust.

The film drives home in a graphic way the dilemma we all face at one time or another. We do our best and yet it still is not enough to make things right. Judaism recognizes this human dilemma, and the Sages give us guidance. The *Ethics of the Fathers* tell us that we should not run

away from a difficult task; rather, we should begin it, do our best, and pray for the help of Heaven. We are only responsible for input. God is in charge of the outcome.

There is another life lesson embedded in *The Hurt Locker*. James is part of a three-man team. When he places himself in danger, his cohorts Sanborn and Eldridge automatically are placed at risk as well. James decides on one mission to take off his radio communication device to enable him to diffuse a bomb while unencumbered. The inability of his team to communicate with him in a hostile setting creates extreme uncertainty, and their straightforward mission is in danger of aborting. James also decides to hunt down terrorists on his own and invites his team to join him on this non-authorized mission, again needlessly placing his men at risk.

This failure to consider the fate of others when one makes decisions that affect other people is irresponsible and selfish. Indeed, James's pursuit of his own adrenaline rush creates havoc for his partners. This self-centeredness is contrary to the Judaic maxim that we are all responsible for one another. As the famous poet Donne said: "No man is an island." We are all connected and the death of one man diminishes every man. Therefore, we are bound to consider the welfare of all when we make decisions, not just what's in it for us.

The implications for how we conduct our own lives are clear. When faced with a daunting task, don't take a pass. Just do your best and leave the rest to God. Furthermore, when making important decisions in life, think about your loved ones and how they will be affected by your decisions. Our decisions create ripple effects on the lives of others.

THE BATMAN TRILOGY (2005-2012)
directed by Christopher Nolan

When I was a principal, I had a conversation with a board member who was a Holocaust survivor about the Holocaust Museum that was being built in Washington, DC. He shared with me his feeling that it was not a wise use of community funds which could be better utilized to support Jewish day school education. I empathized with him, since part of my job was to raise money for the school and I, too, felt that more community money should be directed towards Jewish education.

A couple of years ago, I had the opportunity to speak to my friend again and he shared with me his change of heart about the Holocaust Museum. Now he felt glad that the Museum was here to teach many subsequent generations about the Holocaust. He never envisioned years ago that there would be Holocaust deniers and that anti-Semitism would be alive and well in the world after the atrocities of the Holocaust. Never could he have imagined leaders of so-called civilized nations calling for the annihilation of the Jewish state. The world had changed and it was not for the better. Evil was a potent force in the twenty-first century, and the Holocaust Museum was an important agent of moral education, challenging the perpetrators of evil.

The conversation brought back memories of my own innocent childhood in Mt. Vernon, New York, when everyone thought, post-World War II, post-Holocaust, that the world was now enlightened, that there would be no more war, and that our collective human future was bright. 9/11 brought all that optimistic thinking to an abrupt halt.

The Batman trilogy of films deals metaphorically with how we come to terms with this new world where evil is real and ubiquitous. The

reality of evil in these narratives undercuts our assumptions about the basic goodness of man and leaves us on edge.

The Dark Knight and *The Dark Knight Rises* present two villains who are the personifications of evil: the Joker and Bane. The Joker represents the chaotic nature of evil; Bane represents the committed terrorist, for whom death and destruction are liberating events. Bruce Wayne, aka Batman, begins with a conventional understanding of the Joker's criminal mind. He tells his butler, Alfred: "Criminals aren't complicated. I just have to figure out what he's after." Alfred wisely responds: "You don't fully understand. Some men aren't looking for anything logical, like money. They can't be bought, bullied, reasoned, or negotiated with. Some men just want to watch the world burn." Bruce is ambivalent about how to deal with the Joker and Bane, and it takes him a long time to understand how vicious they are and how he must change his preconceptions about the nature of evil people.

This perhaps can give us some understanding about the biblical approach to unfettered evil, such as we find in Amalek, the arch-enemy of the Jews who attacked the old and weak as they were leaving Egypt. The Bible tells us to eradicate this evil and for the compassionate Jew, this is a hard business. On Passover at the Seder, we are bidden to spill out drops of wine from our cup when we recount the ten plagues, because our cup of joy is never full when others have suffered. Even when justice triumphs, we feel for the victim who suffers. The *Ethics of the Fathers* also cautions us not to rejoice over the fall of the wicked even though he is deserving of punishment. Moreover, the Talmud recounts the story of Beruriah, the wife of Rabbi Meir, who, when her husband wanted to harm bullies who were constantly harassing him, exhorted him to pray that these sinners repent, not to pray that they die.

The Batman trilogy is a brainy thriller. It asks us to leave our simplistic notions of good and evil at the door and to recognize that in our new and dangerous world, we cannot ignore evil. To be naïve in the face of absolute terror and evil, places us at great risk.

GOLDFINGER (1964)
directed by **Guy Hamilton**

Preparing for a trip can be simple or stressful. My wife and I recently traveled to the States to visit our children and had to pack for a five-week stay in America. What to bring? My wife and I had different lists, but we both focused on being prepared for any eventuality. Both of us brought electronic readers in case we had any down time, for we did not want to waste time. I carried an iPad with a digital edition of the Talmud; my wife carried a Kindle and voraciously read historical fiction. We tried to follow the suggestion of the rabbis in the *Ethics of the Fathers*, who say that a wise man is one who anticipates the future, who is not caught by surprise, who possesses what he needs to face uncertainty.

Anticipating the future and preparing for it is one aspect that is present in an obligatory scene of every James Bond movie since the series began in the 1960s, and *Goldfinger* is no exception. Early in the story, James meets a techie in a government installation specializing in weapons. In *Goldfinger*, the techie provides him with two tracking devices and a new car, a 1964 Aston Martin DB5 equipped with a sophisticated weapons system including machine guns, oil slick, smokescreen, passenger ejector seat, and tire slashers. It also possesses bulletproof glass and revolving license plates. How to use them is carefully explained, and it becomes clear to the audience that each of these devices will be used by Bond to carry out his mission.

The plot, such as it is, concerns Auric Goldfinger's attempt to increase his wealth by making the entire gold reserve at Fort Knox radioactive, so that his own stock of gold will be worth ten times its current

value. If it sounds preposterous, it is. But this kind of over-the-top plot is typical of the Bond adventures, and it is part of their appeal.

Goldfinger was the first Bond film I saw. I remember the day vividly. I was a college student, recently introduced to the dark and emotionally intense movies of Ingmar Bergman, a renowned Swedish director. Early in the day I watched a triple feature of his black and white psychological studies in which dialogue is sparse and long close-ups reveal simmering emotions beneath the surface. I left the theatre numb and passed by a cinema showing *Goldfinger*. It promised pure escapism and relief from the morbid aesthetic of Ingmar Bergman, and so I walked into the fantasy world of James Bond.

Another aspect of every James Bond film is its portrayal of the villain. He is never average. He has to be a match for Bond and pose a real existential threat to the world in general and to Bond in particular. In *Goldfinger*, the villain is Auric Goldfinger, but he is assisted by Oddjob, a muscular Asian. At one point, Goldfinger orders Oddjob to demonstrate his favorite weapon, his blade-rimmed bowler hat, which he uses to cut the head off a marble statue not far away. It is clear that Oddjob and James will meet again and that somehow Bond will emerge victorious from their contest.

In Jewish tradition, there is a similar pattern in the battles between good and evil. Moses' arch-enemy is Pharoah, not his underling. In the ethical literature there is a fight between the good and evil inclinations, and the Talmud observes that the more distinguished the righteous person, the more formidable is his evil inclination. It is an adversary not to be taken lightly if one truly wants to win the war. *Goldfinger*, an escapist entertainment, makes some cogent statements about the necessity of wisely preparing for the future and not underestimating your adversary.

Acknowledgements

I would like to thank Norm Gordner, editor of *The Jewish Tribune* in Toronto, for giving me the opportunity to write about the movies on a weekly basis. The commitment to write a column every week forced me to write no matter my mood or situation. I did not have time for writer's block.

Thanks to my editor at Urim Publications, Raquel Kampf, for her many helpful suggestions.

Thanks also to friends and family who read drafts of my reviews and made helpful suggestions. First, thanks to my devoted wife Meryl who read every draft and let me know if the review made sense. Thanks to my son, Benyamin, an author in his own right (*My Jesus Year*, published by HarperOne) whose technical expertise and editorial savvy helped me fine tune my own writing and avoid making silly errors. Thanks to my son, Rabbi Ezra Cohen, and to my granddaughter, Sara Malka Cohen, for reviewing the manuscript at its last stages and making valuable recommendations. Thanks also to Peggy Kristt, a dear friend of many years, who made many wise and helpful suggestions.

Thanks to Roger Ebert, of blessed memory, for showing me that movie reviews can be personal, serving indirectly as memoirs of one's life.

Thanks to the Lord Above for giving me good health and the time to write *Kosher Movies*. May He continue to grant me, my entire family, the nation of Israel, and all humanity an abundance of His blessings.

Herbert J. Cohen
Beit Shemesh, Israel

Alphabetical Listing of Films

Alphabetical Listing of Films

Hustler
I Am Sam
Impossible
Incendies
Inception
Incredible Shrinking Man
Iron Lady
Island
Jeremiah Johnson
King of Comedy
Last Samurai
League of Their Own
Leaves of Grass
Les Miserables
Malcolm X
Man For All Seasons
Margin Call
Marvin's Room
Mask
Minority Report
Moneyball
Mud
Natural
No Direction Home
Nun's Story
On Golden Pond
Page One
Perfect World
Place Beyond the Pines
Proof of Life
Quiz Show
Rain Man
Rainmaker
Real Steel
Remember the Titans

Rise of the Planet of the Apes
Road Home
Rocky
Ruby Sparks
Saving Private Ryan
Say Anything
Searching for Bobby Fischer
Searching for Sugar Man
Silver Linings Playbook
Simple Twist of Fate
Singin' in the Rain
Source Code
Spartacus
Splendor in the Grass
Stranger Than Fiction
Sweet Land
Taken 2
Tender Mercies
Tootsie
Toy Story 3
Tree of Life
Tristan and Isolde
Truman Show
Unfinished Song
Unstrung Heroes
Untouchables
Visitor
War of the Worlds
When a Man Loves a Woman
Words
Wyatt Earp
Young Sherlock Holmes
Young Victoria
Zelig

About the Author

Rabbi Herbert J. Cohen, a veteran educator for over thirty years, has taught both Judaic and secular classes throughout his career. Possessing a PhD in English as well as rabbinic ordination, he enjoys the discovery of common threads in both religious and secular studies.

Rabbi Cohen presently lives in Beit Shemesh, Israel, where he teaches language and literature in Israeli schools. He also writes a weekly "kosher movies" column in *The Jewish Tribune* in Toronto and blogs in *The Huffington Post*. He has written four books including *Kosher Parenting: A Guide for Raising Kids in a Complex World*, *Walking in Two Worlds: Visioning Torah Concepts through Secular Studies*, *Torah from Texas: Perspectives on the Weekly Torah Portion* and *The One of Us: A Life in Jewish Education*.

Rabbi Cohen can be reached at rabbihjco@msn.com and via his website at www.koshermovies.com. He is available for speaking engagements.